One Hundred Stories
Highlights from the
Washington
County Museum
of Fine Arts

One Hundred Stories
Highlights from the Washington County Museum of Fine Arts

Hagerstown, Maryland

Edited by Elizabeth Johns

Sarah Cantor
Margaret Dameron
Alan Fern
Angela S. George
Elizabeth Johns
Mary L. Pixley
Joseph Ruzicka
Ann Prentice Wagner

Washington County Museum of Fine Arts,
Hagerstown, Maryland
in association with D Giles Limited, London

For Washington County Museum of Fine Arts:
Project editor: Elizabeth Johns
Curator, Washington County Museum of Fine Arts:
Ann Prentice Wagner
Copy editor: Fronia W. Simpson
Photographs of objects: Edward Owen
Photographs of gallery installations and Museum
exteriors: Erick Gibson

For D Giles Limited:
Copy edited and proofread by David Rose
Designed by: Anikst Design, London
Produced by GILES, an imprint of D Giles Limited,
London

GILES HB ISBN: 978-1-904832-54-6
PB ISBN: 978-0-914495-02-4
Printed and bound in Hong Kong

All measurements are in inches; height precedes width
precedes depth.

Front cover: Frederic Edwin Church, American,
1826 – 1900, *Scene on the Catskill Creek, New York*, 1847
Back cover (HB edition only): Sarah Miriam Peale,
American, 1800 – 1885, *Portrait of a Woman*
Frontispiece: Edward Steichen, *Yellow Moon*, 1909
Founders' Gifts: [section divider] The William H.
Singer Jr. Memorial Gallery
European Art: [section divider] Schreiber Gallery
American Art: [section divider] American works
on view
Decorative Art: [section divider] Rinehart Gallery
installation

Contents

Foreword

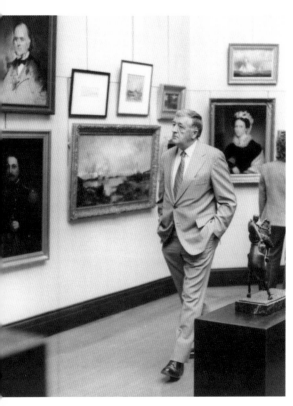

This book is a tribute to the life and legacy of Theron Kenneth Rinehart (1924-1997).

Life happens … timing is important. Being in the right place at the right time inevitably determines a favorable outcome.

After two unplanned stints in the U.S. Army, a degree from Georgetown, and a career of more than thirty years in marketing and public relations with Fairchild Aircraft Industries, Theron Rinehart retired in 1985 while still of sound mind and body.

Having been a member of the Board of Trustees of the Washington County Museum of Fine Arts, he was elected president just as the Museum began its capital campaign for the extensive expansion that was completed in 1995. It was an exciting and rewarding ten years.

above
Theron K. Rinehart at the Museum

right
Antonio Tobias Mendez, *Solitaire?*, 1999. Presented to the Museum by the Friends and Family of Mr. Theron K. Rinehart, Former President, Board of Trustees

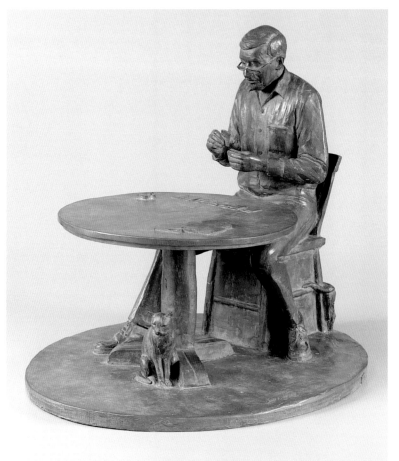

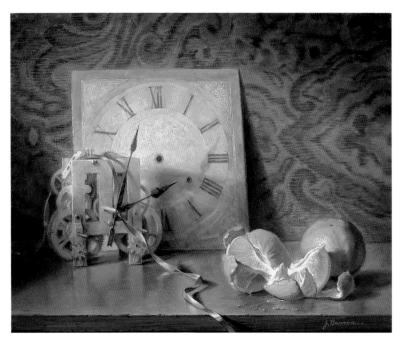

John Bannon, *A Clockworks Tangerines,*
1996. Gift of the Artist, Fairfax Station,
Virginia

My own love affair with art took a giant leap forward with John Bannon's gift to the Museum in 1999 of his painting *A Clockworks Tangerines* (1996), the year the Museum held an exhibition of his work. Acquainted as I was with the book *A Clockwork Orange* by Anthony Burgess and subsequently with the film based on it, I found the painting irresistible. Bannon enchanted me with the magic realism of his textures, especially in the skin of one tangerine and the finely detailed peeled interior of the other, seeming to burst with sweet juices. The complementary luminous hues of orange and blue drew me across and around the image. One of Bannon's favorite themes is the contrast between mechanical and organic elements, which he carries out here by leading the eye from the brilliant tangerines to the shadowy gray clock face and the subtle inner workings of the clock. He connects the elements with a delicate blue ribbon and intricate tapestry background, all of which I found unforgettable.

Bannon (b. 1933), a Baltimore native, began to receive formal instruction in art at the age of eight. He received a bachelor of fine arts degree from the Maryland Institute of Art and a master of fine arts degree from the University of Pennsylvania. At the Maryland Institute he was a protégé of Jacques Maroger (1884-1962), former director of the technical laboratory at the Musée du Louvre, Paris, who was an expert in the artistic techniques of the old masters. Inspired by his teacher and other Maryland artists, Bannon has resisted abstraction, working instead in the traditional forms of landscape, portraits, and still life. After years of teaching, he now lives in northern Virginia, where he continues to travel and paint.

Jeannette Rinehart

Introduction and Acknowledgments

One Hundred Stories celebrates one hundred paintings, sculptures, works on paper, and decorative arts in the Washington County Museum of Fine Arts in Hagerstown, Maryland. The Museum opened in 1931 with a small but very fine collection; directors and trustees have added to the collection with care over the years, through purchases and generous gifts. This book reveals the Museum's strengths and variety, with short entries by scholars on each object that discuss the work's place in the career of its creator, in the historical context of its period, and in art history.

The book begins with an essay by Joseph Ruzicka about the history of the Museum, followed by an essay by Alan Fern on the history of museums in the United States. The entries on each object follow. The objects and their stories are arranged by category: gifts of the founders of the Museum, Mr. and Mrs. William H. Singer Jr.; works by old masters; American works; and decorative arts. The book is addressed to the general audience of museum visitors as well as the more specialized audience of staff in other museums who know little about the Museum's holdings.

This volume was the brainchild of its generous underwriter, Mrs. Theron Rinehart. A staunch supporter of the Museum whose late husband had been chairman of the Board of Trustees, Jeannette Rinehart decided in 2006 that the Museum needed to present itself to the regional and national community with an attractive book. She made suggestions to that effect in a discussion with Joseph Ruzicka, director from 2004 to 2007, and the project was born. Museum staff identified one hundred outstanding objects and, with Jeannette's enthusiastic support, arranged for them to be studied, conserved, and photographed.

How appropriate it is that Jeannette's tribute to Theron be a book and that it honors a museum. Theron Rinehart loved books. He wrote for Fairchild Industries, and toward the end of his career, he developed a museum in the corporate facility depicting Fairchild's history. Having served on the Board of Trustees of the Washington County Museum of Fine Arts, when he retired in 1985 he accepted the Board presidency just as the Museum began its capital campaign for the extensive addition that was completed in 1995.

In addition to my gratitude to Jeannette Rinehart, I am grateful to our authors: Alan Fern, Director Emeritus of the National Portrait Gallery; Joseph Ruzicka, Director of the

Washington County Museum of Fine Arts (WCMFA), 2004-7; Ann Prentice Wagner (APW), Curator of the WCMFA; Margaret Dameron (MD), Curatorial Coordinator of the WCMFA; Mary L. Pixley (MLP), Samuel H. Kress Foundation Curatorial Fellow at the WCMFA in 2005-6, and now Associate Curator for European and American Art, Museum of Art and Archaeology, University of Missouri-Columbia; Angela S. George (ASG), Ph.D. candidate at the University of Maryland and Lecturer in the Decorative Arts at the Corcoran College of Art and Design; and Sarah Cantor (SC), Ph.D. candidate at the University of Maryland and former research assistant in the Department of Old Master Drawings of the National Gallery of Art, Washington, D.C. Our copy editor, Fronia W. Simpson, who worked skillfully with our texts, receives our profound gratitude; all faults, of course, remain our own. The contributions of Linda Dodson, Registrar at the WCMFA, and Christine Shives, Administrative Assistant at the WCMFA, were essential to the project. For the beauty of the book I bow to our conservators, Sian B. Jones (paintings), Constance Stromberg (sculpture and decorative arts), and Carol Ann Small (paper); to our superb photographer, Edward Owen, of Prague, the Czech Republic; and to our wise publisher, Dan Giles (D Giles Ltd) of London, and his terrific staff.

Elizabeth Johns
Project Editor

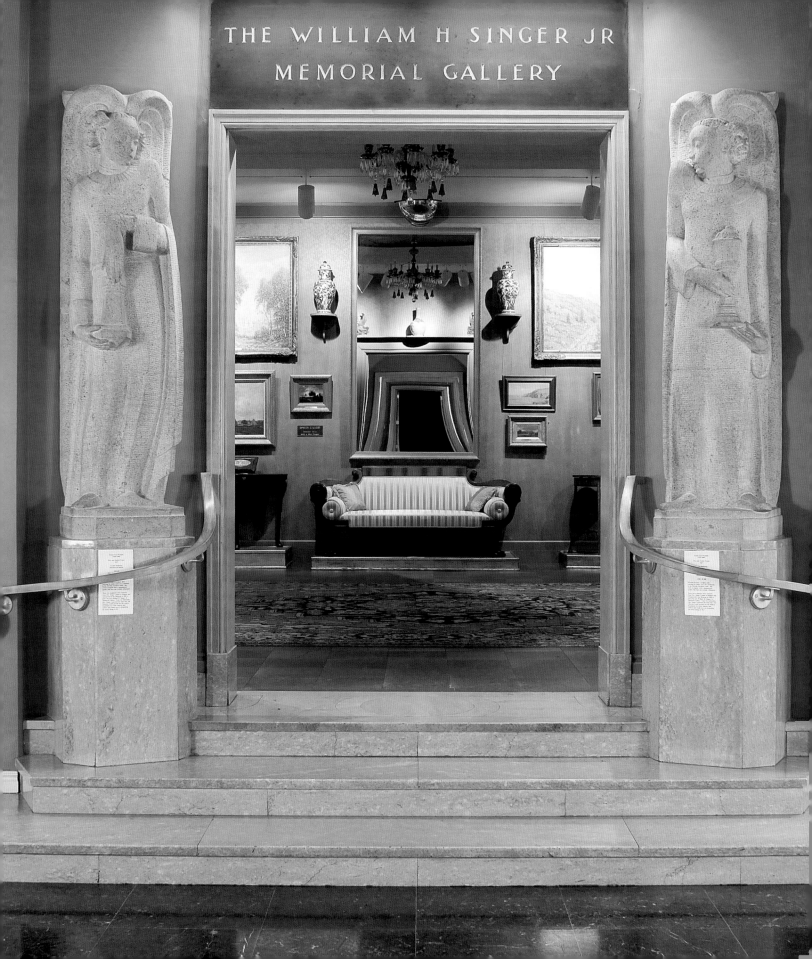

THE WILLIAM H SINGER JR
MEMORIAL GALLERY

"Our fondest dreams and hopes"
History of the WCMFA

Joseph Ruzicka

W hen the Washington County Museum of Fine Arts was incorporated in 1929, Hagerstown was a brawny, bustling, industrial city that had been prosperous for many decades: it was a major railroad hub and a center for the manufacture of clothing, furniture, automobiles, and airplanes. Its downtown was the retail center for the entire region, and the surrounding countryside was abundant and fertile farmland.[1]

What Hagerstown lacked, as our founder, Anna Brugh Singer, clearly recognized, was a dedicated cultural center free and available to the entire community. To be sure, the Washington County Free Library, inventor of the bookmobile, had been a force for literacy and learning since 1898. It is true that the many theaters downtown–including the Maryland Theater–brought live stage performances, movies, and concerts of all manner of music to the citizens of the area. But the region did not have a public institution dedicated to art appreciation, studio art instruction, and free concerts. When the doors of the Washington County Museum of Fine Arts opened in 1931, it assumed its role as the region's versatile cultural center.

On July 15, 1930, in the teeth of the Great Depression, the cornerstone of the Washington County Museum of Fine Arts was laid amid much ceremony and excitement.

"Our fondest
dreams and hopes"
History of the
WCMFA

Citizens and dignitaries gathered on a hot summer afternoon in Hagerstown's City Park to witness the first day of construction. Assisting with the laying of the cornerstone was Miss Anne Spencer Brugh, the four-year-old grandniece of William and Anna Singer Jr.; the founders were living in Norway at the time and unable to attend.

The marriage of William and Anna in 1895 had proved to be a fortuitous event for Hagerstown's cultural life. Anna Brugh was born and raised in Hagerstown, and for a while, she lived across the street from the land that would be transformed into City Park in the early twentieth century. In her statement in honor of the Museum's twenty-fifth anniversary, Anna Singer explained that she and her husband had long envisioned an art museum set in the middle of the park, an institution that would "enrich the lives of our fellow citizens, in keeping with our own experience during our years abroad and our association with the creative genius of distinguished artists … giving younger generations a fuller appreciation of the joys and beauty than had been afforded me."

William H. Singer Jr., a Pittsburgh native, was the son of a partner of the steel magnate Andrew Carnegie, and for a time, he followed his father in the family business. However, he was a gifted painter, and by 1900 he had decided to pursue his calling in Europe. It is notable that through his early adulthood, he lived literally next door to the most prominent supporters of culture in Pittsburgh and, indeed, the nation; his neighbors included the Carnegies, Fricks, Mellons, and Phillipses.

Anna Singer provided the dream to form a museum for the betterment of her hometown. William Singer offered the financial backing and the sense of obligation to build. Although they lived away from the United States for a generation before initiating plans to build, they did not want the Museum named after themselves. For Anna Singer, providing the Museum was an extraordinary act of devotion to and remembrance of her home community.

In a letter dated March 3, 1932, Anna Singer, writing from her home in Olden, Norway, to the Washington County commissioners, noted that all reports forwarded to her regarding the reception of the institution ("so necessary for the spiritual growth of the Town and County") had been most warm and appreciative. She closed by writ-

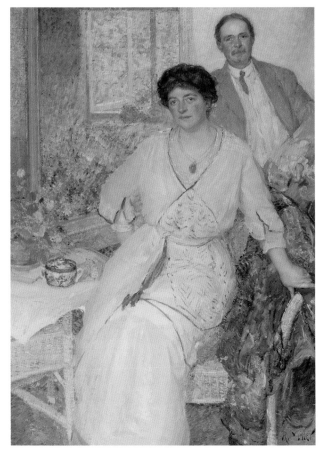

Richard E. Miller, *Double Portrait of Anna B. and William H. Singer*, before 1912. West Norway Museum of Decorative Art, Bergen, gift of Anna Brugh Singer

ing, "That the Museum may fulfill its purpose, even beyond our fondest dreams and hopes, is the heart's desire of my husband and myself."

Anna Singer struck an agreement with Washington County and the city of Hagerstown that stipulated she and her husband would underwrite the cost of constructing the building and would donate art from their private collection to grace its galleries, and the local governments would cover the costs of operating and maintaining it. Admission was always to be free. This farsighted arrangement has allowed the Museum to flourish for seventy-five years in a small community, an ideal public-private partnership.

Sustained growth has been a feature of the institution. The building was expanded twice, first in 1949 to provide more gallery space as well as a concert hall, and again in 1994, providing more galleries, classrooms, a library, office space, and a gift shop. In 2005 the Kaylor Lakeside Garden was designed and built. The Singers' original 1931 gift of several hundred works of art has grown into a collection of some six thousand works of astonishing diversity and quality.

The Singers' initial gifts included bronzes by Auguste Rodin and his American followers, such as Paul Wayland Bartlett; paintings by William Singer's American contemporaries–artists with whom he painted over the years–such as Childe Hassam and Willard Metcalf; paintings, sculpture, and drawings by the Singers' European associates, such as the brothers Jacob and Willem Dooijewaard, and by nineteenth-century European artists they admired, such as Gustave Courbet and Henri Fantin-Latour; and Asian art, mostly from nineteenth-century China and Japan.

Anna and William Singer donated art in the same vein during the 1930s, and Anna continued doing so until 1949, when she contributed funds for the Museum's first expansion. After financing the addition, Anna Singer turned her attention to founding a museum in the Netherlands in memory of her husband, who had died in Norway under Nazi occupation in 1943. This second museum opened in 1956 in Laren. Nonetheless, she remained dedicated to the Washington County Museum of Fine Arts until

"Our fondest
dreams and hopes"
History of the
WCMFA

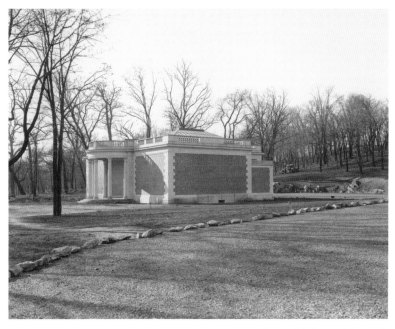

The Washington County Museum of
Fine Arts, 1931

her death in 1962 and assisted financially in the trans-
formation of the collection, helping greatly to expand
the breadth of represented civilizations.

Old master paintings first entered the collection in
1941 with Giovanni Mazone's *SS Mary Magdalene and
Paul.* In the 1950s the Museum began to collect these
paintings in earnest; the result today is a collection of
some fifty important works. It was also during the 1950s
that the institution began to build its significant collec-
tion of nineteenth- and early twentieth-century Ameri-
can art, such as works by Benjamin West, Thomas Birch,
Thomas Cole, Frederic Church, and Edward Steichen.

During the 1960s and 1970s existing areas of the col-
lection were fortified and new areas were established.
Acquisitions of African sculpture expanded the Muse-
um's worldview with art from another continent. Work by such contemporary Ameri-
can artists as Robert Indiana, Helen Frankenthaler, Alfred Leslie, and Frank Stella
entered the collection, bringing the Museum's holdings up to the present. From the
1980s into the early years of the new millennium, the permanent collection continued
to grow with a particular eye toward acquiring artworks created in the mid-Atlantic
region of the United States, among them examples by members of the Peale family,
examples of Pennsylvania Dutch Fraktur, and regional needlework.

The diversity of the collection has been driven in part by the staff's understanding
that the Washington County Museum of Fine Arts might well be the only art museum
that many of its constituents visit. Therefore, the Museum's obligation is to bring as
broad an experience of the world as possible to visitors.

Since the beginning, education has been a cornerstone of Museum activities. Anna
Singer worked closely with the architects Hyde & Shepherd on the specifics of the build-
ing; a requirement of the original design was the inclusion of a classroom, particularly
for teaching children. Anna Singer was well aware of the critical advantages that chil-

dren trained in the arts have as they learn how to think, improvise, solve problems, and dream. Over the years, instructors have offered studio art classes in techniques such as watercolor painting, clay sculpting, and plein air painting (working in outdoor light).

An important component of the Museum's education programs is the now well-established relationship with the Washington County Board of Education. This collaboration was formalized in 1945, when the board superintendent became an ex-officio member of the Museum's Board of Trustees, and it gained great momentum in the 1950s, when the Museum's director and art instructor provided fine arts instruction for the Board of Education's countywide televised distance-learning program, a project underwritten that decade by the Ford Foundation.

For more than five years, the Museum and the Board of Education have been partners in the Arts Literacy Program, in which all third, fourth, and fifth graders in the Washington County public school system pay an annual visit to the Museum. Soon, the first graduating high school class in a generation will leave the school system having gone through all three years of visits to the Museum.

Music, too, has played a major role in the life of the Museum. Anna Singer studied piano at the Peabody Institute in Baltimore and maintained a lifelong devotion to classical music. Evidence of whether the Museum hosted musical performances as early as the 1930s is sketchy, but it is likely that concerts were held periodically in the galleries during those years. However, since 1949, when the first addition was constructed, the Museum has hosted regularly scheduled musical programming, including free Sunday afternoon concerts throughout the year. Anna Singer specified that the north wing (today, the Bowman Music Gallery) double as both gallery and performance space, and she gave the Museum its Steinway grand piano, which she played as part of the dedication of the new galleries in November 1949.

Until the Maryland Symphony Orchestra was established in 1981 in Hagerstown, the Museum was the only source of regularly scheduled classical music in the area. During its 2006–7 season, the Symphony celebrated its twenty-fifth anniversary, and the Museum and Symphony marked their joint contributions to the community by holding four recitals at the Museum by members of the MSO.

"Our fondest
dreams and hopes"
History of the
WCMFA

Museum and Anne G. and Howard
S. Kaylor Lakeside Garden

The classical repertoire makes up the majority of the concert schedule, with the Washington County Museum Consort in residence for many years, and a recently forged relationship with the music faculty and honor students from Shepherd University in Shepherdstown, West Virginia, for performances at the Museum. To increase the diversity of the offerings, the Museum has begun to book other types of music, such as barbershop quartets, jazz, and blues.

The Museum has always understood its obligation to foster the rich and long-lived contemporary art scene in the Cumberland Valley. Since the 1930s it has hosted annual juried exhibitions such as those of the Cumberland Valley Photographic Salon and the Cumberland Valley Artists' Association and has from time to time purchased contemporary regional art from those exhibitions. This has been vital in underscoring the historical importance of this part of the country as an art center.

The history of the Washington County Museum of Fine Arts has been one of vigilant stewardship. Each generation holds the collection, building, and history in trust for the community and for the next generation. Serving the greater good is what makes a museum such a critical part of a society.

1. This essay has been modified from "Our Fondest Dreams and Hopes," which first appeared in Margaret Dameron, Mary L. Pixley, Matthew A. Postal, and Joseph Ruzicka, *"Our Fondest Dreams and Hopes": Commemorating the Seventy-fifth Anniversary of the Washington County Museum of Fine Arts, 1931–2006* (Hagerstown, Md.: Washington County Museum of Fine Arts, 2006).

To touch the Imagination:
An overview of Art Museums in America

Alan Fern

When the Washington County Museum of Art opened in 1931, it took its place in a long series of American art museums, dating back at least 150 years. What was most unusual about it was the fact that it stood in a small Maryland town, not in one of the major urban centers or in an academic center, where most American museums had been located. During the celebration of the Museum's fiftieth year, Mrs. Singer recalled that her purpose had been, not to create a personal monument, "but rather to have a Museum, free to the people, giving younger generations a fuller appreciation of the joys and beauty than had been afforded me."[1]

Anna and William Singer shared with the patrons of other, similar museums a desire to bring cultural opportunities to American citizens and to provide them with a chance to experience works of art of high quality at firsthand, but their stated purpose was not necessarily shared by other museum founders. It is interesting to look at a few other American art museums to understand the special quality of this one, and to consider how it compares with comparable institutions.

Like the founder of the first museum in America, Charles Willson Peale, Mr. Singer was a painter, but he did not intend to show his own work in the museum he and his wife had built. Peale showed no such restraint. By 1782, when he was working

as a portrait painter in Philadelphia, he built an exhibition room near his studio that would serve as a "portrait gallery."[2] The initial impetus for the gallery was to display his own paintings, both to attract sitters and for the enjoyment of the public. But Peale was also interested in the natural sciences, and soon decided to add bird and animal specimens to his display as well, having "no doubt ... [that his] assemblage of nature ... when critically examined [would be] found to be part of a great whole, combined together by unchangeable laws of infinite wisdom."[3] Thus, Peale reflected the views of others of the Enlightenment, who were exploring the relationships of various animal and plant species, pondering the meaning of the diversity they were studying, and relating all they learned to overarching philosophical principles.

In 1786 Peale opened his Philadelphia Museum, soon known as Peale's Museum, first in his own building and later (in 1794) in Philosophical Hall. On display was a selection of the 269 paintings, 1,824 birds, 250 quadrupeds, 650 fishes, and other objects he had assembled. It had been Peale's dream to make his museum a national institution, but he failed to secure funding from the federal government even though the museum was successful in attracting the public; in its peak year–1816–it had more than 47,000 visitors, in a city of fewer than 100,000 people.[4] Growing old, and preoccupied by other concerns, Peale closed the museum in 1820, and its collections were dispersed. Although it later reopened under the direction of two of his sons in Baltimore, the museum never regained the success it had enjoyed earlier.

Expression of a philosophical point of view was not the only impetus for the establishment of art museums in our land. As educational institutions arose in America, a few incorporated art galleries as places for the aesthetic enrichment of students and faculty, as well as to display works that might be useful in instruction. The Dartmouth College museum that was established in 1791 was a museum that combined art and natural philosophy, as Peale's Museum had done. By contrast, the 1811 bequest from James Bowdoin III to the college in Maine bearing his name was exclusively of works of art, and to this day the Bowdoin College Museum of Art holds one of the exceptional collections (despite its small size) of American and European paintings in the nation.[5]

To touch the
Imagination:
An overview of
Art Museums
in America

Yale University soon followed Dartmouth and Bowdoin when, in 1832, it built the Trumbull Gallery to house the works it had received in 1827 from William Dunlap[6] and from the eminent painter James Trumbull. Harvard's Fogg Museum followed much later, opening in 1895–preceded by galleries at Vassar College (1864), Smith College (1882), Princeton University (1888), and Stanford University (1894).

Professional artists felt the need, early on, to have a place where they could introduce their students to the best available works of art. In addition to the growing number of colleges and universities, which were for the education of scholars, clergymen, scientists, and others in intellectual studies, the artists of the new Republic also established institutions of learning. The National Academy of Design in New York City and the Pennsylvania Academy of the Fine Arts in Philadelphia are two of the earliest such teaching centers, and both established galleries for the display of painting and sculpture to both students and the public that exist to this day as active museums of art.

The college and university art museums were for the most part in small communities. Larger urban centers had to wait for their museums until well into the nineteenth century. Boston's Athenaeum was founded as a library and cultural center in 1807 and opened its art gallery in 1827, but it was a modest operation. As Americans increasingly traveled to Europe, the sense of a need for fine arts to take a place in national culture grew evident. Joshua Taylor noted that when some of these travelers returned to the United States, they were struck by the deficiencies in Americans' knowledge of their cultural heritage and were impressed by the importance of the art museums open to the public in the European capitals. They determined that they must "'Raise the public taste' by introducing artists and public alike to the special world of art created by assembled masterpieces from the past and the present."[7]

Besides the great European museums, which had become available to public audiences beginning in the late eighteenth century, another place for the public to learn about art was the world's fair. Starting in 1851, with the Great Exhibition at the Crystal Palace in London, and followed by other world's fairs in Paris and elsewhere, international exhibitions of art and manufacture served as models for artists and de-

signers as well as places of inspiration for the general public. These fairs attracted enormous attendance and suggested to civic leaders the role that the display of art could play in promoting a more sophisticated and educated public. By the time the Philadelphia Centennial Exposition opened in 1876, a number of American cities had established–or were in the process of establishing–public art museums.

In Washington, D.C., the Corcoran Gallery was established in 1859 and opened in 1869, the Metropolitan Museum in New York City and the Museum of Fine Arts in Boston were both founded in 1870, and the Art Institute of Chicago was started in 1879.[8] While the works of American artists were included in these collections, they substantially revolved around the works of European masters. In his 1876 novel *Roderick Hudson*, Henry James captures the spirit of these early museum benefactors: Hudson's "civic obligation [was] to 'go abroad and with all expedition and secrecy purchase certain valuable specimens of the Dutch and Italian school.' This done he could then 'present his treasures' to an American city willing to create an art museum."[9]

Huge sums were paid for works of art by collectors such as Henry Clay Frick, Otto Kahn, Mrs. Henry H. Huntington, Henry Walters, Isabella Stewart Gardner, and J. Pierpont Morgan, to name just a few of the wealthy patrons who supported the establishment of new art museums. Some provided collections central to the recently founded museums in the large cities. Others established museums themselves, bearing their names and containing the objects they had collected.

As noted, most of the collections consisted largely of European masterpieces, with the occasional Chinese or Japanese treasure, Greek or Roman object, or Egyptian tomb relic. Contemporary art and works by American artists of all periods were in short supply in most of the new large museums. This was corrected in the 1920s and early 1930s, when a number of new art institutions came into being.

The Armory Show of 1913 brought the work of European and American contemporary artists to a large audience in New York. Some of the artists shown there, like Pablo Picasso, Georges Braque, and Henri Matisse, had been shown previously in Alfred Stieglitz's small gallery in New York, but now they burst on the American public with great impact. American artists who had worked abroad and learned from

To touch the
Imagination:
An overview of
Art Museums
in America

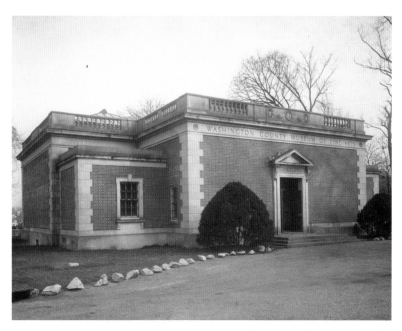

Original entrance to the
Washington County Museum
of Fine Arts, 1931

the European avant-garde painters were also shown by Stieglitz, and with the example of the Armory Show their work began to be collected. John Marin, Arthur B. Dove, Marsden Hartley, Georgia O'Keeffe, John Sloan, George Bellows, and many others entered the public consciousness and the new museums.

In Washington, D.C., Duncan Phillips established a memorial to his deceased father and brother in 1918, and opened a public gallery in his home in 1920. The Phillips Memorial Gallery was the first museum in the United States dedicated to modernism in Europe and America, and continues to fulfill this mission today. A small group of wealthy collectors formed the Museum of Modern Art in New York City in 1929. The artist Gertrude Vanderbilt Whitney transformed her Studio Club into the Whitney Museum of American Art in 1930, and the Solomon R. Guggenheim Museum was founded in 1937, followed by its Museum of Non-Objective Painting in 1939. The Wadsworth Atheneum in Hartford, Connecticut, established itself as a major collector of advanced American and European art in a city where these works had not previously been featured.

Nor was this activity restricted to the American northeast coast. The Taft Museum and the Cincinnati Art Museum opened in Ohio, as did major museums in Cleveland and Toledo. Detroit had its own Institute of Arts, and comparable museums were established in St. Louis, Minneapolis, San Francisco, Seattle, Portland, and many other cities. Specialized museums, such as the Shelburne in Vermont or the Abby Aldrich Rockefeller in Williamsburg, Virginia, were devoted to decorative arts and folk art.

Meanwhile, private collectors continued to establish museums centered on the works they had assembled. The Ringling Museum in Sarasota, Florida, and the Addison Gallery at Phillips Academy in Andover, Massachusetts, both opened in 1930, around the time the Barnes Foundation was established in Merion, Pennsylvania. Evidently, the 1929 stock market crash and the Great Depression that followed did little

1. Margaret Dameron, Mary L. Pixley, Matthew A. Postal, and Joseph Ruzicka, *"Our Fondest Dreams and Hopes": Commemorating the Seventy-fifth Anniversary of the Washington County Museum of Fine Arts, 1931-2006* (Hagerstown, Md.: Washington County Museum of Fine Arts, 2006), 34.

2. Sidney Hart and David C. Ward, "The Waning of an Enlightenment Ideal: Charles Willson Peale's Philadelphia Museum, 1792-1820," in *New Perspectives on Charles Willson Peale*, ed. Lillian B. Miller and David L. Ward (Pittsburgh: University of Pittsburgh Press for the Smithsonian Institution, 1991), 219-35.

3. Ibid., 221.

4. Ibid., 224.

5. *The Legacy of James Bowdoin III* (Bowdoin, Maine: Bowdoin College Museum of Art, 1994). A list of the founding dates of the several art galleries in academic institutions mentioned here can be found on pp. 33-34.

6. William Dunlap, *A History of the Rise and Progress of the Arts of Design in the United States* (New York: George P. Scott & Co., 1834; reprint, New York: Dover, 1969), 1:391-93.

7. Joshua C. Taylor, *The Fine Arts in America* (Chicago: University of Chicago Press, 1979), 143.

8. Ibid., 141-43.

9 Henry James, *Roderick Hudson*, quoted in Neil Harris, *Cultural Excursions* (Chicago: University of Chicago Press, 1990), 254.

10. Quoted in Walter Muir Whitehill, *Museum of Fine Arts, Boston: A Centennial History* (Cambridge, Mass.: Belknap Press of Harvard University Press, 1970), 1:12-13.

to dampen the enthusiasm of benefactors and collectors for sharing their treasures with the public. The museums mentioned, and many others, managed to survive the economic stringencies of the 1930s, and by opening their doors at no (or low) charge to a public eager for a taste of beauty, they provided a needed refuge from the realities of those difficult years.

More recently, the Norton Simon Museum in Pasadena, California, the Nasher Sculpture Center (featuring sculpture of the twentieth and twenty-first century) in Dallas, Texas, and the Neue Galerie in New York City (founded by Ronald Lauder to display his Austrian modern collection and related works) have established themselves as features of the American cultural landscape.

As the Washington County Museum of Fine Arts passes its seventy-fifth birthday, it must seek to take its place in this rich collection of American cultural institutions. Obviously, it has a role to play as the only public showcase for the visual arts in its area, but it has much to compete with in an increasingly mobile nation. As this article was being written, the Art Museum of Western Virginia in Roanoke announced a substantial enlargement of its premises, and an article in the *New York Times* on March 28, 2007, recorded that no fewer than twenty-eight art museums were constructing major additions or—as in the case of the Crystal Bridges Museum of American Art in Bentonville, Arkansas, and the Clyfford Still Museum in Denver, Colorado—opening entirely new museums.

These museums, like the Washington County Museum of Fine Arts, are increasingly challenged to develop their collections, provide programs that will attract a greater segment of the public, and find the resources to support their work. Yet, surely it is worth the effort to provide the public with what, in the words of Martin Brimmer, an early director of the Museum of Fine Arts, Boston, "fills the eye and touches the imagination as nothing else can."[10]

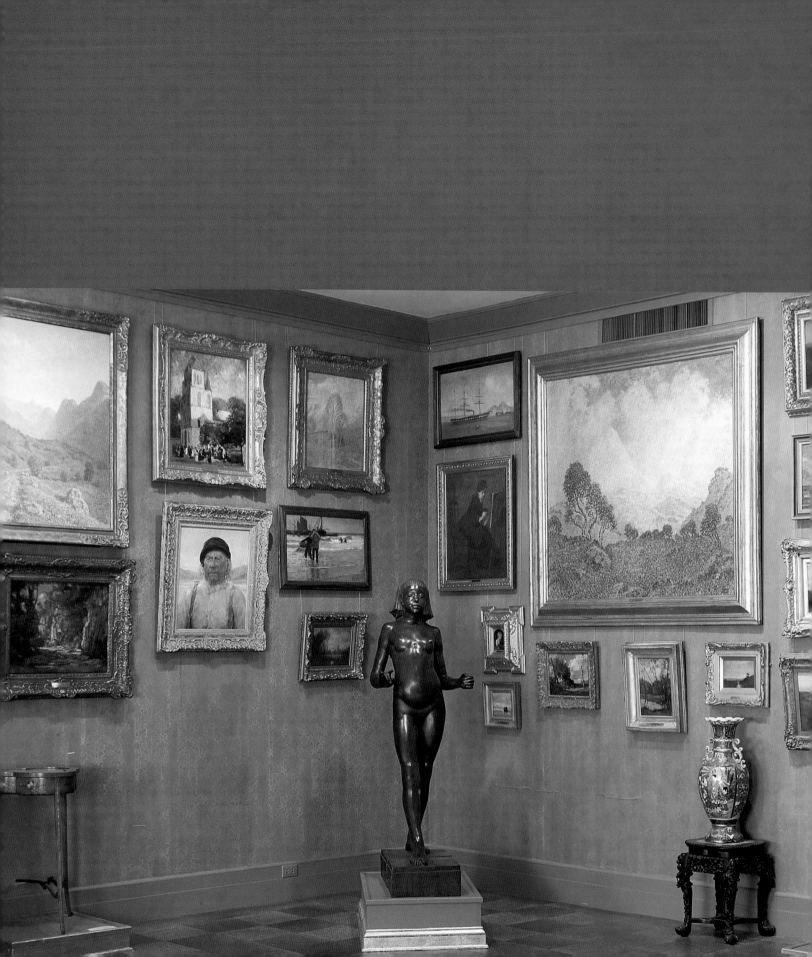

Founders' Gifts

William Henry Singer Jr. was the artist, but Anna Brugh Singer was the collector. An outgoing person who loved traditional painting and the decorative arts, she kept up with what friends were looking at and buying, and she took advice from artist-friends and dealers. The Singers' first acquisitions were paintings and drawings from artist-friends, sometimes received as gifts in exchange for the Singers' financial assistance. Mrs. Singer conceived of the works as decorations for their home rather than as the start of a collection. Works that fall in this category include landscapes by Willard Metcalf and Childe Hassam, American Impressionists alongside whom William Singer painted, and Charles Hawthorne, another friend, who exhibited works with William Singer in the early years of his career.[1]

After World War I, however, Anna Singer began collecting in earnest, with the help of the Amsterdam dealer Joop Siedenburg (1875–1961) and his Frans Buffa Gallery. Buoyed by the emotional and financial support of her husband, she seems to have had museum settings in mind. She bought works by nineteenth-century artists whom Dutch dealers and contemporary collectors particularly admired, painters of pastoral scenes, landscapes, and fantasies by such artists as Henri Fantin-Latour, Camille Corot, Gustave Courbet, Charles-François Daubigny, and Adolphe Monticelli.

Anna Singer's taste was conservative, for neither she nor William thought abstraction was beautiful or meaningful. Yet she admired the work of Auguste Rodin, even though today his use of fragments is considered to have introduced abstraction to modern sculpture. Mrs. Singer purchased works not only by Rodin but by his students Paul Bartlett, Max Kalish, and Malvina Hoffman, each of whom she and her husband had come to know.

By the time the building of the WCMFA was under way and the Singers were planning the gifts of art that would grace the opening, Anna Singer had made purchases that were explicitly for the new museum. This selection of highlights from the Singers' gifts of 1931 and 1934, and of Anna Singer's gifts of 1949 and 1960 after her husband died, represents not only the donors' tastes and friendships but works that would underlie the future direction of the Museum's collections.

EJ

1. For a detailed study of the Singers' lives, collecting, and establishment of museums, see Helen Schretlen, *Loving Art: The William and Anna Singer Collection* (Zwolle: Waanders Publishers for the Singer Museum at Laren, 2006). In the photograph of the Singer Gallery, Isidore Opsomer's portrait of Singer in 1936 is on the far right.

Battista Zelotti
Italian, ca. 1526–1578
The Finding of Moses, ca. 1565

Oil on canvas,
37¾ × 45 in.
Gift of Mrs. Anna Brugh
Singer, Olden, Norway,
1960, A1066

1. Katia Brugnolo Meloncelli,
Battista Zelotti (Milan: Berenice,
1992).

This painting shows the Finding of Moses by the Daughter of Pharaoh (Exodus 2:1–10). To save her child after Pharaoh had ordered the death of all the male infants of the Israelites, Moses' mother placed him in a basket that she then put in the Nile. Pharaoh's daughter, who had gone with her attendants to bathe in the river, found the basket and, on seeing the baby, felt sorry for him and had her servants take care of him.

Zelotti trained with Paolo Veronese (1528–1588) in the workshop of Antonio Badile (1518–1560) in Verona.[1] By 1551 Zelotti was collaborating with Veronese in the decoration of a villa at Treville, near Castelfranco Veneto. During the 1550s Zelotti worked alongside numerous artists, including Veronese, in the Doge's Palace in Venice and collaborated with Veronese again in the decoration of a palace on the island of Murano. Not surprisingly, the art of Zelotti shares numerous stylistic qualities with that of Veronese, which would have been expected of artists working together on the same decorative enterprise.

Many of the stylistic qualities of this painting, however, point to Zelotti's artistic production about 1565. In designing a composition, Zelotti proceeded in an additive fashion, with the result that while figures are placed next to each other, they seem not to share the same physical or psychological space and thus often appear static. At the same time, there is a lovely mellifluous quality to his compositions, owing to the flowing lines and echoing of simple, broad gestures. The quick atmospheric transitions in the landscape, green water, and curving bridge are all staples of the art of Zelotti, as are the dull highlights, limited palette, monochromatic fabrics, and revealing classicizing draperies.

The Renaissance costumes and hairstyles place the event in a contemporary context as Zelotti uses the biblical subject as an excuse to paint an open-air picnic, where luxuriously dressed figures seem at one with a luscious landscape. The richness and festive nature of the scene recall the sumptuous lifestyle conducted by the wealthy in their Palladian villas during the summer.

MLP

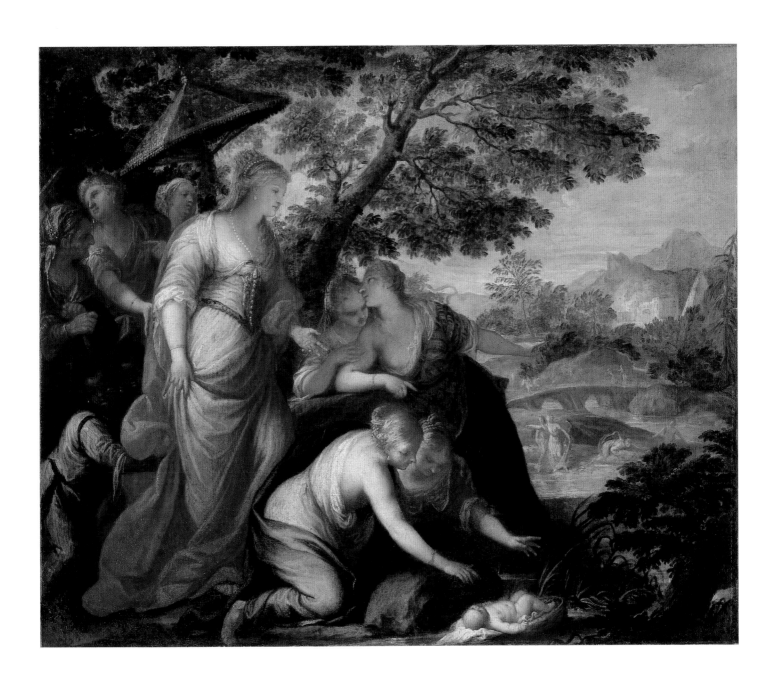

Childe Hassam

American, 1859-1935
White House, Gloucester, 1895

Oil on canvas,
26 × 21 in.
Signed lower left:
Childe Hassam
Gift of Mr. and Mrs.
William Henry Singer Jr.,
Olden, Norway, 1931, A02

1. H. Barbara Weinberg, *Childe Hassam, American Impressionist*, with contributions by Elizabeth E. Barker et al. (New York: Metropolitan Museum of Art, 2004).

One of the first gifts of the Singers to the newly established WCMFA, *White House, Gloucester* radiates the light, bright colors and flickering brushwork that Hassam employed throughout the 1890s. Although he had spent considerable time in France in the 1880s, he typically denied the impact on him of French Impressionists such as Camille Pissarro (1830-1903) and Claude Monet (1840-1926), preferring to present himself as inventing his own style. Recognized with awards and tributes after settling back in Boston and other parts of New England and, ultimately, New York, Hassam was a founding member in 1898 of the group of independent American painters who called themselves the Ten.

Hassam was born in Dorchester, Massachusetts, and began his artistic career designing and cutting woodblocks for an engraver. With training, he then moved to illustration and, finally, printmaking, which he never abandoned. Through years of study and travel as a painter, Hassam was a jovial and self-confident participant in artists' colonies, most notably those of the Isle of Shoals off the New Hampshire coast; Old Lyme, Connecticut (where he first met William H. Singer Jr.); and Gloucester, Massachusetts, the site of this painting. All of these locations offered him ideal subjects for light-filled summer pictures. Although *White House, Gloucester* presents the bravura brushwork of many Impressionists, the picture is structurally precise, with house, carriage house, flagpole, fences, and walkways presenting the space so clearly that the viewer can imagine its dimensions.[1]

EJ

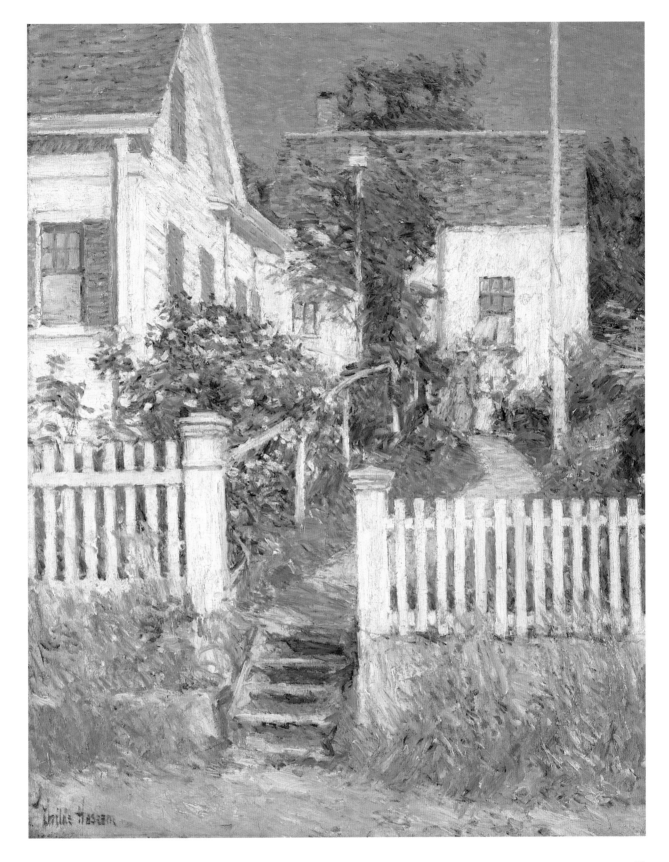

Willard Metcalf

American, 1858-1925
New England Afternoon, ca. 1909

Oil on canvas,
38½ × 36 in.
Gift of Mr. and Mrs.
William H. Singer Jr.,
Olden, Norway, 1931, A02

1. Elizabeth de Veer and
Richard J. Boyle, *Sunlight and
Shadow: The Life and Art of
Willard L. Metcalf* (New York:
Abbeville Press, 1987); and
Bruce W. Chambers, *May Night:
Willard Metcalf at Old Lyme*,
with an essay by Amy Ellis
and catalogue entries by Emily
M. Weeks (Old Lyme, Conn.:
Florence Griswold Museum,
2005).

New England Afternoon radiates the bright yellows and greens of summer. A dark, sinuous creek leads the viewer's eye into the landscape through a foreground dotted with livestock. Blue-tinged mountains in the far distance, a church steeple in the background, and a sky filled with scudding clouds–typical characteristics of New England–give the scene its sweeping scale. Metcalf's high point of view and the nearly square canvas (popular at the time) create a deep space, which the delicate, short brushstrokes fill with a pleasant softness.

Not honored until late in his life as a leading American Impressionist, and thus one of the more conservative painters of his era, Metcalf brought to his landscapes a palette and techniques that he had learned in France. He was born in Lowell, Massachusetts, to a working-class family with a long New England heritage. He first studied art at night school at the Massachusetts Normal Art School in Boston in 1874, and then worked for years as a magazine illustrator to afford a trip to Europe to study. Once in France in 1883, he spent five years at the Académie Julian in Paris and made numerous trips to the French countryside, where he admired the work of Claude Monet (1840-1926) and other Impressionists. After he returned to the United States, he painted in a variety of locations, always trying to attract patronage–Old Lyme, Connecticut; Cornish, New Hampshire; Deerfield, Massachusetts; and Kennebunkport, Maine. The landscapes of New England were his favorite subjects. In 1898, finally recognized as a major artist, he joined Childe Hassam (1859-1935) and others to form the Ten, a group of American artists in New York who modeled their practice on the outdoor Impressionist painting of the French.[1]

The founder of the Washington County Museum of Fine Arts, William Henry Singer Jr., himself a painter, occasionally joined Metcalf at Old Lyme. The two found that they liked to paint together. Metcalf and the Singers became good friends, and in 1913 Metcalf and his wife journeyed to Norway to visit them and gave them several paintings, this one among them. The Singers presented it to the Museum in 1931.

EJ

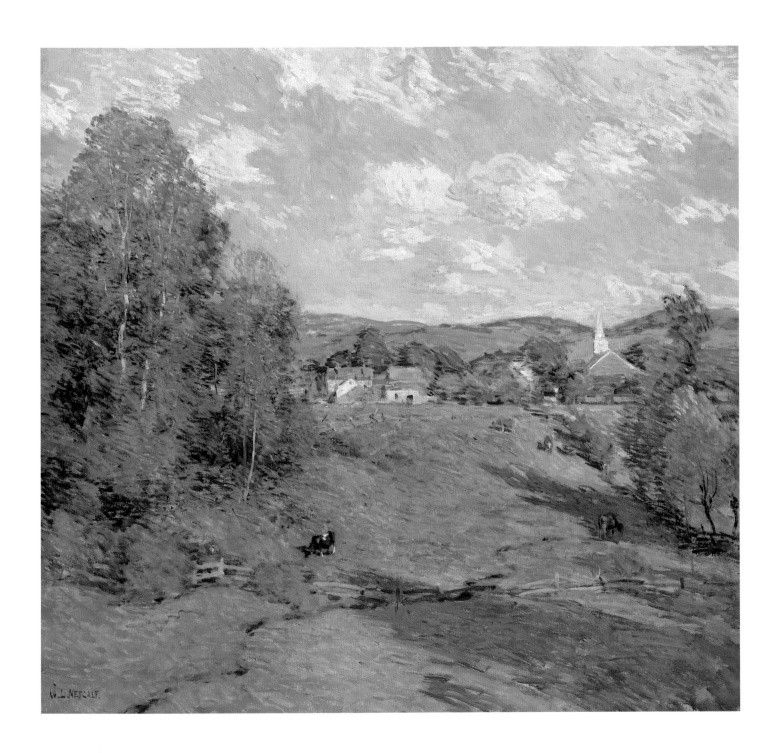

Charles W. Hawthorne
American, 1872–1930
Sewing Girl

Oil on canvas,
30 × 25 in.
Signed lower left:
C. Hawthorne
Gift of Mrs. Anna Brugh
Singer, Olden, Norway,
1949, A584

1. Marvin S. Sadik, *The Paintings of Charles Hawthorne* (Storrs, Conn.: University of Connecticut, 1968).

Hawthorne was one of the artists who had shown in the same exhibitions as Mrs. Singer's late husband. An artist who derived much satisfaction from painting portraits of a psychological delicacy that mirrored his own subtlety, Hawthorne was a colorist as well. Giving his sitters a small activity as a secondary interest, he maintained a focus on their mental world.

His painting *Sewing Girl* exemplifies these qualities. The young woman, seated in the right part of the canvas, with a corner and a chair rail not far behind her, looks beyond the viewer to her own right. She seems to respond with interest to something in that direction and interrupts the sewing in her lap to pay attention. Hawthorne's palette for the portrait emphasizes greens and red; he applied paint sketchily, dragging one color incompletely over another to create the sense of a tentative visual assessment. The young woman's loose blouse is a bright green, underneath which is a subdued yellow; the green is reflected in the flesh of her face, her arms, the white collar of her blouse, and the white garment in her lap that she is sewing. Her eyes are a green very close to that of her blouse. Hawthorne's other major color is red, which he uses in the girl's thick hair, her slightly parted lips, and, to great advantage, in the bright red pincushion in the lower left of the painting. Hawthorne's sitter projects serenity and a simple, matter-of-fact sensuality.

Active in Provincetown, Massachusetts, where he founded the Cape Cod School of Art in 1899 and which he led until his death in 1930, Hawthorne had been a student at the Art Students League in New York in 1894–95. Raised in Maine as the son of a sea captain, in his own work he focused on portraits of ordinary people, such as fishermen and women in interiors performing simple domestic tasks. His school in Provincetown, which became a leading art colony and is now called the Hawthorne School of Art, is on the National Register of Historical Buildings.[1]

EJ

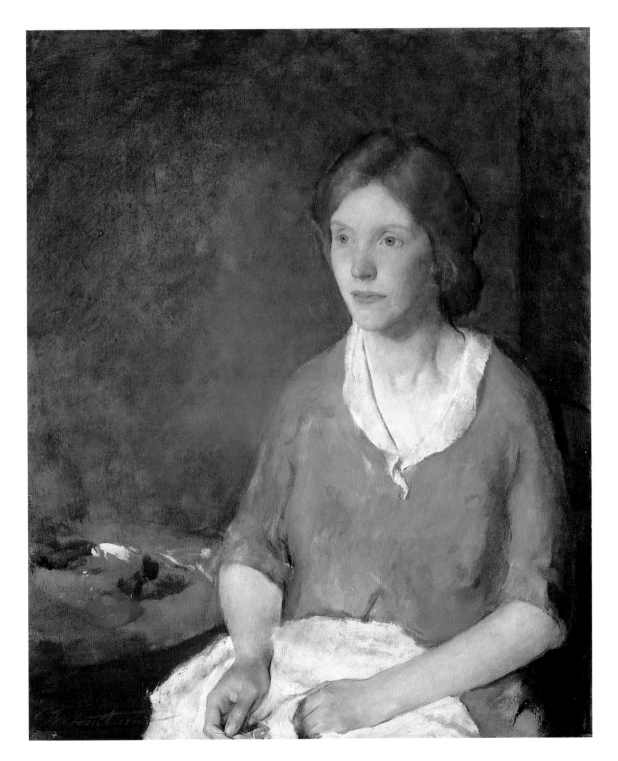

William H. Singer Jr.

American, 1868-1943
Christmas Eve, 1928

Oil on canvas,
40 × 41¾ in.
Signed and dated lower
left: W. H. Singer Jr. 1928
Gift of Mrs. Anna Brugh
Singer, Olden, Norway,
1949, A584

1. William H. Gerdts, "Some
Thoughts on the Painting of
William H. Singer, Jr.," in
William H. Singer, Jr. (1868-1943)
(Hagerstown, Md.: Washington
County Museum of Fine Arts,
1981); and Helen Schretlen,
*Loving Art: The William and
Anna Singer Collection* (Zwolle:
Waanders Publishers for the
Singer Museum at Laren, 2006).

With deep blues and greens, Singer established the atmosphere of a winter night in this painting of a Norwegian village. As viewers, we seem to stand on the water of the fjord filled with ice floes, boats, and fish houses. We look beyond a church and a few houses with lighted windows to the deep snow on the mountains above the village. Stars in the sky shine on the magical scene, with no villagers in sight.

A willing expatriate, Singer was born in Pittsburgh to a father who was a steel magnate. He tried his hand at the steel business but finally convinced his father that painting was his vocation. Soon after his marriage in 1895 to Anna Brugh of Hagerstown, the two spent time on Monhegan Island, Maine, where he first expressed his devotion to the landscape as a subject. He then studied briefly in Paris at the Académie Julian, where students had the opportunity to draw and paint from the live model and receive instruction from renowned painters. He left before long, however, realizing that the academies at the time did not teach landscape painting. He and Anna moved to Laren, the Netherlands, attracted by a group of artists informally known as the "Dutch Barbizon" who used soft brushwork to paint intimate landscapes.

His father's death in 1909 made it possible for him to enjoy a life of comfort pursuing what he loved best and to support Anna in her passion for art collecting. On a trip to Norway in 1903 he discovered that the mountainous landscape captivated him. Throughout his career, he was to evoke the majesty of that landscape, giving titles to his paintings that suggested nature's rootedness in God, such as *Rock of Ages*, *Peace Divine*, and even *Christmas Eve*.[1]

Although Singer relished solitude, painted in a conservative style, and was not interested in some of the avant-garde movements around him, he participated in the exhibitions with which artists established their credentials. In Pittsburgh, his birthplace, the Carnegie Museum of Art had established the Carnegie International Exhibitions in 1896, and Singer first showed at the fifth, in 1900. From 1907 until 1941 he exhibited almost every year in the annual exhibitions at the National Academy of Design in New York, an organization established in 1825 to provide artists with a professional venue for instruction and exhibitions.

EJ

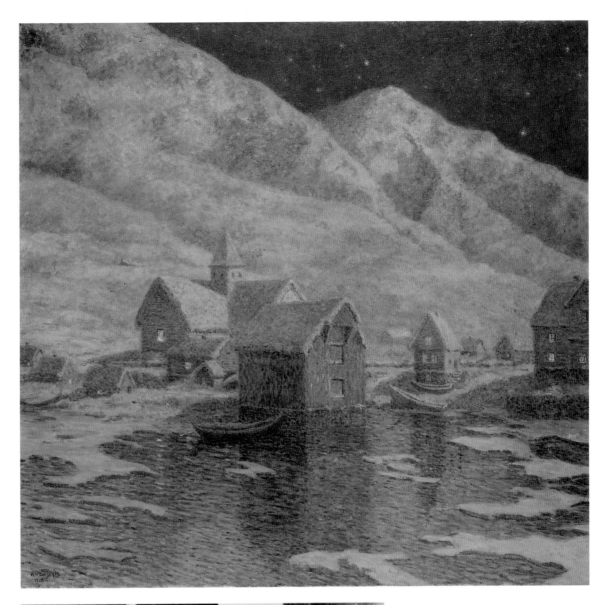

left
William H. Singer Jr. in his Olden,
Norway, studio, 1930s

Jonas Lie

American, 1880–1940
Western Slope, 1923

Oil on canvas, 50 × 40 in.
Signed and dated lower
right: Jonas Lie, 1923
Gift of Mr. and Mrs.
William H. Singer Jr.,
Olden, Norway, 1934, A98

1. William H. Gerdts, *Jonas Lie (1880–1940)* (New York: Spanierman Gallery, 2005).

Well traveled in the northeastern United States as well as in Europe and Central America, Lie painted *Western Slope* at Saranac Lake in the Adirondack Mountains of New York, where he had a cottage. In this large picture, the birch trunks extending beyond the top of the canvas, the deep snow drifts in the foreground and on the hillside slopes, and the reddish orange tops of hills in the mid-distance join the mountains reaching into the dark blue sky and the stream running across the bottom of the slopes to create a landscape of winter peace that is characteristic of Lie's work throughout his life. Attracted to the Impressionists' use of impasto (obvious strokes of paint lying on the surface of the canvas), he spread creamy brushstrokes throughout this winter landscape. He spoke of his intention that nature in his work suggest what lies beyond this world. The picture was a favorite of his and traveled the exhibition circuit winning acclaim. In a letter in the Museum files, he writes of its having hung in his Park Avenue apartment for several years before he sold it to the Singers.

Lie had been born in Norway of a Norwegian father and American mother in a family versed in music, literature, and art. After his father died in 1882, he was sent to Paris to live with relatives, whose friends included the playwright Henrik Ibsen (1828–1906) and the composer Edvard Grieg (1843–1907). After joining his mother in New York in 1893, his first artistic venture involved working as a designer in a textile firm. With training at the National Academy of Design, the Art Students League, and Cooper Union, he became a landscape painter and earned a reputation as a sensitive colorist of the shores and coves of New England and eastern Canada. In 1913 he spent time in Panama, where he documented the canal's construction with pictures that he later donated to the United States Military Academy at West Point.[1]

Active in artistic circles, Lie joined colleagues in such ventures as helping to organize the Armory Show of 1913, which brought European modernism to large audiences in New York, Boston, and Chicago. However, in his own work he was conservative, never abandoning representation; he made his painting current by practicing modern techniques in his loose brushwork and tactile surfaces. Shortly before his tenure as president of the National Academy of Design from 1935 to 1939, Mrs. Singer, eager to include works by contemporary artists in the Museum's collection, purchased *Western Slope* and gave it to the Museum. EJ

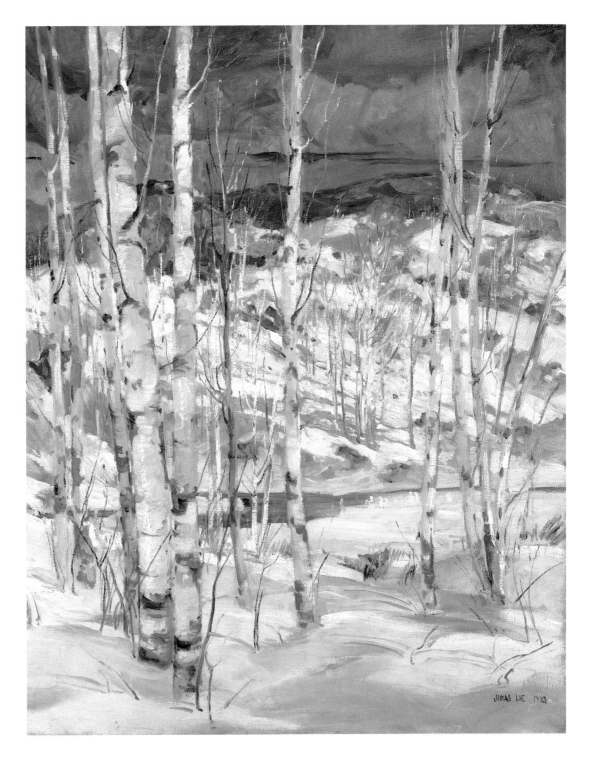

Jacob Dooijewaard
Dutch, 1876–1969
Still Life, 1929

Oil on canvas, 40½ × 38 in.
Gift of Mrs. Anna Brugh
Singer, Olden, Norway,
1949, A584

1. Helen Schretlen, *Loving Art:
The William and Anna Singer
Collection* (Zwolle: Waanders
Publishers for the Singer
Museum at Laren, 2006)
interweaves Dooijewaard's life
with that of the Singers.

Dooijewaard and his work are closely connected
with the WCMFA. Born and trained in Amsterdam,
Dooijewaard became acquainted with William and
Anna Brugh Singer as early as 1901, when they were
all in Laren, the Netherlands, and active in the art
colony there. In 1919 the friendship had developed
to the extent that Dooijewaard became a third mem-
ber of the Singer household, painting almost daily
with William, advising the couple on art purchases,
providing company on their travels, and, after Wil-
liam's death in 1943, serving as a companion to Mrs.
Singer until her death in 1962.[1]

In his art, Dooijewaard honored the Dutch
tradition into which he was born. Like many painters
of his own and slightly earlier eras, he practiced a
Barbizon looseness of style and chose as subjects the
simpler elements of country life—its people, houses,
interiors, and timeworn objects. Following the lead of
the Impressionists, he used light as a major tool and
delighted in color and the casual arrangement of
elements in a landscape or town scene.

By 1929, when he painted *Still Life*, he had
tightened his approach considerably, influenced by
William Singer's Pointillist style (painting with
small dots of color, which in the eye blend from a
distance). Evident in this painting is Dooijewaard's
affection for light and a limited palette (here he
worked with the primary colors of red, yellow, and
blue). He cast against the back wall the shadows of
the drape, double-gourd ewer, and bottle vase. The
metal of the double-gourd ewer and the folded, gold
and red-brown silk cloths on the tabletop reflect
brilliant light coming from the left; the ewer and the
small salt in the foreground reflect the surrounding
colors. One might say that Dooijewaard's still life
has become a collector's boast, replacing the
affection for fruit and flowers of his Dutch
predecessors and American colleagues with the
pleasures of metal, ceramic, and textile objects
gathered on global travels.

EJ

left
Art gallery in William and Anna
Singer's Blaricum, Netherlands,
home, late 1930s

Willem Dooijewaard

Dutch, 1892-1980
Breaking Camp in Mongolia, 1929

Charcoal and chalk on oiled paper, 33 × 27½ in. Signed and dated lower left: William Dooijewaard 1929
Gift of Mr. and Mrs. William Henry Singer Jr., Olden, Norway, 1931, A03

1. Helen Schretlen, *Loving Art: The William and Anna Singer Collection* (Zwolle: Waanders Publishers for the Singer Museum at Laren, 2006), 184.

An inveterate traveler in his young manhood, Willem Dooijewaard, like his much older brother Jacob, helped the Singers amass their collection. After study in Amsterdam, he traveled throughout China, Tibet, Mongolia, Japan, Bali, and North Africa, drawing and purchasing as he went. As a Westerner in the Far East in the 1920s and 1930s, he visited many areas previously unseen by Europeans and Americans. Traveling part of the time with the Austrian artist Roland Strasser (1895-1974), he sketched the indigenous population in their activities, drew landscapes and street scenes, and recorded temples. In addition to pursuing his own work, he served as an agent, buying objects that he calculated would please the Singers and other patrons. These works included tapestries, Tibetan paintings, and figures of the Buddha. Presently in the collection of the WCMFA are more than thirty drawings by Dooijewaard and ten Tibetan paintings on linen.

After 1932, with conflicts within China and with her nearby neighbors making travel unsafe, Dooijewaard restricted his travels to Europe. His purchases of Asian art for the Singers having come to an end, the Singers thereafter relied on dealers in Amsterdam and Kunstzaal Kleykamp in The Hague.[1]

Breaking Camp in Mongolia depicts the nomadic Khalkha tribe preparing to move on to fresh forage for their flocks. Three horsewomen face away from the viewer, watching or supervising the activity, and a fourth looks toward us. Like a good travel artist, Dooijewaard shows us costumes, horse trappings, shoes, and hats, accenting the outlines of the clothing and figures and using light orange chalk for decorative parts of the costumes. On the left we see a yurt, a traditional house made of felt, its doorway delineated in black to intensify the mystery of its interior, and across the middle ground, tents. A mountain cuts off the horizon, suggesting the difficult nature of the geography as well as the great distance between the life in Mongolia and that of the artist's eventual patrons.

EJ

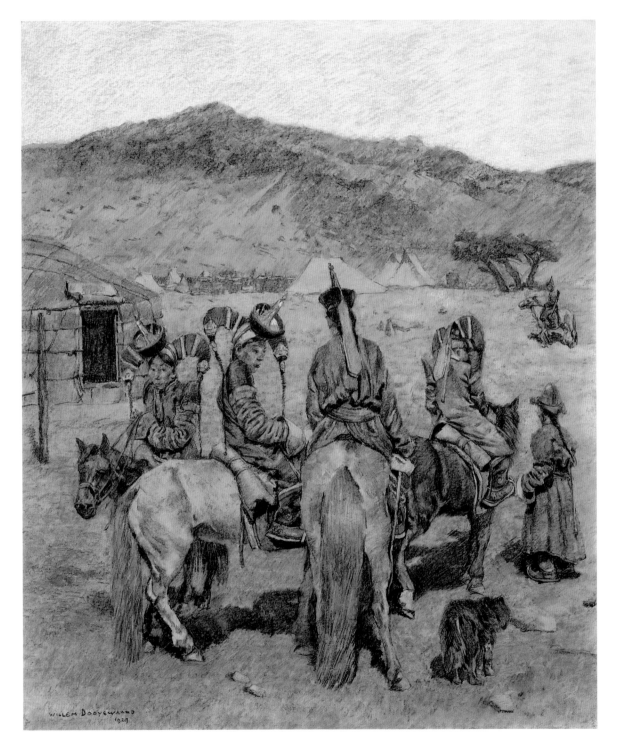

Gustave Courbet

French, 1819–1877
Landscape, ca. 1873–75

Oil on canvas, 18 × 21½ in.
Signed lower right:
G. Courbet
Gift of Mr. and Mrs.
William H. Singer Jr.,
Olden, Norway, 1931, A03

1. Sarah Faunce, *Courbet Reconsidered* (New York: Harry N. Abrams, 1993).

Celebrated since his death as a Realist who insisted on painting what could be seen and touched and, moreover, subjects who were ordinary people in the midst of daily life, Courbet rejected the idealism in art that prevailed at the beginning of his career. Claiming to be self-taught, he violated traditional rules of drawing, composition, and paint application. He typically began his canvases with a dark ground layer, applying color with thick brushwork and a palette knife, fingers, or sponges. His deep colors, overlaid with flicks of a brush to suggest light, gave his work tactility and intensity. Often abrasive in his relations with others, he antagonized critics with his certainties that artists should paint the here and now. Eventually, however, his convictions won him a solid place in the history of art. His methods and ideals became a lightning rod for modernists such as Édouard Manet (1832–1883) and the Impressionists, who turned away from allegory, myth, and narrative to paint the world around them.

Deeply devoted to the land, Courbet painted many works featuring his favorite places in the area near his birthplace in Ornans, Franche-Comté, where he was raised. The WCMFA *Landscape* is typical, in that the viewer looks out from a dark forest dominated by evergreens into light coming from beyond foliage on the left. Cliffs on the right hang over a river channel, which has apparently eaten down through the rock over the ages. Courbet used heavy layers of paint that suggest the age of the earth and colors that pick up the light flickering through the trees.

This particular landscape is painted on a canvas with a coarse weave, which adds to the viewer's awareness of the artist's presence; the brushwork suggests that Courbet painted quickly and with a variety of approaches, all characteristic of his technique.[1]

Courbet's reputation was strong when the Singers encountered his work. They purchased it in the 1920s from their Amsterdam dealer Joop Siedenburg (1875–1961).

EJ

Adolphe-Joseph-Thomas Monticelli
French, 1824–1886
Garden Scene

Oil on panel, 14 × 21 in.
Gift of Mr. and Mrs.
William H. Singer Jr.,
Olden, Norway, 1931, A03

1. Aaron Sheon, *Monticelli: His
Contemporaries, His Influence*
(Pittsburgh: Carnegie Institute
of Art, 1978).
2. Helen Schretlen, *Loving Art:
The William and Anna Singer
Collection* (Zwolle: Waanders
Publishers for the Singer
Museum at Laren, 2006),
148–50.

Garden Scene is almost like a stage, with actors presenting a drama for us. In an opening in a garden, with foliage on the sides and overhead, several figures interact. The five women on the left wear festive clothing and vie for the attention of a man on horseback who moves toward the viewer from the background. The woman closest to the middle holds up a mirror, possibly a symbol of the vanity of the gathering (meaning its transience as well as its preoccupation with dreams). Drawing the viewer into the scene at the lower right is a large white dog with brown markings.

Monticelli laid on his paint thickly and with a variety of textures, possibly even with a palette knife in some places; the topmost layers are bright colors, especially reds, pinks, yellows, and blues, so that the viewer first notices the colors and brushwork and only later mentally puts together the scene. These techniques strongly influenced one of Monticelli's many later admirers, Vincent van Gogh (1853–1890).

Although he also painted portraits and still lifes, Monticelli specialized in scenes of sensuous fantasy, influenced by courtly masquerade scenes by such eighteenth-century artists as Antoine Watteau (1684–1721). Born in Marseilles of humble parents, in the 1850s Monticelli painted in the Forest of Fontainebleau with such artists of the Barbizon school as Théodore Rousseau (1812–1867) and Camille Corot (1796–1875), but he returned to Marseilles and lived in relative poverty. Unlike most painters of his generation, he was a Romantic, devoted to the imagination, and rejected the emphasis on objectivity and natural light of the

slightly younger Impressionists. Not until after his death did his paintings command attention from other artists and from collectors. In fact, Van Gogh, who first saw his work in 1886 after the painter had died, claimed that he was following in the steps first made by Monticelli.[1]

The Singers bought their first painting by Monticelli in 1927 and went on to buy a total of eight.[2]

EJ

Henri Fantin-Latour
French, 1836-1904
Nymph, 1904

Oil on canvas,
24½ × 20 in.
Gift of Mr. and Mrs.
William H. Singer Jr.,
Olden, Norway, 1931, A03

1. Douglas Druick and Michel
Hoog, *Fantin-Latour* (Ottawa:
National Gallery of Canada,
1983).
2. Quoted in Helen Schretlen,
*Loving Art: The William and
Anna Singer Collection* (Zwolle:
Waanders Publishers for the
Singer Museum at Laren,
2006), 133.

In its delicacy, Romanticism, and beauty, *Nymph* is an excellent example of the Singers' taste. The figure in this painting, one of many lovely young women in the paintings in their collections, sits on a rock in the forest, a white drape over her raised right leg and a red area nearby that does not seem to represent anything but serves to draw our attention to that part of the picture. In his technique, Fantin-Latour blended the nymph into the greens, blues, and browns of the forest, creating the illusion of a creature at one with nature. Her eyes closed as though she is dreaming, the nymph shifts her weight and tilts her head, movements that suggest she is a fleeting vision.

The painting also conveys one of Fantin-Latour's major interests. Born in Grenoble and trained by his father, Jean-Théodore Fantin-Latour (1805-1875), a portrait painter, Fantin-Latour the son alternated throughout his career between realism, necessary for portraits, and fantasy. Although he began as a portraitist, a skill that he pursued throughout his life with many commissions, he is best known for flower paintings. Striving for a meticulous naturalism, he brought cut flowers into his studio to capture their freshness. Although Fantin-Latour formed friendships with the major Realists and Impressionists of his era, Édouard Manet (1832-1883), Gustave Courbet (1819-1877), Claude Monet (1840-1926), and Pierre-Auguste Renoir (1841-1919), he did not follow their lead in either his subjects or his techniques. Intrigued by the Romanticism of the music of Robert Schumann (1810-1856) and Johannes Brahms (1833-1897) and, especially, by the operas of Richard Wagner (1813-1883), he

translated the emotions and transience of their compositions into scenes that, like *Nymph*, suggest a dream world.[1]

As with most of their purchases, the Singers bought this painting from the Buffa Gallery in Amsterdam. Frans Buffa (who was succeeded in the business by Joop Siedenburg) praised the work as "a picture [with] a wonderful size, a delicate subject, of the most beautiful quality I never saw a fresher and more delicate nude by Fantin."[2] Fantin-Latour had painted this picture during the last year of his life; it was perhaps one of his last testimonies to the ever-elusive ideal.

EJ

Max Liebermann

German, 1847–1935
Portrait of Constantin Meunier, 1897

Black crayon on paper,
28 × 23 in.
Signed lower right:
M. Liebermann
Gift of Mr. and Mrs.
William Henry Singer Jr.,
Olden, Norway, 1934, A93

1. Helen Schretlen, *Loving Art:
The William and Anna Singer
Collection* (Zwolle: Waanders
Publishers for the Singer
Museum at Laren, 2006), 171.

One senses the deep humanity of the artist Constantin Meunier (1831–1905) in this portrait drawing by Liebermann. Meunier, a Belgian painter and sculptor, began his career painting scenes of monastic life and drawing illustrations of miners and factory workers. From 1885, however, he worked primarily as a sculptor, with commissions for large monuments in parks in Brussels that honored labor. Liebermann, about half a generation younger than Meunier, presented the sculptor in this drawing as ruminative, even tired. The broad-shouldered Meunier seems to emerge from the dark graininess of the background, head tilted and lips parted as though about to speak.

Liebermann was German, born in Berlin. After studying at the High School of Art in Weimar, he went to Amsterdam and Paris for further study. In the Netherlands he admired the spirited portraits of the seventeenth-century Dutch painter Frans Hals (1580–1666), and in France he was attracted to the realistic portrayals of labor of the French artist Jean-François Millet (1814–1875). However, his deepest influence was from the French Impressionists. In 1884 he returned to Germany, where, along with Lovis Corinth (1858–1925), he developed a German Impressionist style. As a painter, he favored scenes of the middle class and was highly sought after as a portraitist. This portrait drawing, long considered by the Singer Laren Museum in the Netherlands to be a lost work, had been at the WCMFA since the Singers' gift in 1934. The nature of the Singers' interest in both artists is not clear, although it is known that Liebermann spent summers in Laren. A letter in the Max Liebermann archive dates the drawing to November 11, 1897.[1]

Liebermann's career came to a disappointing end. In the early years of the twentieth century, he led the formation of an artistic avant-garde in Germany, notably the Berliner Sezession, and became president of the Prussian Academy of Arts in 1920. However, he resigned in 1932 when the academy refused to exhibit works by Jewish artists. In 1933 the Nazis raided museums and private collections, confiscating paintings by Liebermann and other Jewish artists. Reinstatement came only in April 2006, when the Max Liebermann Society opened a museum at Wannsee in the house formerly owned by the Liebermann family.

EJ

Auguste Rodin
French, 1840–1917
St John the Baptist, 1878

Bronze, h. 31 in.
Signed on the center of
the base, between the
subject's feet: A. Rodin
Inscribed near the bottom
of the base at left rear:
Alexis Rudier Fondeur
Paris
Gift of Mr. and Mrs.
William H. Singer Jr.,
Olden, Norway, 1931, A03

1. Albert E. Elsen, *Rodin*
(London: Secker and Warburg,
1974); and Ruth Butler, *Rodin:
The Shape of Genius* (New
Haven: Yale University Press,
1993).

Rodin, honored by mid-career as the greatest sculptor of his era, was devoted to the naturalism of the human body. Rejecting the idealizing Neoclassicism of academic sculpture that was the standard when he began his studies, he insisted on fidelity to human anatomy and evocation of the emotions of his subjects. He hired ordinary people from the street to be his models, creating his sculptures in clay or plaster. These media could show the firmness of bone, the ripple of muscles, the shadows of bodily contours. Cast in bronze, the sculptures provide the almost contradictory pleasures of seeing a naturalistic representation in a hard medium.

Discouragement marked Rodin's early ambitions to be an artist, for he failed the entrance examination to the state-supported Grande École in Paris three times. Finally, to support himself, he took on work as an ornamental sculptor and maker of decorative objects. Thus essentially self-taught, he lived frugally. In 1875 he was able to visit Italy for two months, where the naturalism of the sculptures of Donatello (1386–1466) and Michelangelo (1475–1564) gave him new direction. He would later say that seeing Michelangelo was the turning point in his work.[1]

One of the first fruits of that inspiration was *St John the Baptist*. Rodin presents the figure in motion, moving toward the viewer with a vigorous gesture as though preaching directly to him. Both of the saint's feet are firmly placed on the ground, an unusual walking gait but at the same time suggestive of the physicality of the human body. In the saint's intense gaze and open mouth, we see the spiritual urgency of the young prophet. Early critics

found fault with the sculpture because it did not represent the traditionally emaciated man of the desert. The dark patina (or sheen) of the bronze sculpture captures and reflects nearby light, adding to the lifelike motion of the figure. Because an earlier work, *The Age of Bronze* (1877), was savaged by the critics as *surmoulage* (a cast made directly from a model's body), Rodin was careful to make *St John the Baptist* larger than life, at 6 feet 5 inches. The casting in the Museum collection is from a smaller study.

EJ

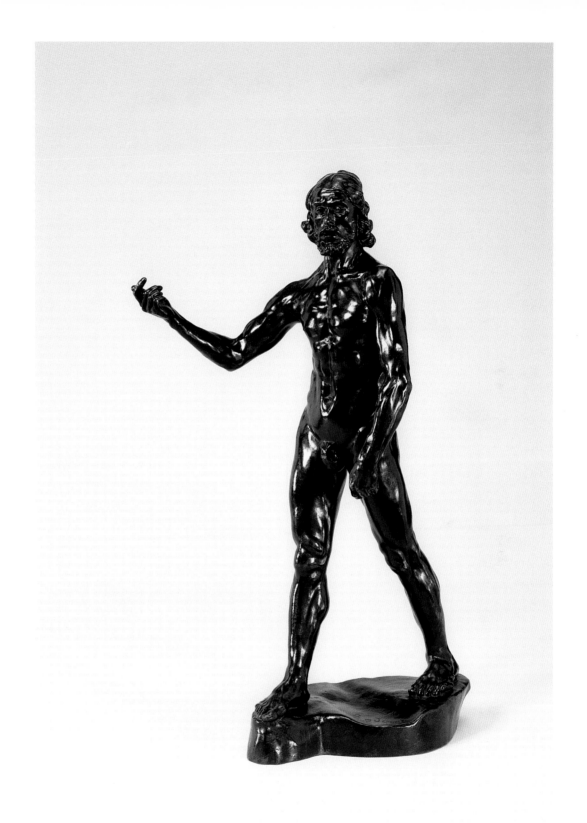

Auguste Rodin
French, 1840-1917
The Prodigal Son, 1899

Bronze, h. 55 in
Signed on base, right front:
A. Rodin
Gift of Mr. and Mrs.
William H. Singer Jr.,
Olden, Norway, 1931, A03

1. Albert E. Elsen, *The Gates of Hell by Auguste Rodin* (Stanford, Calif.: Stanford University Press, 1985).

Rodin disdained allegories and most myths as too distant from the tragedies of daily life, but he drew gratefully on this human story in the New Testament. In this sculpture presenting the emotional agony of the young man in Jesus's parable of the Prodigal Son (Luke 15:11-32), the sculptor imagined the desperation of the young man who has left the comfort of his father's home for a foreign land, squandered his inheritance, and become a pig herder not even able to eat the food fed to the animals. Rodin's figure can be read several ways: Is he grieving at his loss? Is he angry at himself for his foolishness? Or is he imploring the heavens to change his fate?

The idea for the sculpture came from the largest commission of Rodin's life. In 1880 the Directorate of Fine Arts commissioned the sculptor to make the gates for a museum of the decorative arts in Paris. The museum never materialized, but Rodin's fecundity in planning the gates gave him ideas for independent sculptures for the rest of his career. He envisioned the portals as the Gates of Hell, inspired by the poet Dante Alighieri (1265-1321). In his *Divine Comedy*, Dante wrote of a hell of nine circles in which all was in ceaseless motion except Satan, who was frozen in ice at the bottom. Rodin created figures for the gates in high sculptural relief, choosing the most dramatic of the lost souls in Dante's medieval Italian poem. Among these figures was the Prodigal Son, writhing in regret near the bottom of the right gate. The figure most widely associated with Rodin's gates is *The Thinker*, who is seated on the lintel, like Dante contemplating the fate of humanity. As Rodin had done with *The Thinker*, he used many of his figures

for independent sculptures, including *The Prodigal Son*. Rodin felt that traditional pedestals restrained the emotional content of sculpture. One can see the sculptor's enhancement of the Prodigal's misery in the rough pedestal on which he is placed.[1]

Rodin willed the contents of his studio to the French State, along with the right to make casts from his plaster molds, in exchange for the establishment of a permanent museum of his work. This museum, the Musée Rodin, was founded in 1919 in his former residence. *The Prodigal Son* in the WCMFA collection is a duplicate purchased from a Dutch representative of the Musée Rodin.

EJ

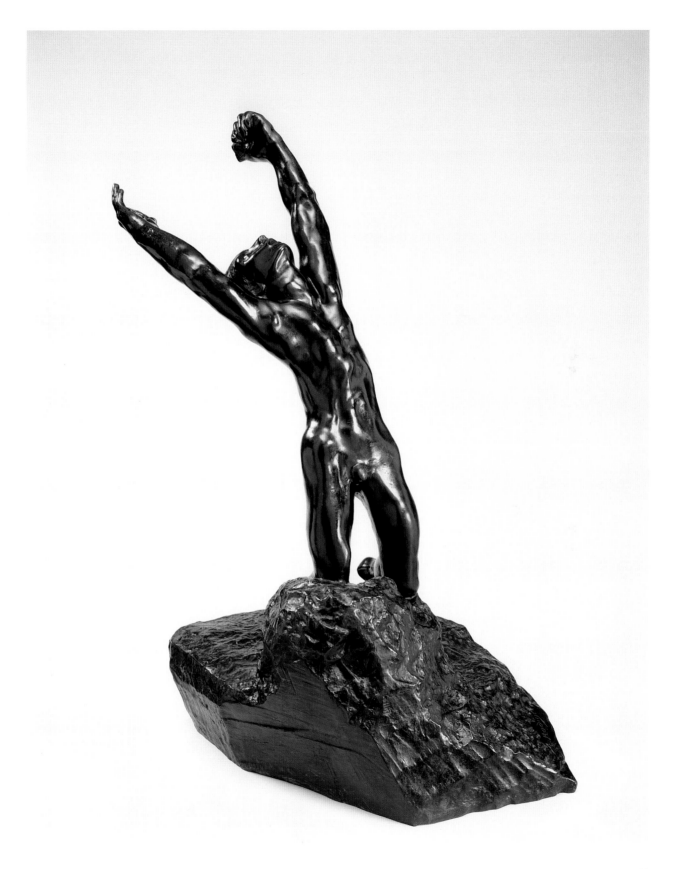

Auguste Rodin

French, 1840-1917
Fugit Amor, 1885-87

Bronze, 19 × 31 × 12 in.
Signed on right side of
base: A. Rodin
Inscribed on the lower left:
A. Gruet aîné Fond: Paris
Gift of Mr. and Mrs.
William H. Singer Jr.,
Olden, Norway, 1931, A03

1. Helen Schretlen, *Loving Art:
The William and Anna Singer
Collection* (Zwolle: Waanders
Publishers for the Singer
Museum at Laren, 2006), 157.

Few viewers have not had the experience that Rodin captures in *Fugitive Love*–the slipping away of the object of one's passion. Planned as part of *The Gates of Hell* but also cast separately, this freestanding sculpture reveals the complex scenario that fueled Rodin's vision. Read as an attempted rape, the sculpture shows the boy atop the young woman; indeed, parts of their legs are fused. Having failed to restrain her, however, he lies on his back, his grip on her about to loosen. The young woman is determined to escape, her eyes shut and her hands grasping the top of her head. Both figures twist slightly, the young man to the right and the girl to the left. The textures of the bronze add to the drama: clawlike marks on the upper part of the woman's breasts intimate the sexual violence that pervades the scene.

Read as an allegory, the sculpture conveys the desperation with which human beings pursue their desires. The object flees, the person is left in agony, nothing is achieved for the pursuer but frustration. This sculpture was the first of several by Rodin that Mrs. Singer purchased.[1]

His reputation still at a high point in the late 1880s, Rodin was astonishingly prolific. Not only a sculptor but also a painter and a graphic artist, he created many portraits and monuments. Among his most well known are *The Burghers of Calais*, commissioned by the French town of Calais in 1885 as a tribute to the burghers who, during the Hundred Years' War with England (1337-1453), had offered themselves as hostages to King Edward III in exchange for the freedom of their city. Also well known is his monument (1893-97) to the French novelist Honoré Balzac (1799-1850). Conceiving of his figures as in motion and fragmentary, he used the same parts of the body to express many possibilities. In this way he influenced the rise of abstraction in the twentieth century, which valued the fragment.

EJ

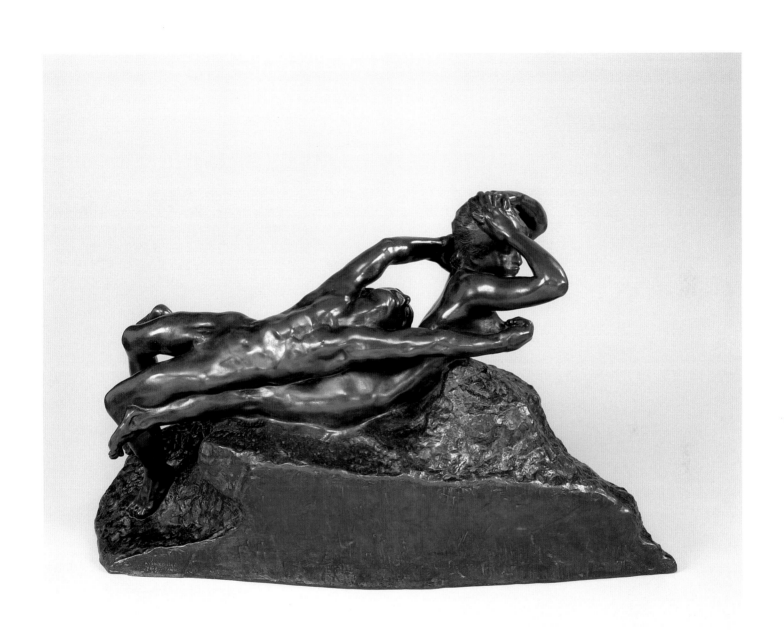

Paul Wayland Bartlett

American, 1865–1925
Benjamin Franklin, 1913

Bronze, 27½ × 25½ × 25½ in.
Signed and dated lower
right corner of base:
Paul W. Bartlett, 1913
Gift of Mrs. Anna Brugh
Singer, Olden, Norway,
1949, A582

Bartlett became a good friend of the Singers, especially William; they shared an admiration for Auguste Rodin (1840–1917) as well as a sense of patriotism for their native country. Singer commissioned this sculpture from Bartlett; both perhaps had in mind Benjamin Franklin's popularity in Europe, especially France, as the practical, wise, ingenious American and their own admiration for his role in the formation of the American Republic.

Yet Bartlett's conception of Franklin challenges our expectations. The figure is not the agile printer of Franklin's youth, the clever politician and compiler of *Richard's Almanac*, the government diplomat arguing his point, or the elegant and ever-popular guest at Paris salons. Rather, he is a tired, thoughtful man who has lived a long life. Seated in rest or contemplation, with his colonial hat cast off to one side and a finger marking his place in a book, he tilts his head as though thinking things through. This sculpture is a tribute to his intellectual qualities rather than a heroization.

Bartlett's original, 1,700-pound sculpture sits outside the Silas Brown Library in Waterbury, Connecticut, an appropriate location for Bartlett's conception of the patriot. When Bartlett, who had been a resident of Waterbury, completed it, the figure traveled to twenty-two cities, following the route that Franklin had taken when he ran away from home (in Boston) in 1723; it finished its tour in Waterbury, where it was dedicated on June 3, 1921. The sculpture was originally intended for the city of Philadelphia, where Franklin made his reputation, but a selection committee there refused it. Besides the small model at the Museum, the U.S. State Department had a replica made in 1982 to celebrate its two-hundredth anniversary and Franklin as its first diplomat.

EJ

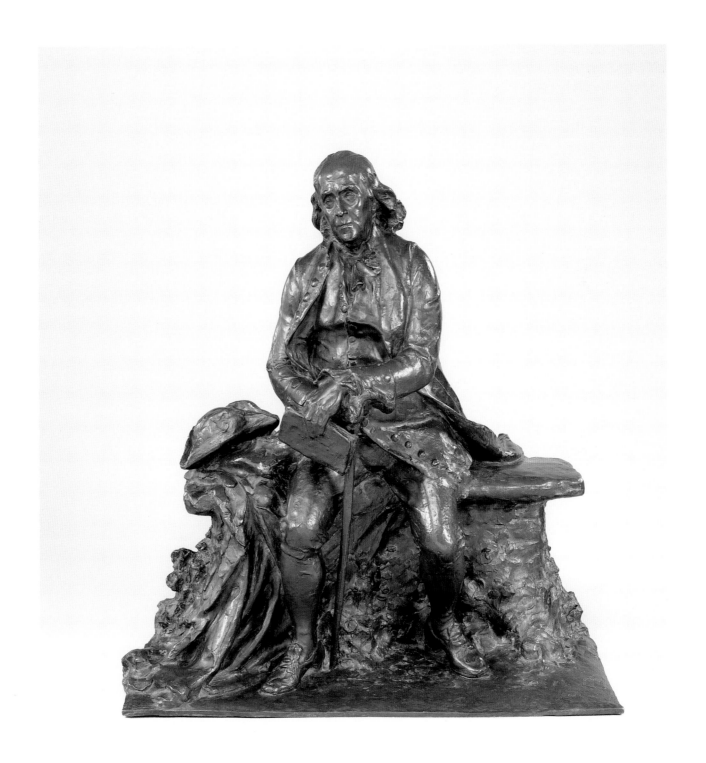

Paul Wayland Bartlett

American, 1865–1925
Equestrian Lafayette, 1908

Bronze, h. 41 in.
Gift of Mr. and Mrs.
William Henry Singer Jr.,
Olden, Norway, 1931, A02

Equestrian Lafayette is Bartlett's study for a life-size statue of the marquis de Lafayette given by the United States to the French government in 1908 in gratitude for the French gift of the *Statue of Liberty*. The Museum's model for the French piece was submitted to the jury of selection for the sculptural gift to France; it won Bartlett the commission. The sculpture was financed by schoolchildren, who gave coins to the Lafayette Monument Fund as they studied the history of the American Revolution. For additional funding, Congress authorized the striking of fifty thousand Lafayette dollar coins to be sold at two dollars each; these were later used as souvenirs rather than currency.

The sculpture reveals the many textures available to artists working in clay that is then cast in bronze, distinct finishes that add to the realism of their work. The mane and tail of the horse on which Lafayette rides, for instance, convey the coarse hairs of the animal, the leather of the saddle and parts of Lafayette's clothing have yet other textures that are realistic, and the Frenchman's face shines with the enthusiasm of his gesture. With his mouth open as though issuing a command, he stands in the stirrups and lifts his sword in his right hand. Altogether he is a person in command. In amusing contrast is the small turtle on the ground near the left back hoof of the horse, apparently a joke that Bartlett shared with his daughter about his slow progress on the monument. Although the sculpture originally stood outside the Louvre, in Paris, it is now located inside the Musée d'Orsay.

Bartlett, born in New Haven, Connecticut, was the son of the sculptor Truman H. Bartlett (1835–1923) and trained in Paris with the prominent animalier Emmanuel Fremiet (1824–1910). Fremiet taught Bartlett a respect for anatomy and painstaking technique. However, in his conception of the role of sculpture, Bartlett was influenced primarily by Auguste Rodin (1840–1917), who was at the height of his fame during Bartlett's formative years in Paris. Bartlett quickly entered the rolls of successful sculptors. By 1887 he was receiving medals at the Paris Salon, and two years later he became a member of the Salon jury. Election to professional societies on both sides of the Atlantic followed.

EJ

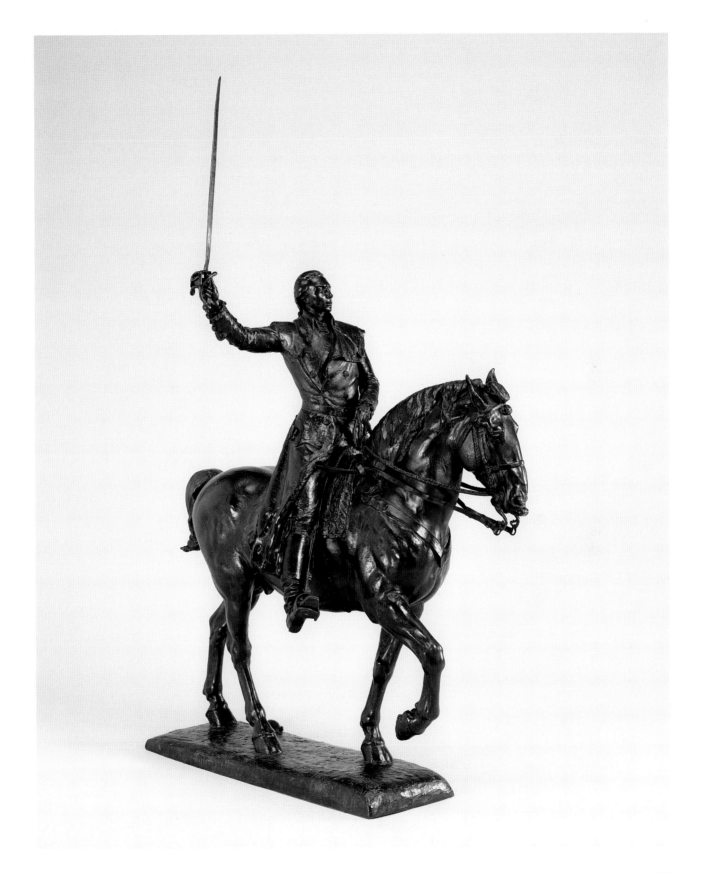

Paul Wayland Bartlett
American, 1865-1925
Sorrow, 1893

Bronze, 9 × 6½ × 9¾ in.
Gift of Mrs. Anna Brugh
Singer, Olden, Norway,
1949, A582

1. Thomas P. Somma, "Rodin's
'American Connection':
Truman Howe Bartlett (1835-
1923) and Paul Wayland Bartlett
(1865-1925)," *Cantor Arts Center
Journal* 3 (2002-3): 204-10.

The male figure *Sorrow*, huddled in grief with his head bowed and one arm wrapped around his legs and the other dropped to the ground, shows the great influence that the French sculptor Auguste Rodin (1840-1917) had on more than one generation of American sculptors. Bartlett, born in New Haven, Connecticut, to the sculptor Truman Howe Bartlett (1835-1923), was taken to Paris by his father. He subsequently became an apprentice to Rodin and worked for and with him throughout the major part of Rodin's career.[1] In his own work, Bartlett expressed his teacher's preoccupation with the capacity of the human figure to express deep emotion. Body structure, muscles, tendons, and the polished patina of the bronze combine with the closed form of the figure to give *Sorrow* a profound poignance.

Bartlett spent much of his career in Paris. Establishing his own foundry as part of his studio, he sculpted relief portrait medallions of friends and famous figures, small sculptures of animals, and a life-size equestrian statue of Lafayette that first stood in the courtyard of the Louvre in Paris and is now in the Musée d'Orsay (see Bartlett, *Equestrian Lafayette*).

A friend of William H. Singer Jr., the founder of the Washington County Museum of Fine Arts, Bartlett influenced the taste of the Singers. Mrs. Singer collected works by both Rodin and Bartlett, many of which she later gave to the Museum.
EJ

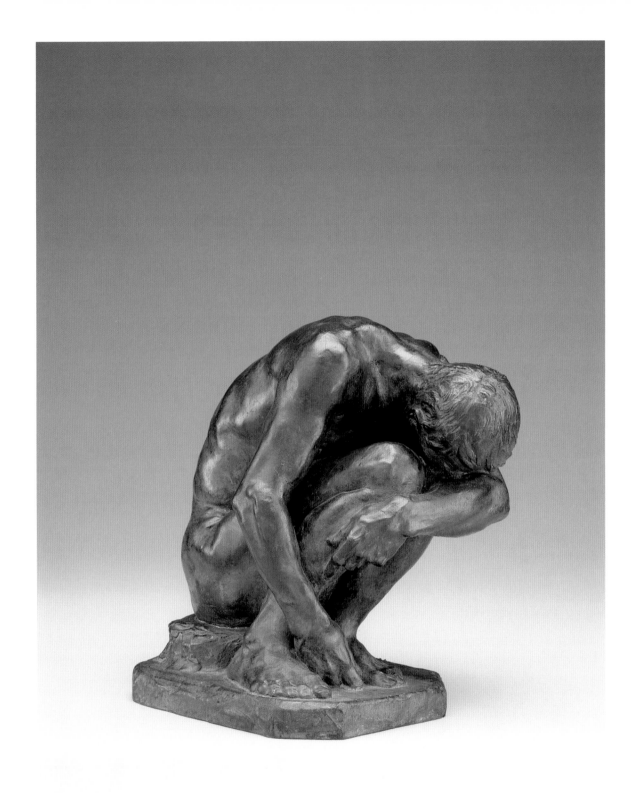

Émile-Antoine Bourdelle

French, 1861-1929

Bust of Beethoven with Hands

Bronze, h. 21 in.
Signed lower right of base:
Bourdelle
Inscribed on back, lower
right: Alexis Rudier /
Fondeur, Paris
Gift of Mrs. Anna Brugh
Singer, Olden, Norway,
1949, A585

1. William S. Newman, "The
Beethoven Mystique in
Romantic Art, Literature, and
Music," *Musical Quarterly* 69,
no. 3 (Summer 1983): 354-87.
2. Angelica Zander Rudenstine
et al., *Modern Painting, Drawing,
and Sculpture Collected by
Emily and Joseph Pulitzer Jr.*
(Cambridge, Mass.: Harvard
University Art Museums, 1988),
4:587.

Bourdelle's passionate tribute to the great composer
and musician Ludwig van Beethoven (1770-1827)
was inspired by the veritable cult for Beethoven
that existed not only in Germany but also in France.
After the musician's death and up until World War
I, an increasing number of critics, historians, writ-
ers, and musicians throughout Europe began to see
Beethoven as the quintessential Romantic–an artist
whose life and work embodied innocence, revolu-
tionary zeal, religious purity, and mysticism.[1] Bour-
delle subscribed enthusiastically to this hero wor-
ship. In the bust at the WCMFA, he portrayed the
composer as gripped by an inward force, his lips
compressed and a vein prominent on his forehead,
his hair disheveled as though blown by the winds of
passion. The composer's hands are remarkable: one
tightly clinched in a fist, the long, large fingers of
the other suggest Beethoven's astonishing powers
of improvisation at the piano. Bourdelle's wife be-
lieved that her husband, self-conscious of his own
artistry, saw the composer as an earlier version of
himself. She reported that when her husband saw a
bust of Beethoven, "The striking profundity of that
extraordinary head overwhelmed him, made an
indelible impression on him, probably in part be-
cause he saw in it a surprising resemblance to his
own. He thought he was seeing himself, and it was
perhaps this fact, in the first instance, that attracted
him."[2]

The son of a wood-carver in Montauban, France,
Bourdelle left school at the age of thirteen to train in
his father's cabinetmaking shop. Soon he began to
study drawing, and then sculpture. He won a
scholarship to the École des Beaux-Arts in Paris at
age twenty-four. In 1888 he created his first
sculptures of Beethoven. He began working as an
assistant in the studio of Auguste Rodin (1840-1917)
in 1893 and soon became a close friend of the older
sculptor. He also was a teacher who attracted
students from around the world.

Mrs. Singer, devoted to collecting the works of
Rodin's contemporaries and students, purchased
this work at an exhibition of Bourdelle's work at the
Buffa Gallery in Amsterdam in 1936. Since she
already owned a bust of Beethoven by Bourdelle,
she gave this one to the WCMFA. Bourdelle
inscribed on the left corner of the base a tribute to
the mystery of Beethoven's music: "Je suis tout ce
qui est, tout ce que a été et tout ce qui sera. Nul
homme mortel n'a levé mon voile" (I am all that is,
all that has been, and all that will be. No mortal man
has ever lifted my veil).

EJ

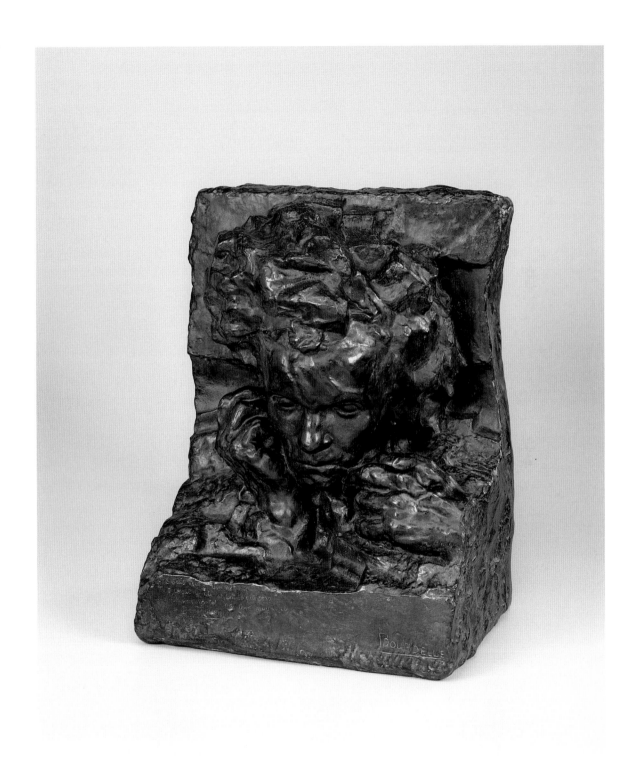

Max Kalish

American, 1891–1945
Towing, 1925

Bronze, h. 12¾ in.
Gift of Mr. and Mrs.
William H. Singer Jr.,
Olden, Norway, 1931, A03

1. N. Lawson Lewis, *The
Sculpture of Max Kalish*
(Cleveland: Fine Arts
Publishing Company, 1933).

The figure in *Towing*, representing a man of endurance and strength at work on a canal or dock, is characteristic of Kalish's devotion to manual laborers. Like many of the American painters in the Ashcan School, Kalish chose the intensity of working-class life for his subjects. He visited industrial sites to absorb the routines of telephone linesmen, riveters, miners, lumberjacks, iron forgers, and others. Inspired, too, by the sculpture of Auguste Rodin (1840–1917), he was devoted to the expressive body. Rather than create allegories or figures that are symbolic representations of natural occurrences, he focused on the actual human being at work. The tension in *Towing* is heightened by the bulging surfaces of muscles at work, evidence of Kalish's modeling of the figure in clay before it was cast in bronze.

"In this great modern industrial age," Kalish wrote, "tremendous heroic tasks are being performed, and it is here that we will find our greatest art expression." During his lifetime, Kalish was honored for his focus on the heroism of the present. "Max Kalish is essentially an artist of present-day America," one critic wrote. "His work emphasizes the fact that subjects for art can with perfect propriety and reason be taken from a modern working world."[1]

Born in Poland and an early immigrant to the United States with his family, Kalish studied at the Cleveland Institute of Art and with the American sculptor Paul Bartlett (1865–1925) in Paris. After 1920 he spent six months of each year in Paris. While in the United States, he worked in Cleveland until 1932, when he moved to New York to attract wider patronage. There his career flourished: he became a member of the National Academy of Design and was inducted into the National Sculpture Society.

The Singers, influenced by their admiration for Kalish's emphasis on the body, bought two of his sculptures from an exhibition at the Milch Galleries of New York in 1927, considering them as gifts to the not-yet-built Hagerstown Museum, for they stored them in New York until the Museum opened in 1931.
EJ

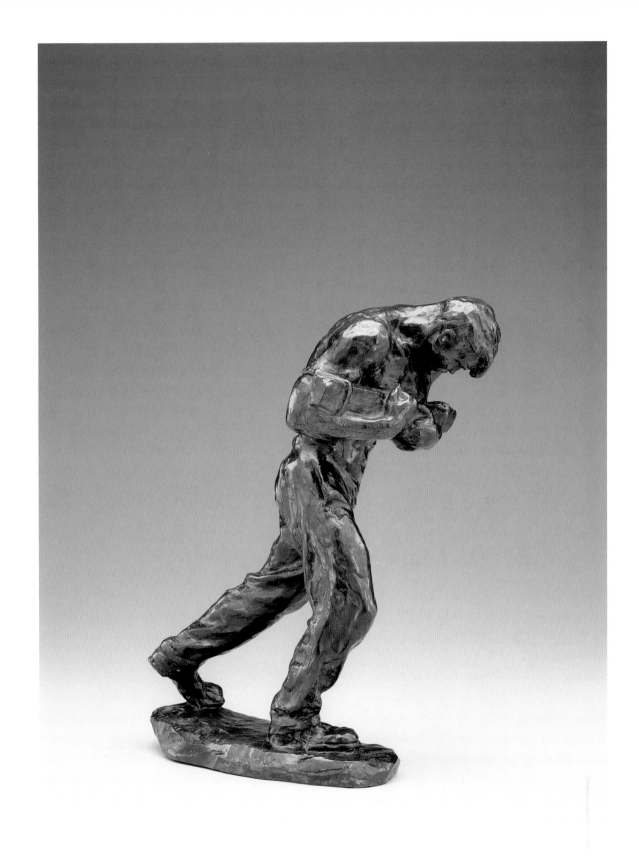

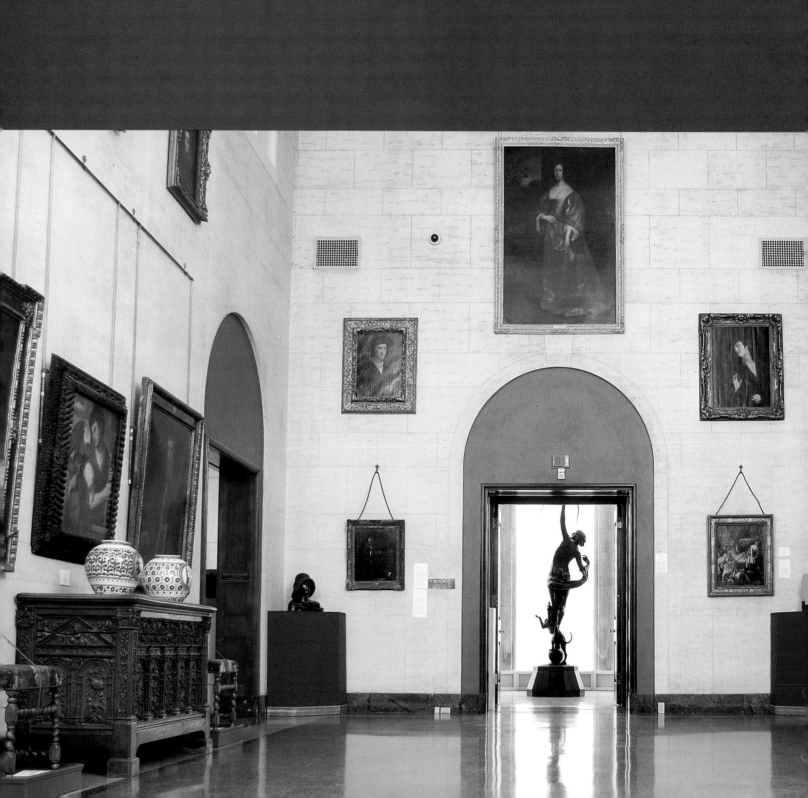

European Art

Old master paintings and drawings form an important part of the collection of the Washington County Museum of Fine Arts. Created during the fifteenth through the seventeenth centuries, and gradually added to the Museum's collection since 1941, their presence provides visitors with a sense of the history of art that precedes the Museum's holdings in nineteenth- and twentieth-century art.

Director John Richard Craft (1940–49) made the first purchase of an old master work with the northern Italian Renaissance artist Giovanni Mazone's *SS Mary Magdalene and Paul*. Over the years, by working with E. & A. Silberman Galleries of New York City and encouraging generous patrons, Craft and his successor Bruce Etchison (1950–64) added one European work after another to the collection, primarily by Italian and French masters. In 1960 Mrs. Anna B. Singer contributed funds for Battista Zelotti's *The Finding of Moses*, attributed at the time to Paolo Veronese. By 2004, when Joseph Ruzicka (2004–7) arrived at the Museum as director, the number of European old masters had reached approximately fifty. He applied to the Samuel H. Kress Foundation for funding for an expert who could research and interpret the collection. Mary L. Pixley was chosen as this expert. As the Samuel H. Kress Foundation Curatorial Fellow in 2005–6, Dr. Pixley made major additions to our knowledge of the Museum's old masters and wrote the entries on paintings that follow,[1] with Sarah Cantor studying and writing about the drawings.

EJ

1. Mary L. Pixley, "Building the Old Masters Collection at the Washington County Museum of Fine Arts," in *"Our Fondest Dreams and Hopes": Commemorating the Seventy-fifth Anniversary of the Washington County Museum of Fine Arts, 1931–2006* (Hagerstown, Md.: Washington County Museum of Fine Arts, 2006).

Giovanni Mazone

Italian, fl. 1453–1512
SS Mary Magdalene and Paul, 1480s

Oil on panel that was
subsequently cradled,
50 × 22⅝ in.
Museum purchase, 1941,
A0314

1. Bernard Berenson to Mr.
Kleinberger, January 30, 1923,
curatorial file.
2. Anna de Floriani, "Verso il
rinascimento," in *La pittura
in Liguria: Il quattrocento*, ed.
Giuliana Algeri and Anna
de Floriani (Genoa: Cassa
di Risparmio di Genova e
Imperia, 1991), 227–524; and
G. V. Castelnovi, "Il quattro e
il primo cinquecento," in *La
pittura a Genova e in Liguria
dagli inizi al cinquecento*, ed.
Colette Bozzo Dufour et al.,
2nd ed. (Genoa: Sagep, 1987),
73–137, 142–44.
3. Simone Chiarugi, *Botteghe
di mobilieri in Toscana*, 2 vols.
(Florence: Studio per Edizioni
Scelte, 1994), 1:389.

The collecting of old masters at the Washington County Museum of Fine Arts commenced in 1941 with this Italian Renaissance panel, which John Richard Craft, third director of the Museum (1940–49), purchased at auction in New York City. A rare and fine work, the painting comes from the region of Liguria in northwestern Italy, which was rarely favored by collectors in the United States.

As a composition, the painting is not complete, as the two saints originally belonged to a much larger altarpiece. St Mary Magdalene carries a golden jar, which contained the ointment she used to anoint the dead body of Christ. Having renounced sin and devoted her life to Christ, she is considered an archetypal penitent sinner and thus viewed as a symbol of hope for all sinners. St Paul holds the sword by which he was martyred. Regarded as one of the greatest Christian missionaries, he is seen as one of the principal pillars of the church founded by Christ.

Already in 1923 the great connoisseur Bernard Berenson attributed the painting to Mazone, calling him the "Crivelli of the North."[1] While referring to the clarity and fine details of the composition, the reference to Crivelli most likely also hints at the extensive use of *pastiglia* (raised decoration) in the painting. His work possesses a Mediterranean and late Gothic flavor owing to the tooled gold and decorative relief work with which he embellished his paintings. Originally from the small town of Alessandria, Mazone worked primarily in and around Genoa as a painter and wood-carver.[2] A talented craftsman, Mazone exercised a high degree of workmanship in his art, as seen in the extraordinarily fine delineation of numerous details, such as the delicate strands of individually described hairs that combine to form flowing waves. The same level of scrupulousness can be seen in the detailing of the gold brocading of the red silk velvet dress worn by the Magdalene, which echoes the pomegranate pattern found in contemporary textiles. Stylistically, Mazone's art stands between the Gothic and the Renaissance and reveals a complex formation. He continued to assimilate a variety of influences throughout his career, and the interest in volume and naturalism seen here reflects an interest in the art of Vincenzo Foppa (ca. 1430–1515), as well as Paduan and Netherlandish painting.

The magnificent carved and painted wooden frame made in the early twentieth century helps disguise the loss of the painting's original context as part of an altarpiece. The quality of the painted decoration and carving point to the Florentine artisan Ferruccio Vannoni, who specialized in modern variants. Indeed, the painted decoration found on the pilasters represents a conflation of features from designs he made for candelabra that were utilized for frames in 1906 (tripodal vegetal base) and 1913 (concave curving forms with coil decoration and flanking vegetal ornament).[3]

MLP

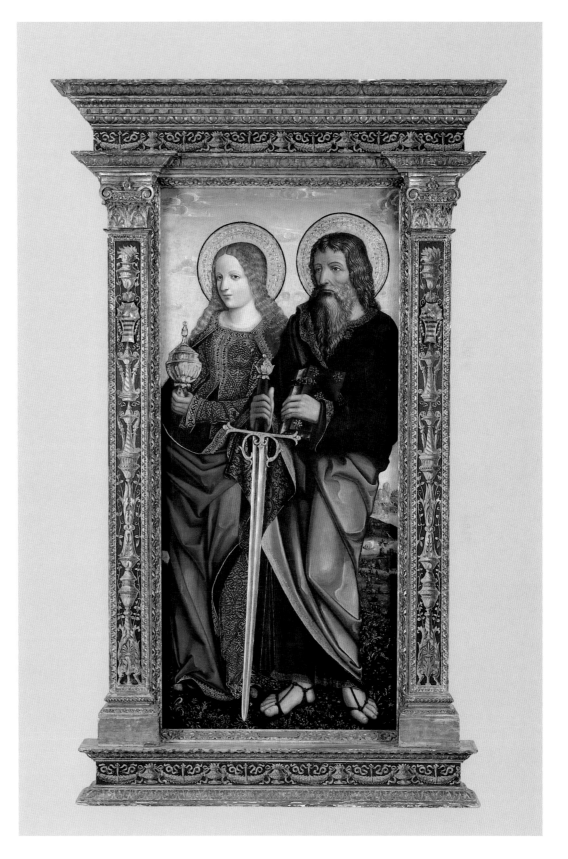

Timoteo Viti
Italian, 1469–1523
Self-Portrait, 1509

Oil on canvas, 29 × 22⅜ in.
Gift of Mr. William J.
Alford, New York, New
York, 1959, A1062

1. In a letter in the curatorial
file of September 29, 1950, Dr.
Hans Tietze recognized the
identity of the author of the
painting.
2. Luciano Arcangeli, "Viti,
Timoteo," in *La pittura in Italia:
Il cinquecento*, ed. G. Briganti
(Milan: Electa, 1988), 2:864–65;
and Maria Grazia Ciardi Dupré
dal Poggetto and Paolo dal
Poggetto, eds., *Urbino e le
Marche prima e dopo Raffaello*
(Florence: Salani, 1983).
3.Christiane L. Joost-Gaugier,
"Ptolemy and Strabo and Their
Conversation with Apelles and
Protogenes: Cosmography and
Painting in Raphael's *School of
Athens*," *Renaissance Quarterly*
51 (Autumn 1998): 760–87 [782].

above right
Detail of painter's palette
showing visual pun of Viti's
name and age of the artist

In his self-portrait, Viti portrayed himself as a finely dressed gentleman, cleverly informing the viewer of his identity by means of the stylized painter's palette to which he points (fig.).[1] The two grape leaves are a picture cipher for his name—in Italian, the word for "grapevine" is *vite*, plural *viti*. He also indicated his age of thirty-six years by using symbols from the Greek Attic numbering system (D=10, P=5, I=1).

Viti also used the portrait to show that he was an exceptionally skilled artist, capable of the feats of realism practiced by the great masters of classical painting, such as the Greek artist Zeuxis (fl. ca. late 5th century B.C.), who is said to have painted a cluster of grapes so realistically that birds flew down from the sky to peck at the fruit. Viti accomplished this by painting the two grape leaves on the palette with such care that they appear to be two actual leaves that have been attached to the wood support. They thus show his mastery as a painter of the visible world while simultaneously making reference to the well-known standard for the perfect imitation of nature in the Renaissance.

Portrayed in a nearly frontal pose, he wears an elegant, white linen *camicia* (shirt). The fabric of the shirt is tightly gathered at the neck, creating a dense frill for the collar. The pleats of this ruff are held in place by embroidery stitches of silver thread that are arranged in an intricate, overlapping geometric pattern. Over this the artist wears a dark brown *cioppa* (overcoat) with very full sleeves, and an elegant chamois glove covers his right hand. The large black hat that finishes the costume is typical of the fashion of Urbino.

The soft, dignified, and quiet style of the work shows the influence of the Bolognese artist Francesco Francia (ca. 1450–1517), with whom Viti is believed to have studied.[2] In harmony with this, the elaborate, gilded reverse frame (in which the edge nearest the picture is the most prominent element) is probably from Bologna and likely to have been constructed in the sixteenth century. It consists of five orders, including overlapping laurel leaves, an intricate arabesque, and a rich garland of leaves and fruits. By 1503 Viti had settled in Urbino, where he became a very popular court painter to several of the dukes of Urbino. He was also a colleague and good friend of Raphael, who portrayed him in his *School of Athens* fresco as the Greek painter Protogenes, who stands next to Raphael shown in the guise of Apelles (Stanza della Segnatura, Vatican).[3]

MLP

Domenico Tintoretto

Italian, 1560–1635
Portrait of Antonio Dandolo, 1580s

Oil on canvas, 45 × 37½ in.
Inscribed upper left:
ANTONIVS DANDVLO / DIVI
MARCI PROC.R / ANNO.
DCCCXLII
Gift of an anonymous
donor, 1975, A1830

1. Giovanni Meschinello, *La chiesa ducale di S. Marco colle notizie,* 3 vols. in 2 (Venice: Bartolameo Baronchelli, 1753–54), 3:81.
2. Paola Rossi, "Alcuni ritratti di Domenico Tintoretto," *Arte Veneta* 23 (1968): 60–71; and Paola Rossi, *Jacopo Tintoretto: I ritratti* (Milan: Electa, 1990).

According to the inscription just above the sitter's proper right shoulder, which appears to be original to the canvas, the painting shows Antonio Dandolo. A Venetian procurator in 842, he wears the late-sixteenth-century style of clothing associated with this office, including a magnificent red silk velvet robe and an elegant stole (*becho*) of pile-on-pile cut velvet with figured decoration.[1] Aside from the Doge, the procurators were the only officers elected for life. They served as the guardians of the church of St. Mark and oversaw many aspects of Venetian life; new Doges were often selected from their rank. The position carried with it immense economic and political power and also granted the holder the privilege of wearing a gown with ducal sleeves. Such sleeves, rather than narrowing at the wrist, opened out to display the expensive ermine lining. In Renaissance Venice, where ostentation in dress was expected, this costume displayed the elevated position and elite social status of the wearer, owing to the vast quantity of silk utilized to make the velvet robe, the costly red dye used to color the silk, and the valuable fur.

Shown in a slightly turned pose, the figure takes up most of the picture surface. He stands before the viewer between curtains dramatically drawn to the sides. Thanks to the overwhelming amount of fabric and low viewpoint of the viewer, the effect is majestic. Such monumentality, grandeur, and extravagance permit little psychological penetration, and Domenico's linear descriptiveness and simultaneous generalization of facial features keep any emotions hidden. Domenico received his training in the workshop of his father, Jacopo (1518–1594), and collaborated with him on a number of projects in Venice, while also working independently. He achieved fame as a portraitist, painting a large number of portraits of Venetian noblemen and officials, which were highly praised.[2]

The Dandolo family was an ancient one boasting numerous important members, including four Doges, the first of which was elected in 1192. Because this ancestral portrait informs the viewer of the much earlier historical importance of the Dandolo family, the portrait may have belonged to a member of that family. Hanging in a private Venetian collection, the painting with its inscription would have emphasized the long and distinguished history of the family and played a role in the continuing construction of the myth and history of the family.

MLP

Gerolamo Bassano

Italian, 1566-1621
The Sepulchre, early 17th century

Oil on canvas,
25½ × 21½ in.
Gift of Miss Florence
Blume, New York, New
York, 1964, AI317

1. Beverly Louise Brown and
Paola Marini, *Jacopo Bassano,
c. 1510-1592* (Fort Worth, Tex.:
Kimbell Art Museum, 1993),390.
2. Bernard Aikema, *Jacopo
Bassano and His Public:
Moralizing Pictures in an
Age of Reform, ca. 1535-1600*
(Princeton: Princeton
University Press, 1996), 125.
3. Livia Alberton Vinco da
Sesso and Franco Sartori, "Il
testamento di Jacopo dal Ponte
detto il Bassano," *Arte Veneta 33*
(1979): 161-64.

Based on a much larger altarpiece painted in 1574 for the church of Santa Maria in Vanzo in Padua by Gerolamo's father, Jacopo Bassano ((1510-1592), the painting depicts the movement of the dead body of Christ in preparation for his burial. The finely dressed Joseph of Arimathea, who offered his own tomb for the burial, stands at Christ's head, Nicodemus appears at his feet, and the Virgin Mary lies on the ground, having fainted at the sight of her dead son. Other significant elements in the composition include the tree stump sprouting a shoot behind the figures, which is a symbol of the Resurrection, and the two candles burning on the left, which allude to the candles used on a Christian altar.[1]

Hanging in a private home, this small devotional painting would have been used in a type of mental prayer that was encouraged in the sixteenth century, described in Mattia Bellintani da Salo's *Della pratica dell'orazione mentale* (*On the Practice of Mental Prayers*).[2] Deriving from medieval types of devotion, the practice required the believer to imagine a scene from Christ's life as if he or she were participating in the event personally, experiencing all of the emotions felt by the participants.

This theme enjoyed great success in the Bassano workshop, as evidenced by the numerous surviving versions. The extreme simplification of the drapery folds, landscape, and simplified color scheme, which relies on cold, bright, and arid colors, indicate the work should be linked to the workshop of Gerolamo Bassano. Gerolamo was the youngest of four brothers, all of whom studied painting in the workshop of their father, Jacopo. While no trace can be seen today, a fine portrait of a distinguished

gentleman exists underneath the current painting, as revealed by X-ray examination (fig.). Painted several decades before the scene of the burial of Christ, the portrait might have been painted by Jacopo as is suggested by the intensity of the sitter's expression and Mannerist pose, and it may have been one of the paintings Jacopo bequeathed to his youngest son, whose career he hoped to benefit.[3]

MLP

above
X-ray showing portrait of a
gentleman underneath the
painting

Marcantonio Bassetti

Italian, 1586-1630
Portrait of a Gentleman Writing, ca. 1621

Oil on canvas,
43½ × 39½ in.
Gift of Mr. Thomas Wesley
Pangborn, Hagerstown,
Maryland, 1963, AI290

1. Anna Ottani Cavina,
"Marcantonio Bassetti,"
in *Cinquant'anni di pittura
veronese, 1580-1630,* ed. Licisco
Magagnato (Vicenza: Neri
Pozza, 1974), 130-62; and
Rodolfo Pallucchini, *La pittura
veneziana del seicento* (Milan:
Electa, 1981), 1:124.

Although Bassetti began his studies of painting in
Verona under Felice Brusasorci (ca. 1539-1605), he
soon moved to Venice, where he befriended Palma
Giovane (1544-1626) and closely studied the art of
Jacopo Tintoretto (1518-1594). The influence of the art
of Jacopo Bassano (1510-1592) can also be seen in
Bassetti's use of light and color. His art belongs to the
seventeenth-century search for realism and dramatic
use of light. In 1616 he went to Rome, where his style
moved toward the art of Caravaggio (1571-1610) and
his followers. He returned to Verona about 1621,
bringing with him the lessons of Rome that became
mixed with his Venetian artistic heritage.[1]

Painted soon after his return, this unconventional
portrait reveals the impact of his Roman sojourn and
his search to represent both the inner psychology
and outer appearance of the sitter. Bassetti places a
burst of light on the face of the sitter, who has just
turned away to look at something outside the space
of the painting. Frozen in an asymmetrical and
interesting contrapposto pose, the sitter steadies
himself with his left hand. The mixture in the same
composition of the studied and the natural supports
an early dating, as does the meticulous detailing to
be found in the hands and face. In Bassetti's later
portraits, these aspects merge to create subtle and
profoundly unified naturalistic portraits that verge
on the Rembrandtesque.

The bold white sleeves, stylized fabric folds
tumbling down the sitter's arms, and brightly lit
hands focus attention on the activity he performs,
which indicates his status as an intellectual, as does
the little still life of books on the table behind him.
The uncertainty in the representation of perspective
is not unusual in Bassetti's work, since the artist
preferred to concentrate on the re-creation of a
striking physical likeness and on the emotional
energy and character of the sitter.

MLP

Erasmus Quellinus

Flemish, 1607–1678
Christ Blessing the Children, 1630s

Oil on panel, 17½ × 26 in.
Museum Purchase, 1951,
A634

1. Jean-Pierre de Bruyn, *Erasmus II Quellinus (1607–1678): de schilderijen met catalogue raisonné* (Freren: Luca, 1988); Jean-Pierre de Bruyn, *Le siècle de Rubens dans les collections publiques françaises* (Paris: Éditions des Musées Nationaux, 1977), 160–63; and Hans Vlieghe, "Erasmus Quellinus and Rubens's Studio Practice," *Burlington Magazine* 119, no. 894 (September 1977): 636–43.

People gather around the figure of Christ, who sits on a carved stone bench. In this episode, recounted in several of the Gospels, Christ responded to the criticism voiced by his disciples, who disapproved of parents bringing their children to Christ for him to bless by saying: "Let the little children come to me, and do not hinder them, for the kingdom of heaven belongs to such as these" (Matthew 19:14). The subject was not a regular feature of painting until the sixteenth century, when the Anabaptists, who espoused adult baptism, challenged Martin Luther's interpretation of this biblical episode to mean that infant baptism was divinely authorized. By showing children brought to Christ by their parents for blessing and by dressing the mothers in contemporary costume, the painting illustrates the belief that children need to be baptized to achieve salvation from original sin.

Jesus, who is placed slightly off center, stretches out his arms to bless the children. The two monumental columns behind Christ, which give majesty to the scene, also serve to isolate the skeptical disciples from the reverent participants. While most of the children remain oblivious to the significance of the event, the child under Christ's right hand stands in a prayerful attitude, aware of the importance of this blessing. Such a thoughtful and persuasive representation of the argument in favor of infant baptism reveals the artist's thorough understanding of the religious issue.

Quellinus's studies in the humanities that led to a degree in philosophy may have inspired this complex narrative, which is embedded in a friezelike composition punctuated with clusters of figures. The incisive style of drawing and sculptural modeling of the drapery indicate the influence of his father, who was a successful sculptor of works after the antique. The fluid brushwork indicates the work was probably painted in the 1630s, when Quellinus frequently worked in the studio of Peter Paul Rubens (1577–1640), participating in a number of important commissions.[1]

MLP

Cornelius Johnson

English, of Flemish descent, 1593-1661

Elizabeth Cokayne, Viscountess Fanshawe (1609-1667),
1639

Oil on canvas,
78¼ × 52 in. (framed)
Signed and dated on the
left side of dress near
bottom of balustrade:
Cornelius Johnson Fecit
1639
Gift of the Estate of
Mrs. Adam F. Arnold,
Washington, D.C., 1961,
A1155

1. Sybil M. Jack, "Fanshawe,
Thomas, first Viscount
Fanshawe of Dromore
(1596-1665)," in *Dictionary of
National Biography* (Oxford:
Oxford University Press, 2004),
19:25-27 [25].
2. The setting may reflect the
family's estate at Ware Park in
Hertfordshire.
3. Ellis Waterhouse, *Painting
in Britain, 1530 to 1790*, 4th ed.
(Harmondsworth: Penguin
Books, 1978), 60-62.
4. Jennifer Lynne Hallam,
"Re-Presenting Women in
Early Stuart England: Gender
Ideology, Personal Politics and
the Portrait Arts" (Ph.D. diss.,
University of Pennsylvania,
2004), 95-98.

Elizabeth was the second wife (m. 1629) of Thomas Fanshawe (1596-1665), first Viscount Fanshawe of Dromore (northern Ireland). A Royalist sympathizer, Thomas held the position of King's Remembrancer, a chief official in the Court of the Exchequer that helped supervise the collection of taxes. His devotion to Charles I was rewarded when he was created a knight of the Bath at Charles's 1626 coronation. Following this in 1629, he married Elizabeth, whose family provided the significant sum of £10,000 for her dowry.[1]

In this full-length, life-size portrait, Elizabeth nobly stands before an elegant balustrade, ornamented with a large flowering plant in a classicizing urn, overlooking a formal geometric garden and lush landscape.[2] Johnson specialized in portraits (head-and-shoulder format, three-quarter length, and full-length depictions), and his conservative portraits proved popular with those just below the highest social circles of Stuart England. Born in London of Flemish parents who had fled religious persecution in the Low Countries after the Spanish conquest, Johnson began producing portraits in the second decade of the seventeenth century.[3] A technically proficient painter, in 1632 he became court painter to King Charles I. By this time he had assimilated the influence of Anthony van Dyck (1599-1641), as seen in the liquid brushwork and ornamental features of this painting. He eschewed the flamboyant tendencies of Van Dyck, however, preferring to create quieter portraits.

A skilled draftsman, Johnson was noted for his gentle characterizations that were sensitive to the individual. Elizabeth's demure demeanor contrasts with her rich tangerine-colored gown and full white chemise. She wears her hair fashionably arranged in curling locks around her face, while in the back her hair would have been drawn into a chignon. Both the large size of the work and the deep décolletage of her dress indicate her elite social status. The deep neckline permitted the artist to highlight her fair skin, which was a sign of feminine beauty. To offset the intrinsic sensuality of the sitter, she modestly wraps the excess fabric of the sleeve across her stomach.[4] The display of such large, regal portraits in the home helped to indicate the power of the family and its social and political connections.

MLP

Willem de Poorter
Dutch, 1608–after 1648
Allegory–Vanitas, 1640s

Oil on canvas,
22½ × 19½ in.
Gift of the Estate of Mr.
William J. Alford, New
York, New York, 1973,
A1758

1. Bob Haak, *The Golden Age: Dutch Painters of the Seventeenth Century* (New York: Harry N. Abrams, 1984), 256–57; and Werner Sumowski, *Gemälde der Rembrandt-Schüler* (Landau in der Pfalz: Edition PVA, 1983), 4:2385–468.
2. See, for example, *Vanitas-Allegorie*, Kulturstiftung Dessau Wörlitz.

A Dutch painter of the Baroque era, De Poorter was born in Haarlem in 1608. The evidence of several historical and religious paintings bearing a marked resemblance to paintings done by Rembrandt (1606–1669) about 1630 indicates that De Poorter probably worked in Rembrandt's Leiden workshop, where Gerrit Dou (1613–1675) was also painting. Even after returning to Haarlem, De Poorter's art continued to reflect his contact with both artists, as seen in the dramatic lighting inspired by Rembrandt and the meticulous technique and predilection for still-life elements learned from Dou.[1]

The figure, while casually resembling the king of Poland, Władysław IV Waza (1595–1648), can be found in other paintings by De Poorter, as can many of the still-life objects shown in the painting.[2] The man wears a fine suit of seventeenth-century German armor and boots; an elaborate shield rests on the floor next to him. The shield boasts a jagged, undulating border and, in the center, a ghastly head with wide gaping mouth. While recalling the fearsome head of Medusa, whose glance would turn the beholder into stone, the large piece of metal jutting from the back of the shield–much more than the necessary support for holding such a shield– probably indicates the addition of a firearm to create a *gonne* shield (gun shield). A relatively rare implement, the terrifying head matched the potential destructive force that could issue at any moment from the creature's mouth.

The painting also contains samples of objects available from Dutch international trade, indicating the material abundance available to wealthy citizens. Only the most affluent of individuals would have been able to afford a Turkish carpet, red velvet cape embroidered with gold thread, and the finely worked large silver vessel. In a world where the knightly mentality still played an important role, the juxtaposition of the implements of war with those of a world-class connoisseur associated the owner of the painting with the realm of the wealthiest and the requirements of that rank. At the same time, the painting is also a *vanitas* (Latin: emptiness) thanks to the presence of the deadly shield, which reminded the viewer of the inevitability of death and thus the vanity of possessing such earthly and worldly pleasures.
MLP

School of Mathieu Le Nain
French, 1607-1677
Henri Coiffier de Ruzé, Marquis de Cinq-Mars (1620-1642),
second half of the 17th century

Oil on canvas,
76½ × 42 in.
Gift of Mr. Chester D. Tripp,
Chicago, Illinois, 1953, A671

1. A. Lloyd Moote, *Louis XIII, the Just* (Berkeley: University of California Press, 1989), 251.
2. Jean Vatout, *Notices historiques sur les tableaux de la galerie de S.A.R. Mgr. le duc d'Orléans* (Paris: Gaultier-Laguionie, 1825), 2:176-84 [176].
3. The lace collar recalls a *punto in aria* pattern depicted in Federico Vinciolo's *Renaissance Patterns for Lace, Embroidery and Needlepoint*, first printed in 1587 and many times thereafter in Italian and French. Federico Vinciolo, *Les singuliers et nouveaux pourtraicts* (Paris: Jean le Clerc, 1606), 42.
4. Anna Matteoli, *La problematica sui fratelli Le Nain e loro cerchia* (Pisa: Giardini Editori, 1990).
5. According to the Museum's records, the collector's mark of Louis-Philippe appears on the back of the painting.
6. Because this painting has undergone various restorations, appears darkened and abraded, and may have been damaged during the French Revolution, a more precise attribution must await a detailed technical analysis of the painting and its support.

Born in 1620, Henri was the son of Antoine Coiffier de Ruzé, marquis d'Effiat (1581-1632), a noteworthy man in France during the reign of Louis XIII (reg. 1610-43) and a member of the king's council, a superintendent of finance, Marshal of France in 1631, and a good friend of Cardinal Richelieu (1585-1642). When Henri's father died, Richelieu took the boy under his protection, making him at the age of fifteen a commander of a new company of bodyguards. Believing that the boy would be easy to control, he introduced him to King Louis XIII. At seventeen Henri became the king's confessor, and by the age of nineteen he was the king's favorite. In 1639, after distinguishing himself in the siege of Arras, he was nominated Grand Écuyer de France (Master of the Horse), an esteemed position to which the gilded helmet and breastplate on the floor of the portrait make reference. Unable to control the headstrong Henri, Richelieu became envious of the clever and powerful favorite, who likewise resented Richelieu's authority. With position and power, Henri developed his own political agenda, and, owing to his negotiations with Spain, then at war with France, Henri was found guilty of conspiracy against the king and beheaded at the age of twenty-two, after a speedy trial managed by Richelieu.[1]

In 1825 the portrait hung in the Palais-Royal in Paris as part of the Orléans collection. Jean Vatout's description perfectly captures the lofty reputation the marquis enjoyed even after his death:

> This gentleman, adorned with all of the gifts of nature, became the favorite of Louis XIII at the flower of his youth. Everything conspired to intoxicate him … his rising was like that of a king or cardinal. Two hundred gentlemen followed him when he attended the king, and he surpassed all the courtiers in the magnificence of his clothes, in his nobility and charm, and in the gracefulness of his manners. Women threw themselves at his head; ministers were at his feet. How does one resist such great seduction. In effect, he lost himself in this cloud of incense, which flattery raised all around him.[2]

Cinq-Mars was known for his good looks, elegance, haughtiness, and bravery, all of which the painting celebrates. He stands life-size before the viewer—elegantly and very fashionably dressed. The costume shows a moment of transition between the earlier military style and the more ostentatious one that followed. He wears a short doublet embellished with bows and ribbons bordered with lace. The loose breeches are densely embroidered with a floral pattern and further ornamented with tiny metallic spheres. The fine and costly needle lace decorating his collar, wrists, and boots would have been imported from Italy.[3]

Three versions of this composition exist today.[4] According to tradition, the first version (private collection) was painted by Mathieu Le Nain between 1640 and 1642, destined to decorate the marquis's luxurious Parisian residence. The painting in Hagerstown appears to have been that owned by Louis-Philippe, the duc d'Orléans.[5] Placing it in his gallery in the Palais-Royal, the duke's interest in the work was probably encouraged by the renewed popularity of the legend and history of Cinq-Mars, which culminated in the publication of a historical novel about the marquis in 1826 by Alfred de Vigny

(*Cinq-Mars, ou Une conjuration sous Louis XIII*), which enjoyed numerous reprintings. Differences between this version and the first one indicate that the Hagerstown work was painted later by an artist probably associated with the Le Nain workshop.[6]

MLP

Charles Beaubrun and Henri Beaubrun

French, 1604–1692 and 1603–1677
Portrait of a Noblewoman with Pearls, 1654

Oil on canvas on panel,
10 × 7¾ in.
Dated lower right: 1654
Gift of the Estate of Miss
Christine Marion Jaques
in Memory of Theodore
Jaques III, 1993, A2773

1. Thierry Bajou, *La peinture
à Versailles: XVIIe siècle*
(Paris: Réunion des Musées
Nationaux, 1998); and Georges
Wildenstein, "Les Beaubrun,"
Gazette des Beaux-Arts 56, no. 6
(1960): 261–74.

Founding members of the French Royal Academy of Painting and Sculpture (1648), the famous painter cousins Charles and Henri Beaubrun belonged to a large family of artists. Ranked as among the finest portraitists of their time, they worked at the courts of Louis XIII (reg. 1610–43) and Louis XIV (reg. 1643–1715). Because they worked very closely together, their styles of painting are virtually indistinguishable.[1]

This portrait is a rare example of a little-known aspect of their production, the non-royal portrait, which is mainly known from prints. The graceful gesture, delicate fingers, and flaccid wrist are characteristic of the portraits painted by the Beaubrun, as is the great attention to detail. The quality of the work sets it apart from works given to the circle of Beaubrun, as seen in the skillful three-quarter view, modeling of the face, the radiance of the pearls, variety of textiles, complexity of fabric folds, and delicacy of coloring. The extraordinary detailing of the curls and strands of the sitter's lustrous hair, the elaborate lace of her puffed sleeves, and the ripples of transparent fabric at the neckline reveal the hand of a master. The year 1654 inscribed on the parapet coincides perfectly with the style of clothing and the cascading curls fashionable at that time.

Aside from the luxurious fabrics of her costume, the noblewoman wears numerous pearls as jewelry, and others have been sewn into her costume. On her bodice, large ones alternate with jewels encased in gold settings, and even larger teardrop pearls hang from decorative flower clusters constructed from smaller pearls. She also wears a necklace of large round pearls and holds still another strand of them. Large pearls were among the most expensive of gems in the seventeenth century and thus an important symbol of status. Since they also symbolized purity and chastity and were a common gift to brides, this dated portrait probably commemorates the marriage of a wealthy noblewoman.

MLP

Follower of Melchior d'Hondecoeter

Dutch, 1636-1695
Peacock, Chickens, and Pigeons in a Landscape,
probably 18th century

Oil on canvas, 29 × 41 in.
Gift of Mrs. Francis D.
Bartow, New York, New
York, 1953, A755

1. Bob Haak, *The Golden Age: Dutch Painters of the Seventeenth Century* (New York: Harry N. Abrams, 1984); Margarethe Poch-Kalous, *Melchior de Hondecoeter* (Vienna: Akademie der Bildenden Künste in Wien, 1968); and Seymour Slive, *Dutch Painting, 1600-1800* (New Haven: Yale University Press, 1995).

This painting features a large peacock in spring plumage surrounded by a number of chickens of various breeds and other smaller birds. Such paintings of domesticated and exotic live birds and animals became quite popular in the seventeenth century. By this time, live peacocks wandered gardens as living ornaments, no longer the preferred centerpiece of formal banquets. Painted specimens like this one also decorated the walls of the country houses owned by the wealthy bourgeoisie, who adopted the lifestyle of the landed aristocracy and royalty. The realistically rendered details, textures, and colors give the work the quality of a still life, a category of painting from which depictions of live animals derived. At the same time, this type of painting also stemmed from the portraits of prize birds and other farmyard exempla requested by breeders.

The composition and lively representation of the birds clearly recall the art of the Dutch Baroque artist Hondecoeter, who came from a long line of painters specializing in the painting of animals and landscapes.[1] Hondecoeter's elegant pictures of birds placed in peaceful landscapes adorned with various architectural features made him the undisputed master of this genre. With the help of various assistants, Hondecoeter's Amsterdam studio was a prolific one, and his work remained very popular even after his death. The simplifications and generalizations found in this portrayal of birds and landscape indicate that it originated outside his studio. Nonetheless, the dynamic balance, close-up views, and artful arrangement of birds placed in a variety of positions combine to create a lively work that reflects the artist's knowledge of the master's paintings. Probably painted in the eighteenth century, the composition appears to derive from the similar painting *A Cockerel with Other Birds*, attributed to Hondecoeter and now in the Wallace Collection, London.

MLP

Pierre Mignard

French, 1612–1695

Christ and the Woman of Samaria, ca. 1691

Oil on canvas,
13½ × 16½ in.
Gift of H. Tom Seely and
Virginia Seely, Berkeley
Springs, West Virginia,
2006, A4133

1. Pierre Rosenberg,
*France in the Golden Age:
Seventeenth-Century French
Paintings in American
Collections* (New York:
Metropolitan Museum of
Art, 1982), 288–90; and Jean-
Claude Boyer, *Le peintre, le
roi, le héros: "L'Andromède"
de Pierre Mignard* (Paris:
Éditions de la Réunion des
Musées Nationaux, 1989).

Despite having been born in France, Mignard studied painting in Italy for twenty-two years, painting a variety of religious commissions and portraits in different cities on the peninsula. As a result, his art remained influenced by several Italian artists, with the Bolognese school and the art of Agostino (1557–1602) and Annibale (1560–1609) Carracci and Francesco Albani (1578–1660) having a particularly lasting impact. When he returned to France, he became one of the leading painters in Paris and, in 1690, First Painter to the king of France, Louis XIV.[1]

This painting shows Jesus talking with a woman at a well. When Jesus traveled from Judea to Galilee, he passed through the region of Samaria and, exhausted from his journey, stopped outside the city of Sychar and sat down by Jacob's well. When a Samaritan woman came to draw water from the well, Jesus asked her for a drink, which surprised the

Pierre Mignard, *Christ and
the Woman of Samaria*, 1681.
Oil on canvas, 12⅝ × 16 in.
North Carolina Museum
of Art, Raleigh, inv. no.
52.9.127

woman as Jews did not usually speak to Samaritans. Demonstrating the same love for Samaritans as for everyone, Jesus talked with her and revealed that he was the expected Messiah, comparing the precious and scarce water of the well with salvation saying: "Whosoever drinketh of this water shall thirst again: But whosoever drinketh of the water that I will give him shall never thirst; but the water that I shall give him shall be in him a well of water springing up into everlasting life" (John 4:13–14).

When Mignard first painted this subject in 1681 (fig.), he drew on several variants of this theme as treated by famous Italian and French artists. The gesture of Christ recalls the composition (Musée des Beaux-Arts, Caen) by Philippe de Champaigne (1602–1674), who painted for the court of Louis XIII, while the pose of the Samaritan woman recalls Carlo Maratti's (1625–1713) treatment (Kartinnaja Gallery, Sebastopol, Ukraine). Mignard's rendition, with its clear gestures, bright colors, and expansive landscape, combines the Italian and French styles of painting to present an eminently readable version of the famous narrative. The existence of several copies after the original testifies to the popularity of the composition. This copy was probably made about 1691, as was a dated version, now in the Pavlovsk Palace, Pavlovsk, when Mignard would have been seventy-nine. Mignard continued to paint until late in life, and such pieces formed an important aspect of workshop activity.
MLP

Godfried Schalcken

Dutch, 1643–1706

Self-Portrait of the Artist Holding a Candle, 1694

Oil on canvas, 45 × 40 in.
Signed, dated, and inscribed
lower right:
G. Schalcken pinxit hanc suam
effigiem Londini 4e 1694
Gift of Mr. Edmund Law Rogers
Smith, Lutherville, Maryland,
1950, A620

1. Thierry Beherman, *Godfried
Schalcken* (Paris: Maeght Éditeur,
1988); Peter Hecht, "Candlelight
and Dirty Fingers, or Royal Virtue
in Disguise: Some Thoughts on
Weyerman and Godfried Schalcken,"
Simiolus 11 (1980): 23–38; and
Christopher Wright, *The Masters of
Candlelight: An Anthology of Great
Masters Including Georges de La Tour,
Godfried Schalcken, Joseph Wright of
Derby* (Landshut: Arcos, 1995).
2. This work is probably the self-
portrait with nearly the same
dimensions described by Hofstede
de Groot, *Beschreibendes und
kritisches Verzeichnis der Werke der
hervorragendsten holländischen Maler
des XVII. Jahrhunderts* (Esslingen: A. N.
Paul Neff, 1912), 5: no. 285.
3. For an example, see National
Portrait Gallery, London, NPG D8974.
4. *Decús obscuris súmpsit ab úmbris*
(He rose to the highest honors from
total obscurity) appears on a mezzotint
by Pieter Schenck (1660–1718/19) after
Schalcken's 1694 self-portrait, London,
National Portrait Gallery, NPG D8975.

A Dutch Baroque painter and etcher, Schalcken first studied with Samuel van Hoogstraten (1627–1678) in Dordrecht. He completed his training in the early 1660s in Leiden under Gerrit Dou (1613–1675), who had studied with Rembrandt, as had Hoogstraten. During Schalcken's apprenticeship, Dou's artistic production included the creation of some meticulously painted candlelit scenes, a creative by-product of the general seventeenth-century Netherlandish interest in light that was inspired by the works of Caravaggio's Dutch followers. These nocturnes and Dou's fine craftsmanship exercised a profound effect on Schalcken, who demonstrated an interest in the effects of light throughout his career and who became internationally famous for his paintings featuring various types of natural and artificial light.[1]

In this self-portrait painted in London in 1694, the artist depicted himself standing before the remains of a large fluted column that once belonged to a grand classicizing building.[2] He holds a candle with his left hand as he presses a heavy cloak to his chest and leans his right shoulder on a stone pedestal, in front of which lie a sculpted bust and a statuette of a satyr. A comparison of this painting with a print made by John Smith (1652–1743) soon after Schalcken painted it shows all of these details and indicates that the Museum's painting retains practically the same dimensions as it did when it was created.[3] Clothed in a white shirt and sumptuous blue jacket with elaborate fasteners (*brandebourgs*) and wearing a wig of long, curly brown hair, Schalcken represented himself as a much younger man at the height of prosperity.

Schalcken's status as a painter of international renown led to his painting another self-portrait in 1695 for the gallery of Grand Duke Cosimo de' Medici, in which Schalcken indicated his artistic profession by including an easel. In this 1694 portrait, however, Schalcken preferred to picture himself with the relics of antiquity, thus showing himself as a refined gentleman and very successful artist, capable of rivaling the ancients. The candle he holds, advertising his personal specialty, was his favorite compositional device, which he used to bring beauty out of shadow.[4]

MLP

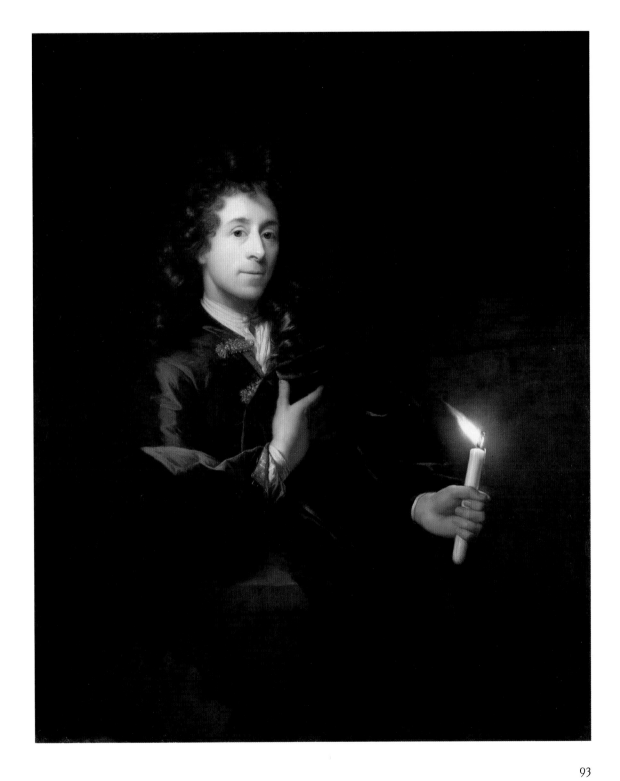

Circle of Titian

Venetian, 16th century
Study of a Nude Male

Pen and brown ink on tan laid paper, 5½ × 4¾ in., irregular
Gift of Mr. William T. Hassett Jr., Hagerstown, Maryland, 1962, A1180

1. For the painting, see Harold E. Wethey, *The Paintings of Titian* (London: Phaidon, 1969), 1: no. 92. The drawings are reproduced in Harold E. Wethey, *Titian and His Drawings: With Reference to Giorgione and Some Close Contemporaries* (Princeton: Princeton University Press, 1987), nos. 21 and 22, figs. 22–24.
2. David Rosand, *Painting in Sixteenth-Century Venice: Titian, Veronese, Tintoretto* (New York: Cambridge University Press, 1997), 13–14.
3. The earliest exception is Hans Tietze and E. Tietze-Conrat, *The Drawings of the Venetian Painters in the Fifteenth and Sixteenth Centuries* (New York: J. J. Augustin, 1944). Rosand, *Painting in Sixteenth-Century Venice* also addresses this issue.

The rapid pen strokes and thick, reinforced contour lines of this drawing bear a remarkable resemblance to several drawings by the celebrated Venetian artist Titian (1490–1576), done in preparation for his *Resurrection* altarpiece of 1520–22 for the church of SS Nazaro e Celso in Brescia.[1] The group is a series of studies for the figure of St Sebastian and features similar areas of parallel hatching (rows of evenly spaced lines that are used to define shading), especially in the short strokes along the left leg of the figure, and include the same broad strokes for the contour lines. Titian's drawings, however, reveal a greater understanding of anatomy and the ability to convey depth through more varied lines and handling of the wash. The figure in the Washington County Museum's drawing is not as fully three-dimensional as those in Titian's drawings, and the awkward position of the right leg, which appears to blend into the torso, confirms that the drawing could not be by Titian himself. But the assured handling, evidenced by the swiftly drawn lines and bold strokes, place the drawing within the master's circle. The precise identity of the artist is difficult to determine because of a continuing lack of comprehensive knowledge of Venetian draftsmanship in the sixteenth century.

In comparison to artistic practice in Florence, where drawing was regarded as essential for the preparation of any painting, Venetian artists often worked directly on the canvas, without completing a cartoon, the final large-scale preparatory drawing for the composition, or without first laying out an underdrawing, or a sketch made on the surface before paint is applied.[2] Thus authors, from the Renaissance until today, regarded Venetian drawings as separate from the process of painting, and little attention has been devoted to the role of drawings in the workshop or the training of an artist.[3] As a result, scholars have not fully fleshed out the character of Venetian draftsmanship in the early sixteenth century.

SC

Anonymous

Italian, 16th or 17th century

*Standing Figure, Drapery Study (Copy after Figure from
"The Journey of the Magi" by Andrea del Sarto)*

Black and red chalk on laid
paper, 13⅞ × 9 in.
Gift of Mr. William T.
Hassett Jr., Hagerstown,
Maryland, 1957, A940

1. See S. J. Freedberg, *Andrea
del Sarto* (Cambridge, Mass.:
Belknap Press of Harvard
University Press, 1963), 2: no.
14, fig. 32 for the fresco.
2. Francis Ames-Lewis, *Drawing
in Early Renaissance Italy* (New
Haven: Yale University Press,
2000), pp. 53–59.
3. See *Andrea del Sarto, 1486–
1530: Dipinti e disegni a Firenze*
(Milan: D'Angeli-Haeusler,
1986) for more on del Sarto's
work as a draftsman.
4. Carmen C. Bambach,
*Drawing and Painting in the
Italian Renaissance Workshop:
Theory and Practice, 1300–1600*
(New York: Cambridge
University Press, 1999)
provides the best overview of
the training of an artist.

This charming drawing reproduces the figure at lower left from *The Journey of the Magi*, a fresco by the Florentine artist Andrea del Sarto (1486–1530) in the church of Santissima Annunziata in Florence, completed in 1511.[1] The delicate handling of the chalk and the use of the two colors confirm that the drawing is not by del Sarto, but is a later copy after the finished painting. Although chalk as a medium had become more popular by the early sixteenth century, the use of red and black chalks to fully exploit the possibilities of color and tonal variations was not common until the latter half of the century.[2] Del Sarto often employed black or red chalk in his figure studies, but his drawings feature bolder strokes and less meticulous attention to the drapery.[3]

This drawing was probably executed as a studio exercise as part of the training of an artist. Through copying the best examples from the past, a young artist would learn not only how to compose a painting but could also absorb the style of the earlier master. The apprentice would then proceed to form his own style by selectively applying forms and techniques from his distinguished predecessors.[4] Drawing after the masters also served as a means of competing with the past. The artist here has focused on the folds of the drapery, only lightly sketching in the head and feet, and has enhanced the three-dimensionality of the figure through the use of tonal variations. Compared with the original model, the figure is taller and slightly more imposing; unlike del Sarto's figure, the one here is not entirely overwhelmed by the swath of drapery across his

shoulder. Although the artist undoubtedly admired del Sarto, he has applied subtle changes to enhance the figure and improve on the work of the celebrated painter.

SC

Anonymous

Flemish or Dutch, 17th century

Copy after "The Last Communion of St Jerome"
by Agostino Carracci

Pen and ink and gray wash on laid paper, 16⅞ × 11¹/₁₆ in. Inscribed on right center of verso in brown ink: Tom[illegible] [illegible] / van[de?]n bruggen [illegible] Gift of Mr. William T. Hassett Jr., Hagerstown, Maryland, 1958, A1005

1. Much has been written on the Carracci Academy, but Gail Feigenbaum, "Practice in the Carracci Academy," in *The Artist's Workshop*, ed. Peter M. Lukehart (Washington, D.C.: National Gallery of Art, 1993), 59–76, provides the best concise overview.
2. For the work of these artists, see *The Age of Correggio and the Carracci: Emilian Painting in the Sixteenth and Seventeenth Centuries* (Washington, D.C.: National Gallery of Art, 1986).
3. Elizabeth Cropper, *The Domenichino Affair: Novelty, Imitation, and Theft in Seventeenth-Century Rome* (New Haven: Yale University Press, 2005), explores the various issues surrounding the controversy.
4. *Allgemeines Künstler-Lexikon: Die Bildenden Künstler aller Zeiten und Völker* (Munich: K. G. Saur, 1996), 14:501 is the most complete source for Van der Bruggen.

This large sheet is an exact copy of an altarpiece painted between 1591 and 1597 by the Bolognese artist Agostino Carracci (1557–1602), originally in the church of San Girolamo della Certosa and now in the Pinacoteca Nazionale of Bologna. It depicts the fourth-century scholar Jerome as he receives his final sacrament. The aged Jerome insisted on being surrounded by his disciples and allowed out of bed, despite his failing health. Agostino's treatment of the subject, an unusual one in the sixteenth century, served as a model for later artists.

Along with his younger brother Annibale (1560–1609) and older cousin Lodovico (1555–1619), Agostino founded an art academy in Bologna in 1582.[1] Their Accademia degli Incamminati (Academy of Those Who Have Embarked upon an Intellectual Discipline), as it was known from about 1590, began as a reaction against the prevailing artistic style in Bologna, consisting of the Mannerist work of such artists as Denis Calvaert (ca. 1540–1619) and Prospero Fontana (1512–1597).[2] The Carracci rebelled against the elongated, overly idealized figures and bright, artificial colors in Mannerist painting, insisting on a return to the study of nature and especially life drawing. The reforms introduced by the Carracci precipitated the style known as the Baroque, which dominated artistic production in the seventeenth century. The Carracci were exceedingly popular throughout the period, and numerous artists made copies after their work. Agostino's altarpiece became the center of a controversy in the 1620s when the painter Domenichino (1581–1641), a student of the Carracci, was accused by a rival artist, Giovanni Lanfranco

(1582–1647), of plagiarizing Agostino's composition for his work of the same subject (1614; Pinacoteca Vaticana, Rome) in the church of San Girolamo della Carità in Rome.[3] Although the accusation of plagiarism was a unique occurrence, artists would frequently borrow motifs and design their compositions around the work of earlier artists. This drawing would have served as a record of Agostino's celebrated painting, and the artist could have employed it as a model for his own work.

The inscription on the verso, or back, of the drawing is in a seventeenth-century script and may be an attribution to a northern artist with the last name of Van der or Van den Bruggen. The most plausible candidate is Jan van der Bruggen, a printmaker who was born in Brussels in 1649 and died in Paris after 1714.[4] As few of Van der Bruggen's drawings are known today, it is impossible to attribute the sheet with any certainty.

SC

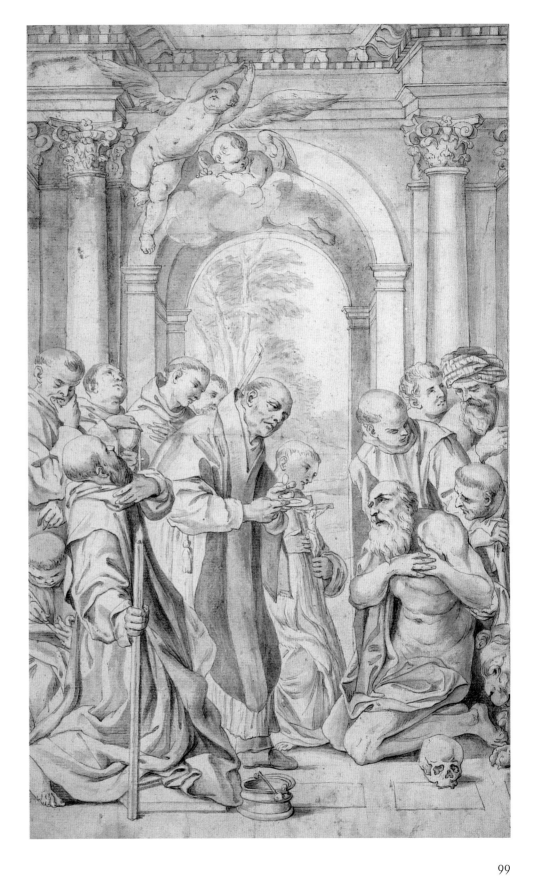

Anonymous
Dutch, late 17th or early 18th century
Animal and Figure Studies

Pen and brown ink on
lightweight ivory laid
paper, 7¹¹/₁₆ × 10¹³/₁₆ in.
Watermark: Coat of arms
with post horn above
D & C BLAUW
Gift of Mr. William T.
Hassett Jr., Hagerstown,
Maryland, 1962, A1180

1. W. A. Churchill, *Watermarks
in Paper in Holland, England,
France, etc., in the XVII and
XVIII Centuries and Their
Interconnection* (Amsterdam:
Menno Hertzberger, 1935), 23,
33, and 80.
2. Jaap Bolten, *Method and
Practice: Dutch and Flemish
Drawing Books, 1600–1750*
(Landau in der Pfalz: Edition
PVA, 1985), 11–14.

The watermark on this sheet of studies provides a general date for the drawing, as the paper was produced by the firm of Dirk and Cornelis Blauw, who were active in the Netherlands after 1621 and whose family continued to operate the business for more than 250 years.[1] The drawing is likely a composite of copies after figures from a drawing book or a volume composed of prints intended for the instruction of artists, which were popular in the Netherlands in the seventeenth and eighteenth centuries.[2] Drawing books offered lessons on anatomy, proportion, optics, and perspective through visual examples. The student would learn to draw by copying the figures in the prints, which usually consisted of studies of the human body, often broken down into parts. Groups of heads, arms, legs, hands, and feet provided models for the inexperienced artist to follow. The artist would then progress to copying entire figures before proceeding to fully three-dimensional forms, first plaster casts of sculptures, then, finally, actual living models.

Drawing books were a relatively new phenomenon in the seventeenth century. Before their appearance, artists kept model books in their studios for the instruction of apprentices and for their own use. Model books were simply a collection of drawings assembled by the master of the workshop, which contained examples of figures, animals, and other subjects. The majority of the drawings were by the hand of the master, but the books also included works by other artists and copies after famous sculptures and works of art. Drawing books did not replace model books in the seventeenth and eighteenth centuries, but, as

collections of prints that were widely published instead of albums kept in artists' studios, they could be employed by amateur artists as well as professionals. Because the sheet of studies is composed of copies and executed in rapid, sketchy strokes, it is difficult to determine the identity of the artist, but the watermark and subject indicate that it originated in the Netherlands.

SC

Hendrik Willem Schweickhardt
German, 1746–1797
Head of a Man

Black, red, and white chalk on blue-gray paper, 14½ × 10 in.
Signed lower left: HW Schweickhardt
Inscribed on verso, lower center in brown ink: Head of a Man 58.222
Gift of Mr. William T. Hassett Jr., Hagerstown, Maryland, 1958, A1005

1. Eric Jan Sluijter, "Hendrik Willem Schweickhardt (1746–1797): een Haagse schilder in de tweede helft van de achittiende eeuw," *Oud Holland* 89, no. 3 (1975): 142–212, provides the most complete biography of Schweickhardt.
2. Ibid., 181–208, reproduces the book in its entirety.

Schweickhardt was born in Hamm, in Germany, but in 1749 likely moved to The Hague, where he later trained with the Italian artist Girolamo Lapis (1732–1798).[1] A memorandum book kept by Schweickhardt from 1773 through 1796 provides records of all the payments he received for his work, along with descriptions of the works and names of patrons and customers, thus supplying extensive documentation for most of his career.[2] Until 1780 Schweickhardt specialized in decorative painting, or panels designed to be set into the walls of interior spaces. He executed at least eight large-scale commissions from 1773 to 1779, mostly landscapes, children, and chinoiserie, that is, images representing oriental scenes, all of which were especially popular in the eighteenth century. After 1780 Schweickhardt turned to cabinet pictures, or smaller easel paintings, which became his primary source of income. He continued to depict landscapes, the style of which reflects the renewed interest in the Dutch Golden Age of landscape of the seventeenth century, and also scenes of children, a type that was based on the work of the celebrated French artist François Boucher (1703–1770). In 1787 Schweickhardt moved his family to London, where he stayed for the remainder of his life, selling his paintings to private clients and through dealers, rather than by commission, and supplementing his income by working as a teacher, mostly giving lessons to amateur artists and the daughters of the nobility.

This drawing, done in three different colors of chalk, demonstrates a high degree of finish, compared to the few surviving academy, or figure drawings, by Schweickhardt. As such, it is probably a work intended for the market and not for use by the artist in his studio. Although he did not sell many drawings during his life, his memorandum book records works in red and black chalk, principally during his first few years in London. The drawing is not a portrait but simply a head study, a popular genre in the Netherlands in the seventeenth and eighteenth centuries.

SC

Anonymous

French, 17th century

Alexander Cutting the Gordian Knot

Gray wash over black
chalk on laid paper,
8⅝ × 15⅝ in.
Gift of Mr. William T.
Hassett Jr., Hagerstown,
Maryland, 1962, A1180

1. Paul Cartledge, *Alexander the
Great: The Hunt for a New Past*
(Woodstock, N.Y.: Overlook
Press, 2004), 143.
2. James Romm, ed., *Alexander
the Great: Selections from Arrian,
Diodorus, Plutarch, and Quintus
Curtius* (Indianapolis: Hackett
Publishing, 2005), 46, provides
a translation of Arrian, a
Greek who wrote the *Anabasis
of Alexander* in the second
century A.D.

The subject of this drawing is an episode from the life of Alexander the Great (356–323 B.C.), the Macedonian king who conquered much of the world known to the Greeks in the fourth century B.C. As the legend goes, the knot was tied by the mythic king Midas of Phrygia, a territory in Asia Minor (modern-day Turkey), in the capital city of Gordium. The knot was tied to the yoke of a wagon that marked the grave of Midas's father, Gordias, the founder of the Phrygian Empire.[1] An oracle prophesied that whoever unraveled the knot would become king of all Asia Minor. In 333 B.C. Alexander arrived in Phrygia, which by then was a territory of the Persian Empire. Unable to locate an end by which he could untangle the knot, Alexander either sliced through it, cutting the rope in half, or removed a peg that separated the yoke of the cart from the pole, thus freeing the knot.[2] He then resumed his campaign, conquering the Persian Empire, which included western Asia and parts of North Africa, and much of modern-day central and south Asia.

In the drawing, Alexander, in full military regalia, strides toward the cart, gesturing at the knot as he raises his sword, preparing to cut through the cord. The crowd reacts with anticipation; some climb over balconies and around columns to witness what they know will be a momentous event that will forever alter the course of history. Narratives from the life of Alexander were continuously prevalent in Western art throughout the years after his death as rulers and nobility alike wished to compare themselves with the heroic leader, but the legends received unusual attention in France in the seventeenth century. Louis XIV aligned himself with a number of mythical and historical figures, but Alexander was a particular favorite. The theatrical setting, with the figures arranged as if on a stage, and the style of pen and wash over black chalk, suggest that the drawing is by a French artist in the later seventeenth century.

SC

Antoine-Louis Barye
French, 1796–1875
Panther Seizing a Stag

Bronze, 14¾ × 22 × 9 in. Gift of Haig & Barbara Farmer, Springfield, Virginia, in honor of the Museum's 75th anniversary, 2006, A4139

1. William R. Johnston and Simon Kelly, *Untamed: The Art of Antoine-Louis Barye* (Baltimore: Walters Art Museum; New York: Prestel, 2006), an exhibition catalogue, reviews Barye's career and achievements.

Certain from his youth that he wanted to be a sculptor, Barye was the son of a goldsmith. He was apprenticed at age thirteen to a steel engraver, from whom he learned to make decorative metal items such as badges and buttons for the French army. Finally, at age twenty, he began formal study, spending time in the studios of the sculptor François Joseph Bosio (1769–1845) and the history painter Antoine-Jean Gros (1771–1835). The dramatic battle scenes of Gros appealed to Barye's sense of drama; indeed, drama became a leitmotif of Barye's career as a sculptor.

He first entered his work in the Paris Salon in 1831, where *Tiger Devouring a Gavial* (crocodile) created a sensation and won a prize. The minister of the interior purchased the animal group for the Luxembourg Palace, and thereafter, Barye received commissions and honors for the rest of his life. Focusing almost exclusively on wild animals, especially those in combat, he was able to establish his own foundry and sales gallery in 1839. For inspiration he made frequent visits to the Jardin des Plantes (Botanical Garden) in Paris, where he sketched wild animals both alive and dead. Obsessed with perfection in his work, he fell into bankruptcy in 1848 but was able to recover and regain commissions and solvency. In 1854, noted for his deep knowledge of the animal world, he became professor of drawing for zoology at the Museum of Natural History and inspired the next generations of French animal sculptors, who called themselves animaliers.[1]

In *Panther Seizing a Stag*, Barye depicted a panther gripping the snout of a large stag and sinking its teeth into the neck, bringing it down to certain death. The titles of other sculptures by Barye similarly point to his interest in animal combat, including *Tiger Devouring a Peacock, Lion and Serpent,* and *Python Killing a Gnu.* Americans were among Barye's most dependable patrons; large collections of his work are found at the Corcoran Gallery of Art, in Washington, D.C., the Baltimore Museum of Art, and the Walters Art Museum, also in Baltimore.

EJ

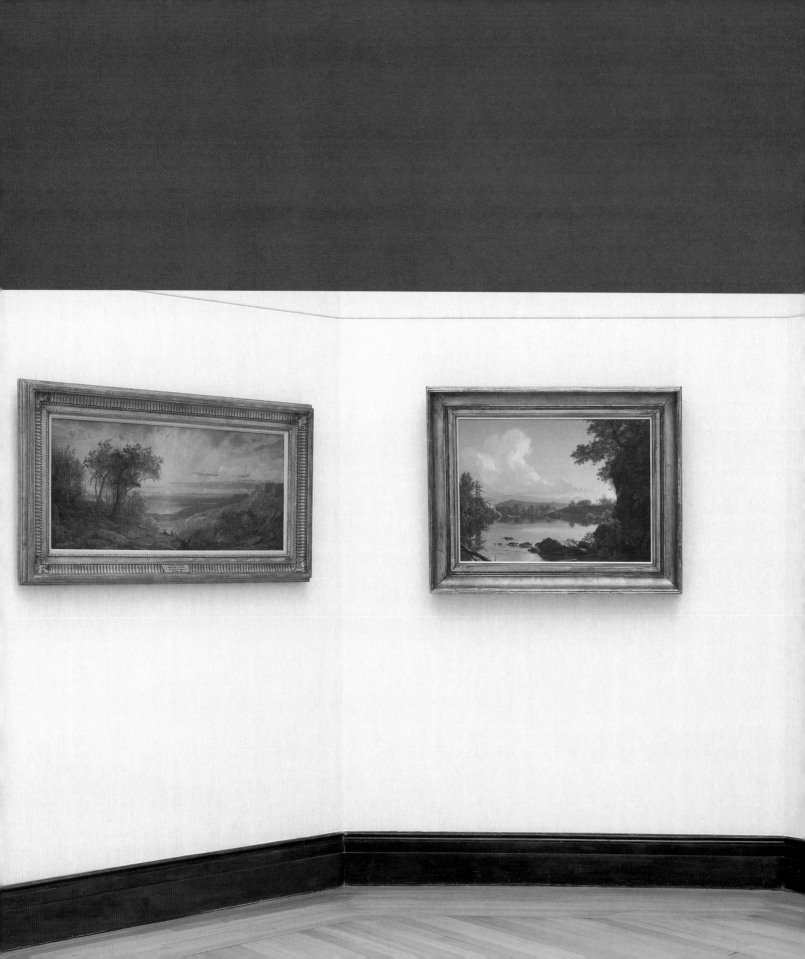

American Art

Early in the history of the Washington County Museum of Fine Arts, leaders of the Museum agreed that the major focus of collecting and exhibition would be American art, even though aspects of the collections came from different parts of the globe. During the Museum's first and second decades, loan exhibitions from a number of institutions, featuring historic and contemporary American works, provided a rich exhibition schedule. Organizing these traveling exhibitions were the College Art Association, the Museum of Modern Art, the Whitney Museum of American Art, the American Federation of Arts, and New York galleries, all of which brought historic and recent paintings to the walls of the WCMFA. By 1940, when the Museum had the funds for a first purchase of an American painting, audiences had seen works from the colonial period through the 1930s and had heard visiting lecturers and critics speak on significant aspects of American art. Audiences voted to purchase Thomas Moran's *Lower Manhattan from Communipaw, New Jersey* (1880), thus adding to the Singers' gifts of landscapes and encouraging the Museum to move toward the present rich collection of American landscapes. Complementing the Singers' gifts of sculpture, in 1941 Anna Hyatt Huntington's *Diana of the Chase* was given to the Museum. This striking work soon became the defining icon on Museum publications.

Postwar recovery made it possible for Director John Richard Craft to seek out and purchase American paintings and prints for the collection. Then, in 1950, the arrival of Director Bruce Etchison coincided with an encouraging art market in which American works surfaced and were affordable.

Under Etchison's leadership, through purchase and gift, the American collection grew promisingly.

By the mid-1970s the collection boasted works that represented the greatest production of American artists over the years: portraiture, which had dominated the Museum's artists' output in the years before the invention of photography and which gained new popularity in the early twentieth century; still life, with which artists often began their careers and which nineteenth-century patrons found appealing; and landscapes, which by the 1840s had become the ideal of painters, tourists, and collectors. Each of these genres is represented in the WCMFA. Marine painting and narrative or storytelling works also found their way into the collection, especially recently through gifts.

The 1970s saw another phenomenon in the Museum's collecting of American art, the turn to prints. Artists had begun to discover the creative challenges that printmaking offered, and with astute purchases of contemporary prints, the Museum circumvented the escalated market for paintings and sculptures. And bringing depth to the American collection, from the 1980s into the early twenty-first century, Director Jean Woods recognized the importance of the Museum as a regional repository and focused acquisitions on the area's artists, both historic and recent.[1]

EJ

1. This history has been drawn from Museum bulletins and directors' reports in the Museum archives, recently catalogued by Curatorial Coordinator Margaret Dameron.

Joshua Johnson
American, 1765–1830
Portrait of Susanna Amos Yoe and Daughter Mary Elizabeth Yoe, 1809
Portrait of Benjamin Franklin Yoe and Son Benjamin Franklin Yoe Jr., 1809

Oil on canvas mounted onto hardboard, each 37 × 26 in.
Gift of Mr. F. Sydney Cushwa, Hagerstown, Maryland, 1994, A2972 and A2973

1. Carolyn J. Weekley, Stiles Tuttle Colwill, with Leroy Graham and Mary Ellen Hayward, *Joshua Johnson: Freeman and Early American Portrait Painter* (Baltimore: Museum and Library of Maryland History and Maryland Historical Society; Williamsburg, Va.: Abby Aldrich Rockefeller Folk Art Center, Colonial Williamsburg Foundation, 1987); and Jennifer Bryan and Robert Torchia, "The Mysterious Portraitist Joshua Johnson," *Archives of American Art Journal* 36, no. 2 (1996): 2–7.

Johnson's activity as a portraitist in Baltimore seems to date to the early 1790s. He first advertised himself as a portrait painter in 1798, assuring potential customers that he was a "self-taught genius." Identified in city directories as "a free householder of colour," Johnson was the son of a white man and a black slave. In 1782, according to manumission records in the Maryland Historical Society, Johnson's father, George Johnson, purchased his son and immediately freed him. After completing an apprenticeship to a blacksmith, Johnson developed his talents with brush and palette and enjoyed broad patronage as a portraitist among successful families in Baltimore.[1] Because he was essentially self-taught, his style is somewhat flat, with firm outlines and little modeling to suggest volume. He is often associated with naïve, primitive, or folk artists, but the designation by no means fits this artist who attracted many commissions in a sophisticated urban community.

In this pair of portraits, Johnson arranged the Yoes in traditional poses: parents seated, children standing nearby. The father, posed in a Windsor chair, is joined by his standing son, who places his left hand on his father's hand and in his other holds a dark red rose, symbol of love. In the portrait of the women, the mother, seated on a Federal-style sofa with a book on her lap, is near her daughter, who is dressed in white and holds pink roses, another symbol of affection. All four look out at their audience. Johnson's arrangement of the figures suggests the way they were hung in the family home: father and son on the right and mother and daughter on the left, so that the parents look toward each other, protecting the children in the middle.

Mr. Yoe had a tailoring business in Baltimore, an occupation he took with him when he moved with his family to Hagerstown in 1810. Benjamin Franklin Yoe Jr., born in 1804, later became an attorney in Hagerstown and a member of the House of Delegates representing Washington County. Daughter Mary Elizabeth, born 1806, married George Fechtig, a Hagerstown merchant, in 1823.

These works are copies of portraits in the Museum of Early Southern Decorative Arts in Winston-Salem, North Carolina. In a common practice, Johnson painted two of each portrait so that both children could have one. The paintings in the WCMFA collection were given by the great-grandson of Mary Elizabeth.

EJ

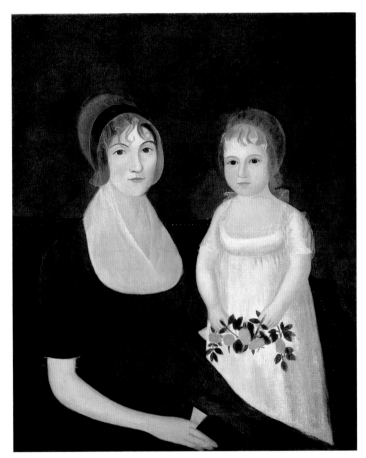

Charles Willson Peale
American, 1741–1827
Portrait of Elizabeth Tasker Lowndes, 1789

Oil on canvas, 23½ × 19 in.
Gift of Edward Bowie
Prentiss, Catharine
Watkins Prentiss
Plummer, and M. G. Louis
Watkins Prentiss Jr. in
memory of their mother,
Helen Bowie Prentiss,
2007, A4298

1. Edgar P. Richardson, Brooke
Hindle, and Lillian B. Miller,
with a foreword by Charles
Coleman Sellers, *Charles
Willson Peale and His World*
(New York: Harry N. Abrams,
1983); and David C. Ward,
*Charles Willson Peale: Art and
Selfhood in the Early Republic*
(Berkeley: University of
California Press, 2004) provide
studies of Peale and his many
accomplishments.
2. Charles Coleman Sellers, *Mr.
Peale's Museum: Charles Willson
Peale and the First Popular
Museum of Natural Science and
Art* (New York: W. W. Norton,
1980).
3. Copy in object files, WCMFA.

Charles Willson Peale, an artist, naturalist, museum entrepreneur, and soldier, founded a painting dynasty in Maryland that lasted for several generations. Born in Queen Anne's County, Maryland, he began to draw as a child. After serving an apprenticeship with a saddle maker and wood-carver, he began to paint portraits, inspired by the examples of John Hesselius (1728–1778) and John Singleton Copley (1738–1815). With help from friends, he was able to spend two years in London beginning in 1767 studying with Benjamin West (1738–1820), the American expatriate who mentored many visiting American students. After Peale returned to America, he settled in Annapolis, where he passed on his skills to his younger brother, James Peale (1749–1831), who became a miniaturist and still-life painter and, like Charles Willson, sired artistic children.

Peale's roster of portraits swelled over the years, especially after he moved to Philadelphia in 1776. His most famous sitter was George Washington, of whom he produced nearly sixty portraits; also sitting for him were Benjamin Franklin, John Hancock, and other statesmen and scientists of the early Republic.[1] His interest in natural history brought him as much renown during his lifetime as his skills as a painter. He founded a museum in Philadelphia (called Peale's Museum) in which he used his capabilities as a taxidermist to display in natural environments animals from the nearby streams and woods. He included in his museum portraits of the many notables who had shaped the United States as well as the huge skeleton of a mastodon that he had excavated on an expedition funded by Thomas Jefferson.[2]

Peale traveled to Bladensburg, Maryland, to paint the portrait of Mrs. Lowndes (1726–1789) during her final illness. In 1747 Elizabeth had married Christopher Lowndes (1713–1785), and at some point, Peale had painted a miniature of her. He was called in to paint this portrait as a parting gift for her children. In the portrait, Mrs. Lowndes's illness shows in the lines on her face; her blue and gray dress, fichu and bonnet, lovely as they are, suggest her condition as well. An obituary proclaimed, "To a temper the mildest and most cheerful, she joined the most benevolent heart, and during a long and painful illness, felt more for those about her than for herself."[3]

Three of Peale's children–Rembrandt (1778–1860), Raphaelle (1774–1825), and Titian Ramsay (1779–1885)–became acclaimed artists.

EJ

Raphaelle Peale
American, 1774–1825
Portrait of Anthony Slater, ca. 1814

Watercolor on ivory,
2⁵⁄₈ × 3½ in.
Signed on the paper
backing on reverse:
Painted by Raphaele
Peale AY Slater late of
Chesterfield & Liverpool,
now of Philadelphia Born
28 August 1779
Gift of Mr. & Mrs.
J. Robert Dodge,
Sykesville, Maryland, 1991,
A2681

1. Lillian B. Miller, ed., *The Peale Family: Creation of a Legacy, 1770–1870* (New York: Abbeville Press in association with the Trust for Museum Exhibitions and the National Portrait Gallery, Smithsonian Institution, 1996) studies the Peale family legacy.
2. Nicolai Cikovsky Jr., *Raphaelle Peale: Still Lifes* (Washington, D.C.: National Gallery of Art, 1988) provides a detailed look at Raphaelle Peale's still lifes.

American artists who became miniaturists were drawing on a fairly recent tradition. Artists had begun to paint miniatures in the sixteenth century, at first on vellum and, by the eighteenth century, on ivory. The small portraits, approximately an eighth of the size of nature and painted in watercolor, served as mementos of family and loved ones; they could be stored in a pocket or purse for travel and, at home, in a drawer or box to be brought out on special occasions. Few artists could master the precise technique required. Those who did typically specialized in miniatures, appealing to patrons who could not afford large oil portraits or who wanted a miniature for private use.

Raphaelle Peale, the oldest of Charles Willson Peale's children, was born in Annapolis. Trained by his father and considered by him the most talented of his children, he painted miniatures and profile portraits throughout his career and fairly late in his short life became a still-life artist as well.[1] He joined his brother Rembrandt (1778–1860) in several artistic ventures. When their idea for a portrait gallery of distinguished Baltimore citizens failed to materialize, they traveled together in Virginia, the Carolinas, and Georgia as a portrait team, with Rembrandt painting large oils and Raphaelle miniatures. Back in Philadelphia in 1821, Raphaelle advertised portraits on ivory for $15, colored profiles on paper for $3, and "likeness[es] after death" for $50. The latter, Raphaelle assured customers, would require a maximum of fifteen to twenty minutes with the deceased.

Anthony Slater (AY was the abbreviation for Anthony), born in England in 1779, was a Philadelphia importer and wholesaler listed in the city directories from 1806 to 1824. Peale's portrait depicts Slater in profile, well-dressed with dark curly hair, backed by a characteristic light background of blue sky with yellow clouds. The painting is in its original frame.

Raphaelle's health began to fail in 1814, the year he painted this miniature. He devoted the rest of his career to still life and is generally recognized as America's first professional still-life painter. He established a tradition in that genre that was contributed to by his uncle, James Peale (1749–1831), and carried into midcentury by his cousin, Sarah Miriam Peale (1800–1885).[2]

EJ

Rembrandt Peale

American, 1778–1860

Portrait of Henry Robinson, ca. 1816

Oil on canvas, 27 × 22 in.
Museum purchase, 1964,
A1345

1. Lillian B. Miller, with essay
by Carol Eaton Hevner, *In
Pursuit of Fame: Rembrandt
Peale, 1778–1860* (Washington,
D.C.: National Portrait Gallery,
1992) studies Rembrandt Peale
in detail.
2. Wilbur Harvey Hunter,
*The Peale Family and Peale's
Baltimore Museum, 1814–1830*
(Baltimore: The Museum, 1965)
traces the history of Peale's
Baltimore Museum.

The second son of Charles Willson Peale
(1741–1827), Rembrandt took up his father's interest
as a painter and museum entrepreneur.[1] Encour-
aged by his father, he studied in London and Paris.
In 1795, when he was only seventeen, he sketched
George Washington from life, accompanied by his
father. He completed ten portraits based on those
sketches. Then in 1823, dissatisfied with the results,
he started over and used the famous sculpture of
Washington made in 1785 by the French sculptor
Jean-Antoine Houdon (1741–1828) as a model for a
new portrait. He made more than eighty replicas
from the result over his lifetime, meeting the clamor
of patrons for an image of the first president of the
country.

Peale's study in Paris in 1808 and 1809–11, where
he absorbed the smooth surfaces and clear outlines
of the Neoclassical styles still in fashion, is apparent
in this portrait of Henry Robinson. In a
straightforward pose with only a slight tilt of his
head, a well-dressed Robinson looks out through
spectacles that give dignity to his warmly colored
face. Diffused lighting, broken by a slight shadow
under the glasses' rims, adds to the clarity of the
picture. Only the background and lower part of the
coat are sketchy. A copy of this portrait in oil on
paper is at the Bayou Bend Collection in Houston,
perhaps made so Rembrandt could keep at least a
copy of a painting he was pleased with.

Following his father's interest in museums,
Rembrandt founded the Peale Museum in Baltimore
in 1814.[2] The founder of a gasworks company that
lighted Peale's museum, Henry Robinson was not
only a subsidizer of the museum but a friend of

Rembrandt's as well. Rembrandt probably painted
the work in gratitude to Robinson for his help. The
painting was popular in the early twentieth century,
when it was exhibited at the Panama-Pacific
International Exposition in San Francisco in 1915
and at the Pennsylvania Academy of the Fine Arts
in 1923.

Peale eventually settled in New York, where he
became president of the American Academy and
was a founding member of the National Academy of
Design. He wrote books on drawing, natural history,
and artists.

EJ

Sarah Miriam Peale
American, 1800-1885
Portrait of a Woman

Oil on canvas, 30 × 24 in.
Museum Purchase, 1967,
A1486

1. Lillian B. Miller, ed., *The
Peale Family: Creation of a
Legacy, 1770-1870* (New York:
Abbeville Press in association
with the Trust for Museum
Exhibitions and the National
Portrait Gallery, Smithsonian
Institution, 1996) studies Peale
along with other members of
her family.

Sarah Miriam Peale, the last child of James Peale
(1749-1831), was trained as an artist by her father and
her uncle, Charles Willson Peale (1741-1827). Born in
Philadelphia, she began her artistic career painting
still lifes, a typical subject for a woman artist. Soon,
however, she developed skills in portraiture. In 1825
she settled in Baltimore, where she had a studio in her
cousin Rembrandt Peale's Museum from 1825 to 1829.
She became one of the most popular portraitists in the
region, painting at least one hundred portraits of prom-
inent Baltimore citizens and making several trips to
Washington from 1841 to 1843 to paint statesmen.[1]

Her portrait of a woman whose identity we have
lost suggests the artist's attractiveness to potential
patrons. The sitter looks out directly, with pensive blue
eyes and dark brown curls evident under her bonnet.
Peale's choice of color compliments her sitter: a black
Empire-style dress with shirred upper sleeves and a
white lace collar. Her white stole is ornamented with
an intricate woven edging of red and green. Accenting
both the collar and her bonnet are tiny jewels that
reveal the artist's painstaking technique. That we no
longer know the sitter's identity points to the irony of
portraiture, whether done with paints or photographs:
made to preserve one's identity, portraits often last
long after the name of the sitter has been lost.

In 1847 Peale moved to St. Louis, where she focused
on still lifes, and in 1878 returned to Philadelphia to
live with her artist sisters Anna Claypoole Peale
(1791-1878) and Margaretta Angelica Peale
(1795-1882). Sarah is considered the first professional
woman painter in the United States.

EJ

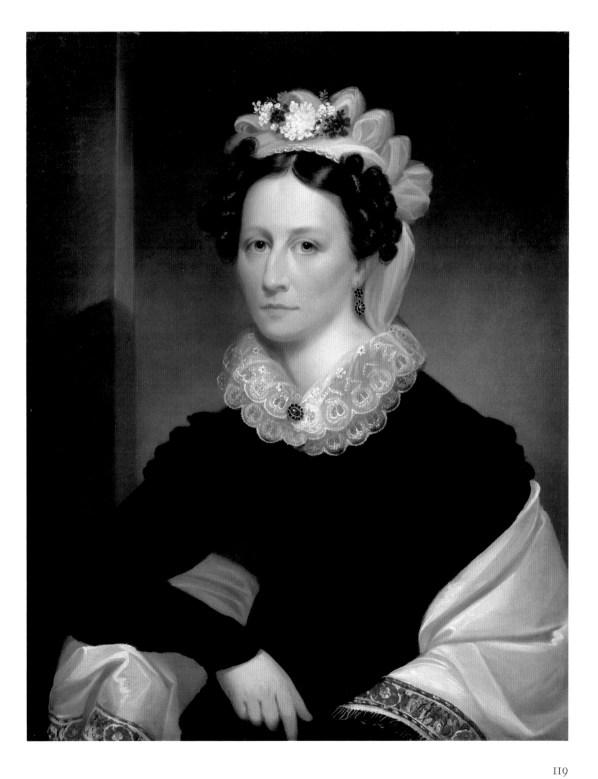

Robert Henri

American, 1865–1929

Michael, 1913

Oil on canvas, 18 × 14 in.
Signed, dated, and
inscribed lower middle
right: Robert Henri; verso:
Robert Henri, Ireland 1913
Michael
Museum purchase, 1969,
A1562

1. Bennard B. Perlman, *Robert Henri: His Life and Art* (New York: Dover Publications, 1991); and Valerie Ann Leeds, *My People: The Portraits of Robert Henri* (Orlando, Fla.: Orlando Museum of Art, 1995).
2. Elizabeth Milroy, with an essay by Gwendolyn Owens, *Painters of a New Century: The Eight and American Art* (Milwaukee: Milwaukee Art Museum, 1991).
3. Jessica F. Nicoll, *The Allure of the Maine Coast: Robert Henri and His Circle, 1903–1918* (Portland, Maine: Portland Museum of Art, 1995).

Michael, a portrait of the young Irish boy Michael "Red" Lavelle, was painted by Henri during the artist's first trip to Achill Island, County Mayo, in western Ireland in June 1913. Michael was thirteen years old and in later years remembered having worn a new, homemade sweater (a "yansey") for the sitting. The portrait, which Henri painted in broad, heavy brushstrokes that left traces of brushwork on the canvas (impasto), exemplifies the artist's commitments to the vitality of the working class and of everyday life. A popular teacher, he taught his students that the faster they worked, the better: his credo was that one should always start and finish a painting in one session.[1]

Henri, painting in New York along with John Sloan (1871–1951), George Luks (1866–1933), George Bellows (1882–1925), and others, considered himself a "revolutionary" artist, working in the early years of the twentieth century to challenge the old standards for realistic subjects. He and his colleagues rejected genteel topics, such as the landscapes and garden scenes that had attracted Impressionists like Willard Metcalf (1858–1925) and Childe Hassam (1859–1935), in favor of themes of urban and working life. Beginning in 1908 several of these artists, including Henri, exhibited together as the Eight, sponsored by the gallery dealer William Macbeth. Although the exhibitions traveled to major cities and the artists won patrons, critics disparaged their work as the Ashcan School because of the ordinariness, even ugliness, of some of their subjects. The term was a misnomer for work by artists in the group like Arthur Bowen Davies (1862–1928), who painted dreamlike themes, and

Maurice Prendergast (1858–1924), who painted beach scenes and watercolors of Venice. However, the effect of the challenges that all eight of the artists offered to tradition was to pave the way for the introduction of European modernism in the Armory Show of 1913.[2]

The energetic Henri, born in Cincinnati, had studied at the Pennsylvania Academy of the Fine Arts in Philadelphia and earned his living as a newspaper illustrator before moving to New York. In search of ordinary people for his subjects, he traveled widely in American and European rural areas, especially in Maine, western Ireland, Brittany, and Spain.[3]

EJ

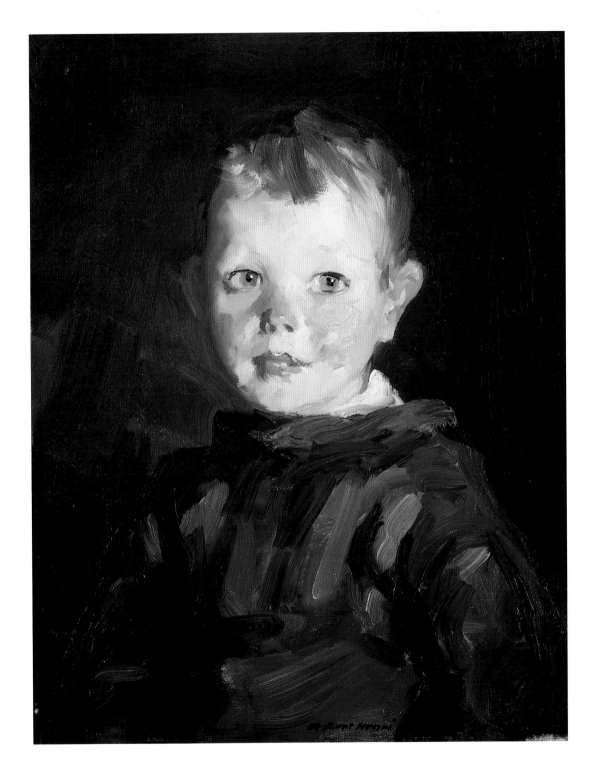

George Luks
American, 1866–1933
Portrait of a Young Girl

Oil on canvas,
32¼ × 25½ in.
Signed lower right:
George Luks
Museum Purchase, 1969,
AI555

1. *George Luks, 1866–1933: An Exhibition of Paintings and Drawings Dating from 1889–1931* (Utica, N.Y.: Munson-Williams-Proctor Institute, Museum of Art, 1973) studies the artist's entire career. See also Rebecca Zurier, *Picturing the City: Urban Vision and the Ashcan School* (Berkeley: University of California Press, 2006).

Beginning his career in Philadelphia as a newspaper illustrator and art student at the Pennsylvania Academy of the Fine Arts, Luks favored working-class subjects from the beginning of his career, wanting his art to be "democratic." From 1885 to 1891 he studied in Germany, France, and England. Then, in 1896, he moved to New York to participate in the heady art world there. He joined Robert Henri (1865–1929) and other artists who painted what was around them–the street life, immigrants, and curious happenings in burgeoning New York City.

Unlike some of his colleagues, Luks continued to work as a newspaper illustrator, for he felt that painters who captured what was happening on the streets had a rich experience of humanity achievable in no other way. Something of a renegade (he liked his drink and was quick to challenge a point of view), Luks was an amateur boxer who abhorred what he called "pretty" paintings. He delighted especially, he said, in the chaos of Manhattan's Lower East Side, a landing place for generations of immigrants. Like other Ashcan School artists, Luks painted quickly, leaving his brushwork in plain evidence on the canvas. He exhibited with the group called the Eight in 1908 and also in the Armory Show of 1913.[1]

The vigor with which Luks lived is perhaps just behind the knowing expression he gave the young girl in this dignified portrait; she is considerably more dressed up than many of his subjects.

The leadership of an avant-garde in the United States by the Eight came to an end with the famous Armory Show of 1913, which was dominated by European modernists, particularly the French and Italians.

EJ

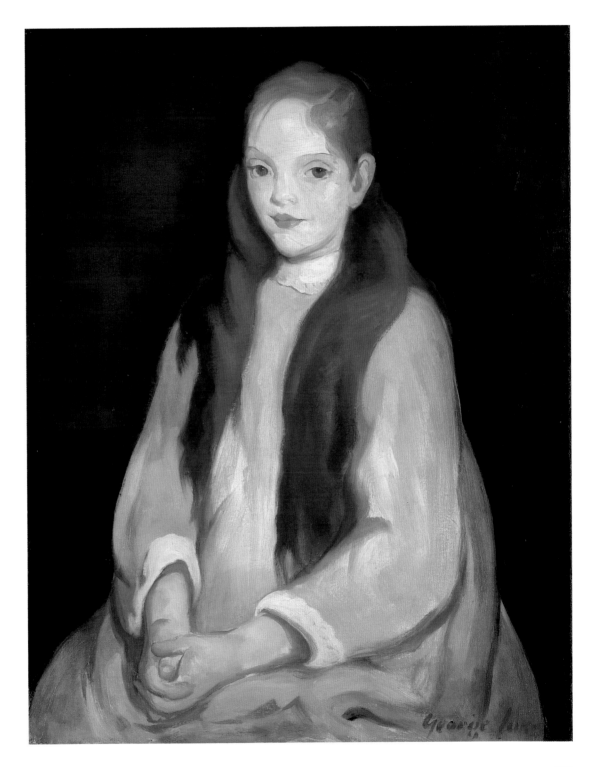

Philip Guston

American, 1913-1980
Portrait of Shanah, 1941

Oil on canvas, 35¼ × 21¾ in.
Signed and dated lower
left: Philip Guston, 1941
Museum purchase,
1948, A566

1. Robert Storr, *Philip Guston*
(New York: Abbeville Press,
1986); and Michael Auping,
Philip Guston Retrospective (Fort
Worth: Modern Art Museum
of Fort Worth, 2003) study
Guston's career.

The sitter, looking slightly to her left, holds a palette and brushes. Sitting in a studio, she leans on a table on which rests another palette. The sitter is Shanah Shatz, a student of Guston's at the University of Iowa in 1941. She was apparently an admired student, for in the background of the portrait is a painting of a nude with a face that looks like her own–perhaps a self-portrait.

Guston, born Philip Goldstein to Russian émigré parents in Montreal, moved to Los Angeles in 1919 with his family. As an aspiring artist, he studied the work of the Italian modernist Giorgio de Chirico (1888-1978) for his dreamlike abstractions and that of Renaissance painters for their careful architectural space. Always attentive to milestones in the history of art as well as to contemporary art, during his early years he painted Social Realist scenes, following many American artists' interest in the 1930s in painting everyday life. His *Portrait of Shanah*, with a clear structure and solid application of paint, honors the student and, by implication, the teacher as well, who passes an artistic heritage to his students.

Guston explained his process as a painter in 1951: "There seems to be a sort of destiny for the disposition of everything in a canvas. I usually am on a picture a long time, painting out many preconceptions, until the moment arrives when unsuspected relationships appear which feel meaningful and fated." Influenced by his friends Jackson Pollock (1912-1956), Willem de Kooning (1904-1997), Reuben Kadish (1913-1992), and Mark Rothko (1903-1970), who developed Abstract Expressionism in the late 1940s and 1950s, Guston changed his style radically in the 1950s, adopting their abandonment of art's reference to the outside world. In the late 1960s Guston altered his direction again, spending the rest of his life making pictures with cartoonlike figures that critiqued Americans' consumption, politics, and self-satisfaction.[1]

EJ

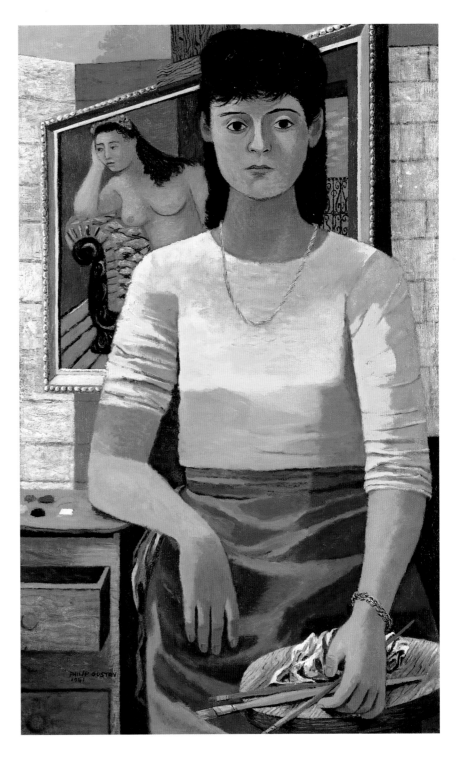

Benjamin West

American, 1738-1820

Ascension of Christ (Study), 1798

Oil on canvas,
20½ × 16½ in.
Signed and dated lower
center: B. West 1798
Museum Purchase,
1952, A678

1. Helmut von Erffa and
Allen Staley, *The Paintings of
Benjamin West* (New Haven:
Yale University Press, 1986)
provide a full study of the
artist.

Born in Pennsylvania and encouraged in his ambitions to be an artist by generous patrons who in 1760 sent him to study in Rome, Paris, and London, West settled in England after his travels and never returned home. Finding himself among such successful artists in London as the portraitist Sir Joshua Reynolds (1723-1792) and the landscapist and portraitist Thomas Gainsborough (1727-1788), he undertook what was considered the most challenging type of subject, history painting. Based on the figural and technical achievements of the old masters and tied to a scriptural or historical text, history painting was not yet widely practiced in England. Nevertheless, perhaps because of his ambition, West quickly earned the respect of prominent British artists, became court painter to King George III (all the more astonishing because of the artist's American birth), and was elected president of the Royal Academy of Arts of London. A kind and generous teacher, he attracted many American students to his studio, including Charles Willson Peale (1741-1827) and his son Rembrandt (1778-1860).[1]

The subject of West's study *Ascension of Christ* had been painted by innumerable artists in the Renaissance and Baroque periods. West undertook it as a commission from King George for the decoration of the chapel at Windsor Castle, a project that ultimately was not carried out. The study—its signature and date reveal West's pride in the work—shows fluid drawing, a thoughtful contrast of light and dark, and a brilliant capture of the movement with which West imagined the event taking place. As Christ ascends into the heavens in the upper left accompanied by angels, his followers on the ground react with fear and amazement, creating a scene filled with emotion. Many of West's completed history paintings are static, with figures frozen in overly dramatic gestures. Hence this study is testimony to what West could do in the early stages of planning a painting.

The sketch, a masterpiece in itself, was included in the exhibition *The Hand and the Spirit: Religious Art in America, 1700-1900*, at the University Art Museum, University of California, Berkeley, in 1972-73. The completed painting that most closely resembles this study is in the collection of the Tate Gallery in London; another painting by West of the *Ascension* is in the War Memorial Chapel at Bob Jones University in Greenville, South Carolina.
EJ

Sarony, Major & Knapp
after Rembrandt Peale
American, 1778-1860
Court of Death, 1859

Chromolithograph,
23 × 31 in.
Gift of Spence & Cinda
Perry, Hagerstown,
Maryland, 2005, A4031

Rembrandt Peale was perhaps the most ambitious and energetic of Charles Willson Peale's (1741-1827) children, working as a portraitist, history painter, and museum entrepreneur. Studying in Paris from 1808 to 1809-11, he learned technical excellence and ways to succeed as a professional painter. Like many of his colleagues in the United States, Peale was eager to prove his mettle as a painter of history paintings. These images, usually large, took their subjects from famous historical events, literary themes, scripture, or moral or religious poetry. Artists typically wrote explanations of the subjects of the paintings, arranged for a tour of several cities, and charged admission. Such procedures celebrated painting as an educational tool, even in the case of religious subjects, as one that would lead to moral living. Often in advance of such a tour painters contacted clergymen, who recommended to their congregations that they visit the work and ponder its message.

Peale's inspiration for the *Court of Death* was a popular poem by the British reformer Beilby Porteus (1732-1809) that enjoyed wide circulation. Porteus, an anti-Calvinist who believed that individuals were not subject to determinism but could work toward their own spiritual destiny, considered his poem to promote that hope. Peale painted his original work in 1820 and sent it on exhibition through many cities. In 1859 he sold the huge painting (which measured 11½ × 23 ft. and is now at the Detroit Institute of Arts) to Dr. G. Q. Colton, who arranged for a chromolithograph to be made so that the inexpensive print could have even wider distribution.

The uplifting message is driven home by the separate explanation that accompanied the print. In the center of the image sits Death, the "Monarch of darkness." On the right, the four "prime ministers of Death" rush out of the picture, denoted since the book of Revelation as the four horsemen of the apocalypse: War, Conflagration, Famine, and Pestilence. In the center of the picture, just to the right of Death, a saintly looking old man is led by a lovely woman the legend calls "Faith." Having lived an upright life, he has not yielded to the immoral pleasures and intemperance that have marked the life of the youth in the foreground, with their consequences of remorse, delirium tremens, and, finally, suicide.

Chromolithography, developed in the 1830s, followed the invention of lithography in 1798, in which a design was drawn or painted with an oil-based ink on a flat stone from which thousands of copies could be printed. Color was soon added to the process, for which one stone would be responsible for each color. With typically three or four stones providing the color, the printmaker would have to align the prints carefully so that the different stones would print in register.

The advertisement for this print included such commendations as that from the *Christian Advocate and Journal* of December 8, 1859: "In this brief description we have given but a faint idea of the beauty and general effect of this instructive picture." EJ

Daniel Ridgway Knight

American, 1839–1924
The Burning of Chambersburg, 1867

Oil on canvas, 49 × 62½ in.
Signed and dated lower
left: D. R. Knight 1867
Museum Purchase, 1968,
A1541

1. Pamela Beecher, *A Pastoral
Legacy: Paintings and Drawings
by the American Artists Ridgway
Knight and Aston Knight* (Ithaca,
N.Y.: Cornell University, 1989).

This large painting commemorates the anxiety and suffering experienced on July 30, 1864, by the citizens of Chambersburg, a town in south-central Pennsylvania, after they refused to pay a ransom to the troops of the Confederacy. The ransom, demanded by Confederate General John A. McCausland in retaliation for the burning of cities in the Shenandoah Valley of Virginia by Union troops, was to prevent the Confederate Army from burning Chambersburg to the ground. When the citizens of Chambersburg refused to pay the sum demanded–$100,000 in gold or $500,000 in U.S. currency–the conflagration, robbing, and plundering of private homes as well as public buildings began.

Knight, who was born in Philadelphia and trained at the Pennsylvania Academy of the Fine Arts and then in Paris, enlisted in the Union Army in 1863 and was thus in a unique position to paint a number of scenes from the Civil War. Local tradition has it that he was in Chambersburg at the time of the burning. However, whether he was or not, the outrage of the Chambersburg conflagration inspired him to create this memorial to the people of the town. Around the light-penetrated middle space of the barn floor, he placed several poignant groups, each face expressing fear and exhaustion. On the right a woman tends to the wounds of a fellow citizen. Next to them, a man with white hair and beard clasps his hands in prayer, and, just beyond, a young woman sleeps on the floor; perhaps her child and the child's grandmother are the figures nearby. In the left foreground, a turbaned African American woman bows in exhaustion; behind her is another dark figure, looking on in anxiety. Across the

foreground of the painting Knight placed a few objects that reveal the desperate flight of the citizens to refuge, among them a canteen and a woven basket. In the rear of the painting, where outside light enters the barn interior, three men peer out beyond the sagging door, seeming to check on the progress of the flames. A number of photographs of the devastated town exist in private collections and the Pennsylvania State Archives.

Knight returned to France in 1871, settled in Rolleboise, near Bonnières-sur-Seine, and pursued a successful career painting peaceful genre scenes of peasant women and landscapes. He had had enough of scenes of war.[1]

EJ

John George Brown
American, 1831–1913
The Dilettante, 1882

Oil on canvas, 18½ × 12¼ in.
Signed and dated lower
left: J. G. Brown, N.A. 1882
Gift of Mr. & Mrs. Lee
Stine, Sharpsburg,
Maryland, in honor
of the Museum's 75th
anniversary, 2005, A4084

1. Martha J. Hoppin, *Country
Paths and City Sidewalks: The
Art of J. G. Brown* (Springfield,
Mass.: George Walter Vincent
Smith Art Museum, 1989); and
Claire Perry, *Young America:
Childhood in 19th-Century Art
and Culture* (New Haven: Yale
University Press in association
with the Iris & B. Gerald Cantor
Center for Visual Arts, Stanford
University, 2006).

Brown tapped the market in the latter part of the nineteenth century for pictures of urban street boys that sentimentalized their poverty and cleverness. An excellent example of such works is *The Dilettante*, in which a shabbily dressed young fellow with scuffed shoes and holes in his socks holds up for admiration a vase of dubious condition. He has apparently just rescued it from the nearby trash barrel. The boy's happy facial expression suggests that he is proud of his "taste." In contrast to his surroundings and clothing, the boy's face is clean and his hair neat, although his hands are grubby. Despite their contrived subjects, such genre paintings are popularly thought of as depicting scenes of "everyday life." Whereas landscapes idealized nature, genre paintings focused on human foibles for the entertainment of patrons who felt themselves superior to the persons depicted.

Born in Durham, England, in 1853 Brown came to America, where at the National Academy of Design he completed his art education that he had begun in England and Scotland. To support himself, he worked in Brooklyn as a glassblower. Before long, he opened his own studio and was able to make a living with paintings of children, at first country girls and boys in idealized rural settings and later boys in urban street scenes. He specialized in images of bootblacks and vendors on crowded, dirty streets. In an era in which moral crusaders preached against urban poverty, patrons seemed to like Brown's paintings because the pictures denied the misery of urban urchins, attributing to them a jolly, carefree existence. Brown made a fortune by copyrighting his paintings and arranging for prints of them to be reproduced in the thousands. His tightly controlled painting style not only rewarded close looking for details but made the implied narratives of his pictures a natural for reproduction as lithographs.[1]

To escape the limits of his reputation for urban street scenes, a notoriety he had brought on himself, he escaped from time to time to the White Mountains of New Hampshire and areas of the Hudson River Valley to paint landscapes.

EJ

Norman Rockwell

American, 1894–1987
The Oculist, 1956

Oil on canvas, 33⅞ × 32 in.
Museum Purchase, 1957,
A934

1. Norman Rockwell to Bruce
Etchison, June 13, 1957,
WCMFA. Christopher Finch,
*Norman Rockwell: 332 Magazine
Covers* (New York: Abbeville
Press and Random House,
1979). Finch uses the variant
title *New Glasses*.
2. Bruce Etchison, interviewed
by Margaret Dameron, June
11, 2006.

Rockwell became one of America's best-loved artists on the basis of his illustrations for American magazine covers. He is best known for the 322 *Saturday Evening Post* covers he created between 1916 and 1963, the first of which he made at the age of twenty-two.

Some of Rockwell's most famous paintings represent the foibles of childhood, as this one showing a freckle-faced boy being fitted with a pair of glasses by an optician. While the optician maintains a good-natured appearance, the young boy's expression makes clear his disgust at the situation. With his baseball glove ready for action and a Brooklyn Dodgers baseball cap tucked into his belt, he would rather be on the baseball field than indoors.

The original painting, which first appeared on the cover of the May 19, 1956, issue of the *Saturday Evening Post*, demonstrates Rockwell's technical abilities in a way that is not easily conveyed in reproductions. The crisply defined edges of the office furniture place the viewer in the sterile office, and the careful modeling of the figures conveys their body language and facial expressions. Rockwell has used a flat paint application through most of the painting, but in the foreground, built-up paint on the floor adds texture and life.

The Museum acquired this painting in 1957, through Director Bruce Etchison's direct contact with the artist. In response to a letter from Etchison to Rockwell's dealer, Rockwell wrote, "I am very pleased to know that you would like one of my pictures. Your museum sounds like just the sort of place where I would like to be represented." Knowing that the Museum was able to offer only a fraction of the usual selling price for the painting, Rockwell continued, "Although I get kind of fat prices for my work, I would be very glad to sell you the Post Cover painting showing the boy being fitted for eye glasses. (Mr. Stuart said this was the one you were interested in)."[1] Etchison later reflected that he had inquired about *The Oculist* in particular because the boy reminded him of his own son.[2] That sentiment represents the reason so many Americans have embraced the works of Norman Rockwell: his subjects remind them of the people and places they know best.

MD

Severin Roesen
American, 1815–1872
Still Life

Oil on canvas, 10¾ × 13 in.
Signed lower right with
the tendrils of a grape
stem: Roesen
Museum purchase, 1961,
A1135

1. Judith Hansen O'Toole,
Severin Roesen (Lewisburg,
Pa.: Bucknell University Press,
1992) provides a detailed study
of the artist. For an earlier
chronology and bibliography,
see Lois Goldreich Marcus,
Severin Roesen: A Chronology
(Williamsport, Pa.: Lycoming
County Historical Society and
Museum, 1976).

Roesen came to the United States after the German
revolutions of 1848, bringing with him solid training
and indefatigable energy. Over the next twenty
years, traveling throughout the mid-Atlantic states,
he painted hundreds of carefully naturalistic still
lifes of fruits and flowers. He modeled his composi-
tions and fidelity to the shape, sheen, and color of
fruit on the Dutch techniques that he had learned in
his studies.

The best-known still-life artist of the middle
years of the century, Roesen exhibited in New York,
Brooklyn, Baltimore, and Philadelphia and
influenced a number of artists. Most of his works
have been found in Williamsport, Pennsylvania, but
he dated very few of them, so there is no precise
chronology of his prodigious output. His paintings
were typically quite large; they were popular
decorations for the spacious homes of patrons
newly wealthy after the Civil War.

Roesen's painting *Still Life* celebrates abundance.
On a small canvas various fruits nearly fill the pictorial
space: a stem of raspberries, several of which fall over
the table edge, stems of peaches and plums, a red
apple and a pale cantaloupe, and bunches of purple
and green grapes with their leaves. A glass of white
wine on the left provides a contrasting vertical line
and reflects light from an unseen window. Roesen,
never far from poverty, apparently painted very few of
his works from life; he rearranged images of favorite
fruits and flowers on the same veined gray marble
tabletop and often combined flowers that do not bloom
at the same time.[1]

EJ

Robert Spear Dunning

American, 1828-1905

Still Life in a Dining Room Interior, ca. 1875

Oil on canvas, 30 × 24 in.
Signed lower left: R. S.
Dunning/pinxt
Museum purchase, 1989,
A2628

1. For Dunning and his fellow
artists, see the exhibition
catalogue *The Fall River
School, 1853-1932* (Fall River,
Mass.: Greater Fall River Art
Association, 1970), cited in
William H. Gerdts, *Painters of
the Humble Truth: Masterpieces
of American Still Life, 1801-1937*
(Columbia: University of
Missouri Press; Tulsa, Okla.:
Philbrook Art Center, 1981), 116.

Dunning has given his still life an important role in
a fashionable Victorian dining room. Arranging
peaches, a pineapple, a cantaloupe, pomegranates
or plums, and three varieties of grapes on an orna-
mented silver tray in the foreground, he encourages
the viewer to note the room's profusion of comforts.
The tray sits on the dark surface of a table, the edge
of which shows fine carving, and rich drapes in the
left background admit light that reveals three large
paintings on the back wall: an oval still life of a dead
bird suspended vertically, a landscape featuring a
wide waterfall, and an expansive horizontal sea-
scape. A folding screen on the right, presumably
separating the room from a parlor, brings the eye
back to the foreground.

Dunning was born in Brunswick, Maine, but
raised in Fall River, Massachusetts. He studied in
New York City with the portraitist and history
painter Daniel Huntington (1816-1906). By 1852
Dunning was back in Fall River, where with fellow
artists he developed a regional school of still-life
painting that was remarkable in an industrial and
textile town. Although he also painted landscapes
and figural scenes, he was best known, and
cherished, for his depictions of fruits and flowers.
Over the years, Dunning exhibited in Boston, locally
in Fall River, and at the National Academy of Design
in New York. Evidently the artist's popularity
spread beyond American borders, for when the
Museum purchased the painting, it had been owned
until 1981 by a London dealer.[1]

EJ

John La Farge
American, 1835–1910
Bowl of Flowers

Watercolor, 10¼ × 13 in.
Gift of William Macbeth
Gallery, New York, New
York, 1951, A662

1. George Parsons Lathrop,
"John LaFarge," *Scribner's
Monthly Magazine* 21 (February
1881): 510; Kathleen A. Foster,
"The Still-Life Paintings of John
LaFarge," *American Art Journal*
11 (July 1979): 4–37.

La Farge painted still lifes only occasionally during a brilliant and versatile career, yet the delicate and poetic beauty of his floral pieces, especially those in watercolor, lead many to identify him as the greatest still-life painter in America. He was born in New York into a wealthy and educated family who saw to it that he had a classical education and traveled widely. After graduating from Mount St. Mary's College in Emmitsburg, Maryland, he read in the law and traveled to Europe. In Paris he studied painting with the Frenchman Thomas Couture (1815–1879), a teacher who emphasized painstaking technique, and then in Newport, Rhode Island, with William Morris Hunt (1824–1879), who employed a loose style and emphasized direct observation. At that point, La Farge decided to become an artist.

Throughout his life he was attracted to Japanese design and to color. During the 1860s, a peak time in the popularity of floral pieces in England and America and an era in which the water lily enjoyed great popularity, La Farge painted a number of water lilies in oil. Enthralled by color, he went on to design stained-glass windows, for which he developed brilliant opalescent color reminiscent of medieval stained glass. He produced murals for a number of churches, most prominently in 1873 for Trinity Church, Boston, and wrote articles and drew illustrations.

In the late 1870s he returned to floral pieces and began to paint them in watercolor. *Bowl of Flowers* reveals La Farge at his most poetic. The light blue bowl, partially filled with water, is set off center. The brilliantly colored peonies and chrysanthemums are seen both inside the bowl and thrusting up over the edge. The tabletop does nothing more than establish a flat surface, and the background is vague. Despite all of La Farge's achievements, it was the poetry of his floral pieces such as this one that attracted the praise of an early biographer in 1881, "In the painting of flowers he has a peculiar strength and delicacy…. The drawing [is] exquisite … the flowers are bathed, as they should be, in the dreamy light of their poetic quality."[1]

EJ

William Merritt Chase
American, 1849-1916
Fish, Plate, and Copper Container (Still Life)

Oil on canvas, 35 × 40 in.
Signed lower right:
William M. Chase
Museum purchase, 1969,
A1557

1. Duncan Phillips, "William M. Chase," *American Magazine of Art* 8 (December 1916): 49. For a recent study of Chase, see Barbara Gallati, *William Merritt Chase* (New York: Harry N. Abrams in association with the National Museum of American Art, Smithsonian Institution, 1995).

One of the most multifaceted artists in late-nineteenth-century America, Chase cultivated a bravura style in painting interiors, landscapes, portraits, and still lifes. He was born in Williamsburg, Indiana, but in 1861 his family moved to Indianapolis, where he began artistic study. Talented and ambitious, he moved to New York in 1869 to study at the National Academy of Design and began exhibiting in 1871. That year he visited St. Louis, where his family had moved, and patrons there supported the artist's studies at the Königliche Akademie in Munich from 1872 to 1878, where teachers emphasized the dark tonalities and brilliant brushwork of the seventeenth-century Dutch painter Frans Hals (1580-1666).

It was in Munich that Chase developed his signature style: a dark palette and visible, bold brushwork. After a trip to Venice in 1877 with fellow American artists Frank Duveneck (1848-1919) and John H. Twachtman (1853-1902), he returned to New York in 1878 and established his famous studio in the Tenth Street Studio Building. Filled with luxurious objects that he obtained on his travels, including trips to France and Spain in 1881, Chase used his studio to attract patrons and his objets d'art to fill his pictures. He became a sought-after teacher in his summer workshops at Shinnecock, Long Island, where he developed a light-filled Impressionist landscape style. He served as president of the Society of American Artists for more than ten years.

Fish, Plate, and Copper Container is a classic Chase "kitchen picture," painted in warm browns and reds with highlights of gold and silver. Working in the Dutch tradition of fish still lifes that required fast painting before the color of the fish scales faded, Chase often finished such a picture in two hours. He included favorite metal containers such as gleaming copper kettles and pewter or ceramic plates in these paintings whose solidity contrasted with the soft, organic forms of the fish. The Washington, D.C., collector Duncan Phillips praised Chase as "unequalled by any other painter in the representation of the shiny, slippery fishiness of fish."[1] A master of brushstroke that conveyed at once color, texture, and light, Chase painted an astonishing number of works–at least two thousand.

EJ

Edith McCartney

American, 1897-1981

Still Life–Blue Vase with Chinese Figurines, ca. 1930

Pastel, 35¼ × 25½ in.
Signed upper right: Edith
McCartney
Gift of Mr. Edward Tobey,
Washington, D.C., the
artist's husband, 1982,
A2187

This elegant still life reveals McCartney's debt to the Arts and Crafts movement, a late-nineteenth-century crusade that stressed the beauty of handcrafted work and subtle use of decoration. The ceramics in the painting, imported from China, offer a startling juxtaposition of scale–the vase looms over the human figures. The delicate flowers arc in space in a demonstration of the beauty achieved by a few, rather than many, branches. Because flowers, vase, and figurines are pushed forward by the varied gray background, the composition achieves a subtle balance.

Born in Boston, where she studied at the New School of Design and with Herman Dudley Murphy (1867-1945), a prominent painter of still life and landscape as well as a designer of frames, McCartney moved to Washington, D.C., in 1923. There she joined the Washington Water Color Club and the Georgetown Artists' Group and taught at the Art League. She exhibited actively in Washington with solo exhibitions at the Washington Art Center in 1924 and at the Washington Art Club in 1932 and 1940. Exhibiting also in New York and Boston and winning many awards, McCartney achieved her reputation as a pastelist, especially in her portraits of children. Among her famous sitters were the grandchildren of President and Mrs. Franklin D. Roosevelt.

EJ

William Glackens

American, 1870-1938

Bouquet in Blue Paper Wrapped Pot, ca. 1930-35

Oil on canvas,
19¼ × 12¼ in.
Gift of Mr. and Mrs. Ira
Glackens, Shepherdstown,
West Virginia, 1989, A2629

1. William H. Gerdts, with essay
by Jorge H. Santis, *William
Glackens* (Fort Lauderdale, Fla.:
Museum of Art; New York:
Abbeville Press, 1996) studies
the career of the artist.

Glackens began his career in Philadelphia as a newspaper illustrator and student of Robert Henri (1865-1929) at the Pennsylvania Academy of the Fine Arts. In 1896 he moved to New York, where he, Henri, and others formed the group of New York artists who would eventually become known as the Eight and the Ashcan School. As part of his studies, he traveled in France and Spain, finding the work of Pierre-Auguste Renoir (1841-1919) particularly inspiring.

When he returned to New York, Glackens took his subjects from the pleasures of middle- and upper-class life around Washington Square. Whereas Henri and George Luks (1866-1933) preferred immigrants for their themes, Glackens took pleasure in scenes of the comfortable classes enjoying cafés, theaters, shopping, picnics, and beaches. When the group of eight artists exhibited together at the Macbeth Gallery in 1908, the event that led to the sobriquet the Eight, Glackens was viewed as the most cosmopolitan among them. At ease in social situations, he helped organize the Armory Show of 1913, which introduced New Yorkers (and later, viewers in Chicago and Boston) to European modernist works, and in 1917 he was elected the first president of the Society of Independent Artists.[1]

In the late 1920s, attracted by the influx of European art to the experiments of the Cubists in flattening space and emphasizing pattern, Glackens turned away from social scenes. *Bouquet in Blue Paper Wrapped Pot*, with its tilted-up background and emphasis on color and pattern, shows his tentative engagement with the process of abstraction.

EJ

Thomas Birch
American, 1779–1851
The Shipwreck, 1837

Oil on canvas, 40 × 60 in.
Signed and dated lower
center: Thomas Birch,
Philadelphia, 1837
Museum purchase, 1964,
A1318

1. The painting was exhibited
at the Philadelphia Museum
of Art in *Three Centuries of
American Art*, 1976. For a
study of Birch in the context
of other marine painters, see
John Wilmerding, *A History
of American Marine Painting*
(Salem, Mass.: Peabody
Museum of Salem, 1968; repr.
New York: Harry N. Abrams,
1987), 74–82.

In its heightened drama, *The Shipwreck* reveals the marine painter Birch at his most effective. Artists in the Netherlands had developed the seascape as a favorite subject in the seventeenth century, focusing on harbors and ships, battle scenes and stormy weather. During the mid-eighteenth century the French artist Joseph Vernet (1714–1789), living in Italy, established a reputation as a marine painter of nature in all her moods, including stormy coastal scenes. During that period English painters, as a result of travels on the Continent, took up marine painting. They depicted with detail and national pride shipyards, the River Thames, and sailing ships. The destructive power of wind and weather became a favorite Romantic topic in such paintings as *The Shipwreck* (1805; Tate, London) by J. M. W. Turner (1775–1851). "The Shipwreck," a popular poem by William Falconer published in England in 1762, inspired many paintings, including some that were commissioned by shipwreck survivors.

Birch's father, William (1755–1834), a painter and engraver, brought this interest in marine painting to the United States when he immigrated in 1794 with his family, which included Thomas. Settling in Philadelphia, father and son developed their reputation with cityscapes and views of country estates along the Schuylkill River, many of which became prints. Thomas Birch then concentrated on landscapes, the most accomplished of which are those of Point Breeze, New Jersey, the country seat of Joseph Bonaparte (1768–1844). Bonaparte's collection of old masters and contemporary European works was a great attraction for Birch and other American painters.

Birch turned to marine painting during the War of 1812 with Britain, which provided him with naval engagements as subjects. With scrupulous accuracy he painted shipping on the Delaware River and activity in New York Harbor. Stormy coasts, in the tradition of Vernet and Turner, became a favorite topic. In this large painting, the situation for the three shipwrecked sailors is dire. Two grasp a mast that has separated from the distant foundering ship, and a third, in red, clings to a rock on shore. The sea somersaults toward the shore, with a cliff of overhanging rocks on the left suggesting the inhospitable area at which the sailors have washed up. In the middle distance, brown designates the reef that has disabled the sinking ship. Three white birds circling the wreck provide dashes of white like those in the vigorous sea.[1]
EJ

Thomas Cole

American, 1801–1848

Study for "The Voyage of Life: Childhood"

Oil on canvas,
12½ × 13½ in.
Museum purchase from
William Macbeth, Inc.,
New York, New York, 1953,
A756

1. The complete chronology of
Cole's work on *The Voyage of
Life* is given in Paul Schweizer,
*"The Voyage of Life" by Thomas
Cole: Paintings, Drawings and
Prints* (Utica, N.Y.: Munson-
Williams-Proctor Institute,
Museum of Art, 1985), esp.
3, 4, 30–32. Cole's tracings
from his original *The Voyage*

Although born in England, Cole became the most
influential American landscape painter before 1850.
The American public admired both his realistic
views of nature and his allegorical works with land-
scape settings. Cole's art helped to establish na-
tional pride in the American wilderness and opened
the way for his student Frederic Edwin Church
(1826–1900) and the other artists known as the Hud-
son River School.

The series *The Voyage of Life*, depicting human
life as a journey down a river, exemplifies Cole's
allegorical productions. *Childhood*, for which this
painting is a study, begins the series with the
traveler as a happy baby in a gilded vessel guided
by a guardian angel between riverbanks laden with
spring flowers. The series continues with *Youth*, in
which a young man steers his own boat toward a

fabulous castle-in-the-air; in *Manhood* the harried
traveler struggles to navigate a rocky, storm-tossed
river; at last, in *Old Age* an angel guides the now
aged man through the shadows of night toward the
light of heaven.

Cole painted *The Voyage of Life* in 1839 for the
New York banker Samuel Ward, who wanted to
hang it in his personal picture gallery as a moral
example for his daughter Julia Ward (later Howe).
When Ward died late in 1839, the paintings were not
finished, but his heirs paid Cole to complete the
commission in 1840. The artist, eager to continue
exhibiting the series after he surrendered the works
to the Ward family, wanted to paint a second ver-
sion. Beginning in November 1840 Cole traced the
original paintings and executed oil studies of the
figures, including this depiction of the figures and
boat in *Childhood*.[1] He took these studies on his 1841
trip to Europe and completed the second version of
The Voyage of Life in Rome in April 1842 (fig.). He
exhibited the series widely before selling it.[2]

This study for *Childhood* appeared with Cole's
other studies for the series in the exhibition *"The
Voyage of Life" by Thomas Cole: Paintings, Drawings
and Prints*, at the Art Museum of the Munson-
Williams-Proctor Institute, Utica, New York, held
from October 5 to December 15, 1985.

APW

left
Thomas Cole, *The Voyage of Life:
Childhood*, 1842. National Gallery
of Art, purchased through the Ailsa
Mellon Bruce Fund

of Life paintings, including the tracing from which the WCMFA's oil study was made, are now in the collection of the Detroit Institute of Arts. Paul D. Schweizer, "*The Voyage of Life*: A Chronology," in ibid., 23–25, 27. The original series of *The Voyage of Life* is in the collection of the Munson-Williams-Proctor Institute, Utica, New York. The second version of the series is in the collection of the National Gallery of Art, Washington, D.C.

2. Cole sold the series to the Cincinnati art collector George K. Shoenberger in 1845 or 1846. Franklin Kelly, with Nicolai Cikovsky Jr., Deborah Chotner, and John Davis, *American Paintings of the Nineteenth Century, Part 1*, The Collections of the National Gallery of Art Systematic Catalogue (Washington, D.C.: National Gallery of Art, 1996), 96.

Frederic Edwin Church

American, 1826–1900

*Scene on the Catskill Creek,
New York*, 1847

Oil on canvas,
21½ × 29¾ in.
Signed and dated lower
right: F. Church 1847
Museum Purchase, 1962,
A1230

1. Franklin Kelly, with
Stephen Jay Gould, James
Anthony Ryan, and Debora
Rindge, *Frederic Edwin Church*
(Washington, D.C.: National
Gallery of Art, 1989).

Church was among the earliest artists after Thomas Cole (1801–1848) to dramatize the beauty of the American landscape. Before Cole, American landscapists in the late eighteenth and early nineteenth centuries had made "estate" paintings, following British precedents by picturing the mansions and surrounding property of successful settlers. Other artists, also following European practice, had made "views" of such natural wonders as Niagara Falls. With the rise of tourism to upstate New York and New England in the 1820s and tourists' demand for pictures of favorite sites, Cole, Church, and others took the wilderness itself as their subjects. Church, born in Hartford, Connecticut, to a wealthy family who encouraged his talent, studied with Cole from 1844 to 1846. Believed to be Cole's only student, Church absorbed from him a reverence for the American wilderness. He was precocious in his technique and imagination, taking a studio in New York at age twenty and elected an academician of the National Academy of Design two years later.

Scene on the Catskill Creek, New York reveals his ability to guide the viewer through every aspect of the picture. A tree on the right, its dark bark and leaves depicted in minute detail, rises beyond the top of the painting, helping to create depth. Seemingly from behind it, pink light pours across the painting, filling the clouds that appear to be moving leftward and, in the near foreground, reflecting off a large rock and a downed tree branch. Ripples in the creek break the late-day stillness of the image.

Traveling throughout New England and New York, Church visited Niagara Falls several times and made an early reputation with his *Niagara*

(1857; Corcoran Gallery of Art, Washington, D.C.). Intrigued by the descriptions of South America in scientist Alexander von Humboldt's (1769–1859) *Cosmos: Sketch of a Physical Description of the Universe*, translated into English in 1849, Church visited the Andes of Colombia and Ecuador in the early 1850s and secured his reputation with large, dramatic canvases celebrating the grandeur of nature, of which *Heart of the Andes* (1858; The Metropolitan Museum of Art, New York) remains, along with *Niagara*, one of his best-known works. He continued his travels, visiting Newfoundland and Labrador to satisfy his curiosity about the Arctic regions and, after the Civil War, Greece, North Africa, and the Near East. Enthusiastic critics urged viewers to bring opera glasses to see his pictures so that they would not miss the many tiny details that he included.

Church eventually settled in Hudson, New York, with his family, building and continually adding on to a Persian-influenced villa that he called Olana. The house is now a state historic site. Although he painted landscapes from travels beyond the United States, Church is considered to be the quintessential Hudson River School painter, having been among the earliest artists to call attention to the glory of the American wilderness.[1]

EJ

153

Albert Bierstadt
American, 1830–1902
In the Rockies

Oil on paper, 12½ × 17½ in.
Signed lower right:
Bierstadt
Purchased with funds from
The Elsa Emma Pangborn
Fund, 1953, A734

1. Nancy K. Anderson and Linda
S. Ferber, *Albert Bierstadt:
Art and Enterprise* (New York:
Hudson Hills Press, 1991).

Born in Solingen in the Rhineland, Bierstadt was brought to New Bedford, Massachusetts, in 1832 by his parents. Self-taught and ambitious, he traveled to Düsseldorf, Germany, to study but learned on arriving that the teacher he had hoped to study with (Johann Peter Hasenclever [1810–1853]) had died. However, two American artists stepped forward to mentor him: Emanuel Leutze (1816–1868) and Worthington Whittredge (1820–1910). After three years of study, Bierstadt and Whittredge embarked on a sketching tour through Germany, Switzerland, and Italy, after which Bierstadt returned to New Bedford. Technically proficient, with a portfolio of sketches of the Swiss Alps for large pictures that he soon exhibited in New York, Bierstadt was poised for success in painting the American West.

Although artists early in the century had accompanied adventurers and surveyors on their trips west, Bierstadt was the first to use his western sketches to make large exhibition pictures. In 1859 he joined the survey team of Colonel Frederick West Lander (1822–1862), which traveled to the South Pass region of Wyoming, a point on the Continental Divide that was to become an alternative passage for emigrants on the Oregon Trail. There, Bierstadt made oil sketches he would use for the rest of his life, along with stereoscopic photographs of native Americans, emigrants, and the survey party. *In the Rockies* would seem to have been made at this time, then placed with many others into his traveling gear to take back to New York. His most well-known finished picture of his experience in the Rockies is *The Rocky Mountains, Lander's Peak* (1863; The Metropolitan Museum of Art, New York).

Bierstadt continued to travel in the West, visiting Yosemite, Yellowstone, Alaska, and the Canadian Rockies. Detailed and large, his paintings featuring waterfalls, snow-covered mountains, buffalo, native Americans, and plateaus represented for many the theme of Manifest Destiny—which held that Americans were chosen by God to settle the great West. By the 1870s, however, his realistic, panoramic pictures (called by some "bombastic") had gone out of style, replaced by small, intimate, and softly brushed pictures that called for poetic taste in interpreting them. He died a disappointed man.[1]

EJ

John Frederick Kensett

American, 1816-1872

A Mountain Pool, 1863

Oil on canvas, 30 × 22 in.
Signed and dated lower
left: FK '63
Museum purchase, 1968,
A1542

1. John Howat, "John F. Kensett,
1816-1872," *Magazine Antiques*,
September 1969, 397.
2. John Paul Driscoll and
John K. Howat, *John Frederick
Kensett: An American Master*
(Worcester, Mass.: Worcester
Art Museum in association
with W. W. Norton & Company,
1985); and Rebecca Bedell, *The
Anatomy of Nature: Geology and
American Landscape Painting,
1825-1875* (Princeton: Princeton
University Press, 2001).

One of the generation of landscapists known as the Hudson River School because they celebrated the scenery on and near New York's Hudson River, Kensett was the son of an engraver who trained him in a graphic approach to image making. He spent his early years helping his father, engraving labels, cards, and maps. In his twenties, a colleague encouraged him to try painting landscape. Kensett exhibited his first such work at the National Academy of Design in 1838 and by 1840 had decided on a career as a landscapist. For the next eight years, he studied and traveled in Paris, Rome, London, and along the Rhine and was especially attracted to the countryside of England. He later recalled, "My real life commenced there, in the study of the stately woods of Windsor, and the famous beeches of Burnham, and the lovely and fascinating landscape that surrounds them."[1]

On his return to the United States, he spent his summers walking and riding through the Adirondacks, Catskills, Berkshires, Green and White Mountains, along the Shrewsbury River in New Jersey, and, later, around Newport, Rhode Island. During the winters he worked his sketches into delicately colored and finely detailed paintings.

A Mountain Pool reveals Kensett's appeal to his many patrons. It seems to be topographical, a category buyers wanted: the scene seems to be the cliffs of North Conway, New Hampshire, a popular tourist destination. In a vertical format, Kensett suggests an evening in early fall. Visible in the middle distance between the large dark cliffs in the foreground, water falls down to a pool. Mist rises in the foreground, and across the sky, pink clouds move quietly above a mountain glowing with the last light of day. On a path on the left-hand cliff, a tiny figure in red makes his way into the depths of the picture. Thin layers of paint suggest the quick-changing mood of early evening.

Kensett regularly visited the favorite spots of tourists for his subjects, depending on their recognizing the scene so that they would purchase his pictures. A favorite among other artists, Kensett was active in the Sketch Club and president of the Artists' Fund Society, which benefited widows and children of deceased artists.[2]

EJ

William Stanley Haseltine

American, 1835-1900
Nahant Rocks, New England, 1864

Oil on canvas, 17 × 29 in.
Signed and dated lower
right: W. S. Haseltine,
N.Y. '64
Gift of Mrs. Helen Haseltine
Plowden, London, England,
1961, A1140

1. Rebecca Bedell, *The Anatomy
of Nature: Geology and
American Landscape Painting,
1825-1875* (Princeton: Princeton
University Press, 2001), 109.
2. Ibid., 119, which also
reproduces the Museum's
painting.
3. Helen Haseltine Plowden,
*William Stanley Haseltine:
Sea and Landscape Painting
(1835-1900)* (London: F. Muller,
1947), 81.

Haseltine painted *Nahant Rocks, New England* dur-
ing one of his many trips along the Massachusetts
and New Hampshire coasts. Having begun his stud-
ies in his native Philadelphia, Haseltine graduated
from Harvard College in 1854 and left immediately
for Düsseldorf, Germany, where for two years he
learned careful draftsmanship and strong design. It
was in Germany that he became close friends with
Albert Bierstadt (1830-1902) and Worthington Whit-
tredge (1820-1910), both of whom were to become
major American landscapists in the 1850s and
1860s. Like them, Haseltine returned to the United
States to pursue his career.

In *Nahant Rocks, New England*, Haseltine has
presented a startlingly realistic depiction of the
rocks along a peninsula in the Massachusetts Bay
north of Boston. He was so intrigued with the site
that during the mid-1860s he painted more than
sixteen pictures of it.[1] The gigantic rocks, strong in
their diagonal thrust, are given scale by the tiny
human figures in the distance. That Haseltine's
focus was the smooth-topped igneous rocks rather
than the sea or sky suggests his interest in the
geological studies of the professor-scientist Louis
Agassiz (1807-1873), who was on the Harvard
faculty during Haseltine's student years. Attentive
to the recent discoveries of geology, Haseltine told
his friends, "Every real artist is also a scientist."[2]
Agassiz was an anti-Darwinian who believed that
nature pointed directly to God, and he theorized
that in an early universal ice age glaciers had
sculpted the land; his theories of direct creation
were radically challenged by the evolutionary
studies of Charles Darwin (1809-1882).

An encomium by his friend Whittredge at
Haseltine's death could describe this very painting:
I should sum up Haseltine's excellencies as an
artist, with three phrases: he was, from the
beginning, a superior draughtsman; he is a good
colourist; and he has sentiment coupled, in an
unusual degree, with strength and frank
expression. His pictures can always be
understood; they have a largeness and grandeur
in form with agreeable masses of light and shade
not often met with.[3]

EJ

James Fairman
American, 1826-1904
Songo River, Maine, 1865

Oil on canvas,
13¼ × 21¼ in.
Signed and dated lower
left with initials in
ligature: JF'65
Inscribed on the reverse:
Songo Lake, near Bethel,
Md. / JAS. FAIRMAN / New
York 1865
Gift of Dr. Richard D.
Robbins, Baltimore,
Maryland, in memory
of Mrs. Betty Sumner
Michael, 1995, A3082

Born in Glasgow, Scotland, Fairman came to the United States with his parents when he was six. He began studies at the National Academy of Design in New York in 1842 and first exhibited drawings two years later at the American Institute. After serving in the Civil War for two years, he established a studio in New York City. From there, he traveled throughout New England, painting landscapes that appealed to residents and tourists alike. He is often identified with the White Mountain School because of the number of landscapes he painted in that area of New Hampshire. Critics have sometimes labeled his style, along with that of John Frederick Kensett (1816-1872) and others, "Luminist" because of the glow that seems to emanate from his canvases.

Such a quality can be seen in *Songo River, Maine.* Hovering over a low horizon, the sun radiates warm light through clusters of pink-tinged clouds, both above and below. The water in the middle of the picture–a river that connects Sebago Lake to Brandy Pond–reflects a golden light; precise brushstrokes depict ripples near the marshy foreground. Trees on the hills, left and right, enclose the central lake on which two figures occupy a dugout canoe, one dressed in red. Across the body of water small houses hug the land and tiny figures go about their chores. Painted in thin, fluid color, the canvas has few touches of impasto (three-dimensional areas of paint), so that it looks almost as though it had been created without human hand.

Fairman traveled throughout England, France, Italy, Germany, and the Holy Land from 1871 until the early 1880s. After his return, he taught on the faculty of Olivet College in Michigan and became a prominent critic and lecturer.

EJ

Jasper F. Cropsey
American, 1823–1900
Autumn Landscape with View of River, 1870

Oil on canvas, 17½ × 36 in.
Signed and dated lower
left: J. F. Cropsey, 1870
Museum purchase, 1955,
A828

1. Curated by William S. Talbot,
the exhibition traveled to the
Cleveland Museum of Art,
the Munson-Williams-Proctor
Institute, in Utica, New York,
and the National Collection
of Fine Arts, Washington,
D.C. (now the Smithsonian
American Art Museum).

An artist known primarily for his scenes of the brilliant American autumn, Cropsey enjoyed a reputation in both the United States and England. His *Autumn Landscape with View of River* is typical of the fall scenes that pleased his patrons, particularly those in England who were unfamiliar with the deep reds of American maples. In this painting, we see the distant, sinking sun, almost precisely in the middle of the picture, sending its golden light across the sky and onto the river below. As viewers, we assume the peace enjoyed by the two hunters seated with their dog looking out over the valley, our view framed on the left by white-barked birches and an ancient green hemlock and on the right by a cliff, rocks, and scattered shrubs. Near us on the left a small campfire sends out an orange glow–a crisp detail typical of Cropsey. Completing the serenity of the scene are the pinks on the lower edge of the clouds irradiated by the setting sun. A number of American painters chose autumn as their favorite season for landscapes, not only because of the spectacular beauty of the fall colors but also because the season suggested the gradual dying of the American wilderness.

Known as a second-generation Hudson River School painter because he followed those who had established an interest in the landscape of the region, Cropsey admired Thomas Cole (1801–1848). During his studies abroad in the late 1840s, he actually lived in the studio that Cole had occupied in Rome. In the United States, Cropsey painted scenes along the Hudson River, the Wyoming Valley in Pennsylvania, the White Mountains in New Hampshire, and the Greenwood Lake area of New Jersey.

Born on Staten Island, as a young man Cropsey first studied architecture, discovering a penchant for landscape painting while practicing as an architect. When the patronage for painting fell during the Civil War, he designed several important buildings. Disturbed by the implications of the war, he painted a number of allegorical pictures.

This painting went on tour in 1970 in the exhibition *Jasper F. Cropsey, 1823–1900*.[1]
EJ

Hugh Bolton Jones

American, 1848–1927
Pool in the Meadow, 1875

Oil on canvas, 16 × 20 in.
Signed and dated lower
left: H. Bolton Jones 1875
Gift of Mrs. Florence
H. Trupp, Baltimore,
Maryland, 1982, A2195

An artist particularly associated with pastoral land-scapes in Maryland and New Jersey, Jones was born in Baltimore and studied at the Maryland Institute of Art. In 1865 he began studies in New York City with the landscapist Horace Wolcott Robbins (1842–1904) and within two years was exhibiting at the National Academy of Design.

Having decided that landscape was his forte, he traveled throughout Maryland and West Virginia and as far north as the Berkshires in western Massachusetts. In his stylistic choices, he was influenced by the devotion to detail of artists of the Hudson River School, who had been ascendant during the years of his studies.

Pool in the Meadow reveals Jones's mastery of delicate brushwork to render a specific scene. Throughout the foreground and middle ground of this landscape, cattle drink from the sparkling pool and graze in the wildflower-dotted meadow. With their shapes reflected in the foreground wa-ter, they are rendered so specifically that one can imagine the owner identifying each one. In the depth of the scene is a distant cottage, smoke drift-ing from its chimney. Clouds fill the sky, leaving occasional patches of blue. The sky and most of the painting beyond the foreground are painted with a matte, or non-glossy, surface, suggesting the hu-mid heat of midday.

From 1876 to 1880 Jones traveled in Europe, accompanied by his brother, the genre painter Francis Coates Jones (1857–1932). They visited Pont-Aven, in Brittany, where they painted with the American painter Thomas Hovenden (1840–1895) and where Jones learned to paint in outdoor light

(*en plein air*). The two also visited Paris, Italy, and Switzerland.

Jones returned to the United States in 1880, establishing a studio in New York. Thereafter, his landscapes emphasized the time of day and the season and featured the softer style of the Barbizon artists of France. Recognized by critics and fellow artists, he was elected to the National Academy of Design in 1893 as an associate. He exhibited at the world's expositions in Paris in 1889 and 1900 and in St. Louis in 1904 and won awards at all three.

EJ

James E. Buttersworth

American, 1817-1894

Puritan and Priscilla off Sandy Hook

Oil on panel, 12 × 18 in.
Gift of Mr. Sidney A. Levyne,
Pikesville, Maryland, 1966,
AI473

1. Helen Comstock, "Marine
Paintings by Two Buttersworths,"
Magazine Antiques 85 (January
1964): 99-103; Richard
B. Grassby, "The Marine
Paintings of James Edward
Buttersworth," *Magazine
Antiques* 146 (July 1994): 62-69;
and John Wilmerding, *A History
of American Marine Painting*
(Salem, Mass.: Peabody Museum
of Salem, 1968; repr. New York:
Harry N. Abrams, 1987), 146-47.

Born on the Isle of Wight, England, Buttersworth came to New York about 1845.[1] He was a superb draftsman, fascinated by yachts, clipper ships, and, later, steamships. He achieved such fame with his accurate depictions of ships that after 1850 the lithographic firm Currier and Ives based most of its marine prints on Buttersworth's oil paintings. He worked on a small scale, almost like a miniaturist using delicate brushes sometimes of only two hairs.

His talent coincided with the era of the clipper ship, the fastest sailing vessel at the time and beloved by many as the most beautiful. The speed records of clipper ships on their routes from Boston to New York and San Francisco made newspaper headlines, and Buttersworth painted the "portraits" of many of them. With minute detail, he depicted rigging and sails. To convey the ships' control of the seas, he delineated precisely measured waves even when the sails strained at their rigging with the force of the winds. When clipper ships were eclipsed by steamships, Buttersworth shifted to pictures of yacht racing, a sport indulged in by the wealthy. A popular location for these races was along the New Jersey shore, with the Sandy Hook Light providing a convenient observation post.

Racing over the pale green seas, the vessels in Buttersworth's painting lean toward their destination. The artist's suggestion of light, air, and movement is impeccable.

EJ

Thomas Moran

American, 1837-1926

Lower Manhattan from Communipaw, New Jersey, 1880

Oil on canvas,
25³/₁₆ × 45¼ in.
Museum Purchase, 1940,
A303

1. *Bolton Evening News*,
Thursday, June 15, 1882, quoted
in Nancy K. Anderson, with
contributions by Thomas P.
Bruhn, Joni L. Kinsey, and
Anne Morand, *Thomas Moran*
(Washington, D.C.: National
Gallery of Art, 1997), 115, cat.
58.

Like many other artists whose works are in the Museum collection, Moran was brought to the United States as a youngster by parents who had been displaced by the industrial revolution. Leaving Bolton, Lancashire, England, Moran's family settled near Philadelphia. The young artist apprenticed to a wood-engraving firm when he was sixteen and was soon sharing a studio with his brother Edward, a marine painter. Thomas was intrigued by the American West and in 1860 began his first trip to the American frontier, visiting Lake Superior. He used his sketches from that trip, as well as from subsequent journeys, throughout his career. The next year he went to England, where he copied the paintings and watercolors of J. M. W. Turner (1775-1851) at the National Gallery, astonished by the color. Turner was to be a lifelong inspiration for Moran, and in 1872 the American went to Venice to see for himself the source of Turner's great Venetian landscapes.

Although the American West was to become Moran's favorite subject, he also painted landscapes of the American East Coast, particularly around New York, where he moved in 1872. *Lower Manhattan from Communipaw, New Jersey* shows Moran's vision of the city and the technique that supported it. Using a variety of techniques including blending wet paint into wet, creating highlights with thin scumblings of opaque paint (placing opaque color over transparent color), and glazing repeatedly to achieve deep shadows, he suggested the grit of the foreground, the reflections on the river surface, and the smoke over the city skyline. The painting surveys the broad scope of human activity from the man in a red vest in the left foreground to the machinery in the middle ground to the industrial pollution over the skyline. To prepare for the painting, he made a small pencil drawing of Communipaw that is also in the Museum collection (A403).

His reputation established, Moran arranged for his work to be exhibited in his birthplace of Bolton, England, in 1882. A critic for the *Bolton Evening News* reviewed *Lower Manhattan from Communipaw* with enthusiasm, describing it as

full of exquisitely rendered details … the silvery greys in which it is painted render it peculiarly refreshing to the eye …. Notice the unpromising foreground material of this picture, from which most artists would have turned in contempt. The rendering of the distance and shipping is peculiarly tender and beautiful.[1]

Audiences at the WCMFA agreed with this commendation, choosing in 1940 to purchase this painting among five offered as the first painting to enter the collection by purchase.

EJ

Arthur Bowen Davies
American, 1862–1928
Horizons, ca. 1906

Oil on canvas, 18 × 40 in.
Signed lower left: Arthur
Bowen Davies
Museum purchase 1975,
A1825

1. Bennard B. Perlman, *The
Lives, Loves, and Art of Arthur
B. Davies* (Albany, N.Y.: State
University of New York Press,
1998); and Milton W. Brown,
*American Painting from the
Armory Show to the Depression*
(Princeton: Princeton
University Press, 1955).

A quintessential Romantic who helped foster modern art in America, Davies was born in Utica, New York. His family moved to Chicago when he was sixteen, making it possible for him to study at the School of the Art Institute there. By 1887 he was in New York City, studying at the Art Students League and earning his living as a magazine illustrator. He became friends with George Luks (1866-1933) and Robert Henri (1865-1929) and took a studio over the Macbeth Gallery. Shortly thereafter his first trip to Europe gave him models that were to serve him for the rest of his life: the shadowy allegories of the French painter Pierre Puvis de Chavannes (1824-1898) and the decorative figures of American expatriate James McNeill Whistler (1834-1903).

Horizons, like Davies's other paintings, radiates mystery. The Museum painting suggests a landscape of dreams. The viewer floats in the atmosphere, not grounded and not quite sure what is in the distance—whether snowcapped mountains or low, full clouds. Davies's choice of colors—deep green, yellow, and blues, in addition to the white at the horizon—adds to the unreality of the scene. Many of his paintings feature a single figure, typically female, whose presence in the landscape alludes to myths and Arcadian dreams.

A man of broad tastes in the art of others, Davies joined with painters represented by William Macbeth, including Luks, Henri, and William Glackens (1870-1938), in an exhibition in 1908 of scenes of urban life. The exhibition led critics to call the group "urban realists" or "the Ashcan School" and the artists "the Eight"; characteristically, Davies exhibited his usual Romantic fantasies.

Respected by others for his cosmopolitanism, he was elected president of the Society of Independent Artists in 1912, a group that protested the conservative exhibition practices of the National Academy of Design. With Davies at the helm, the society planned *The International Exhibition of Modern Art* in 1913, which came to be known as the Armory Show. For this exhibition Davies and colleagues traveled to major art centers in Europe, borrowing works of art in order to introduce American artists and audiences to Cubism, Futurism, and other modernist styles. Ironically, Davies did not become a modernist himself beyond a brief infatuation with Cubism. He continued to work in a variety of media, including murals, tapestry designs, lithographs, and etching.[1]

EJ

Edward J. Steichen
American, 1879-1973
Yellow Moon, 1909

Oil on canvas, 24 × 25 in.
Gift of Mrs. Conger
Goodyear, Westbury, New
York, 1953, A736

1. The artist was baptized
Éduard Jean Steichen. After
World War I he changed
the spelling of his first
name to Edward. Penelope
Niven, *Steichen: A Biography*
(New York: Clarkson Potter
Publishers, 1997), 66.
2. Edward Steichen, *A Life
in Photography: Edward
Steichen* (Garden City, N.Y.:
Doubleday & Company, 1963),
unpaginated.

Steichen[1] is now best known as a photographer, but for twenty years he divided his creativity between photography and painting. *Yellow Moon* is a rare survival from those early years of painting.

Steichen began his artistic career as an apprentice lithographer in Milwaukee, Wisconsin. The teenager was soon drawing and making photographs for advertisements. After hours, Steichen and some friends started a painting class taught by local artists. Steichen often rode the streetcar out of town to paint and photograph, explaining, "The romantic and mysterious quality of moonlight, the lyric aspect of nature made the strongest appeal to me."[2] His paintings and photographs of woodland landscapes, often seen in moonlight, were atmospheric studies in mood rather than detailed depictions of sites.

In 1900 Steichen traveled to Paris to study art, but he quickly grew impatient with academic instruction. The young artist preferred to work with the Pictorial photography movement that strove to establish photography as fine art. In 1902 Steichen, in need of money, returned to the United States to start a portrait photography studio in New York City. There he collaborated with the photographer Alfred Stieglitz (1864-1946) to found a Pictorialist organization they called the Photo-Secession.

In 1908 Steichen, now married and with a young daughter, returned to France. The family split their time between an apartment in Paris and a house in rural Voulangis. Steichen was fascinated by the modern art he saw in Paris; he arranged exhibitions of drawings by such French modernists as Auguste Rodin (1840-1917) and Henri Matisse (1869-1954)

for Stieglitz's gallery in New York. Matisse's vivid colors particularly impressed Steichen, who in works like *Yellow Moon* brought greater brilliance to his formerly gray, misty landscapes.

Each year Steichen painted and photographed in France for most of the year, then after Christmas took his works to the United States for exhibition and sale. *Yellow Moon* was one of many paintings he made during the summer and autumn of 1909. In January 1910 the Montross Gallery in New York exhibited Steichen's photographs and thirty-one of his paintings, probably including *Yellow Moon*. The exhibition drew enthusiastic critical response, securing Steichen's reputation as a painter.

However, traumatic experiences during World War I caused Steichen to abandon painting as unsuited to the harsh postwar world. In 1922, in his garden at Voulangis, he burned all of his paintings. Only those that had already left his hands, like *Yellow Moon*, survive. Thereafter, Steichen devoted himself to photography. He earned a high reputation as a portraitist and commercial photographer as well as a creative modernist and a curator of photography.

APW

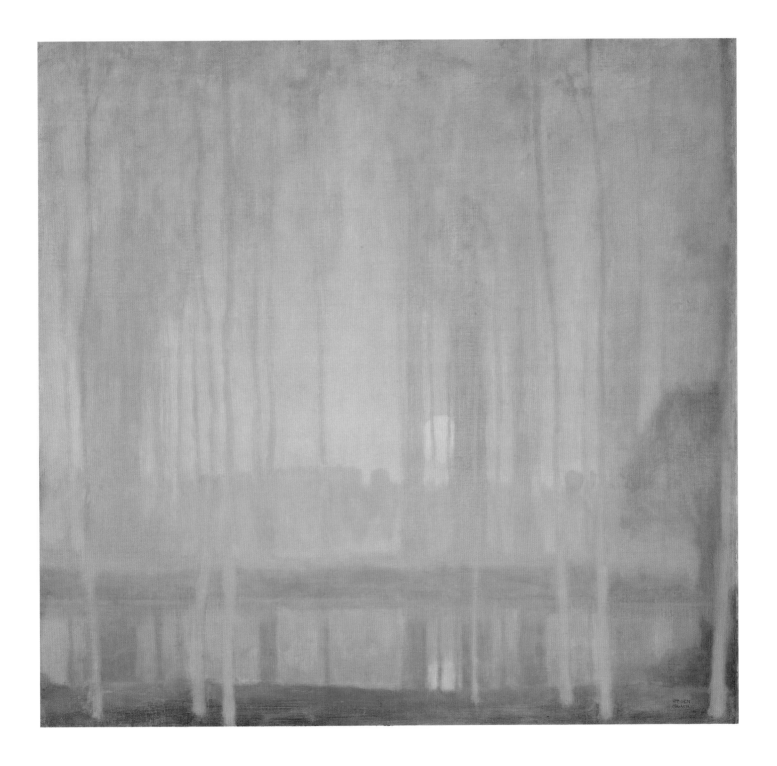

Thomas Moran

American, 1837–1926

Grand Canyon of Arizona from Hermit Rim Road

Lithograph, 32 × 38 in.
Signed lower left: TYM
Published by American
Lithographic Co., New
York; copyright 1913 by
the Atchison, Topeka, and
Santa Fe Railway System
Gift of Spence and Cinda
Perry, Hagerstown,
Maryland, in honor
of the Museum's 75th
anniversary, 2005, A4030

1. Quoted in Rebecca Bedell,
*The Anatomy of Nature: Geology
and American Landscape
Painting, 1825–1875* (Princeton:
Princeton University Press,
2001), 128; and see Joni
Kinsey, *Thomas Moran and the
Surveying of the American West*
(Washington, D.C.: Smithsonian
Institution Press, 1992).

Moran is best known for his spectacular views of the American West. His pictures of Yellowstone and the Grand Canyon helped convince Congress to establish the national park system. Moran followed the lead of his older brother Edward to become a painter; attracted to landscape, they first sketched in the forests around Philadelphia. Not until 1871 did Moran make his first trip west of the Mississippi River; encountering Yellowstone, he realized that he had found a new, major subject for pictures. That year he joined the government surveyor and geologist Ferdinand V. Hayden (1829–1887) in mapping the Yellowstone region and made sketches that would serve him the rest of his career. The United States Congress secured Moran's reputation in 1872 when it bought his large painting *The Grand Canyon of the Yellowstone* for $10,000 and displayed it in the nation's Capitol. Thereafter, Moran encouraged the nickname "Tom 'Yellowstone' Moran" and devised a three-letter monogram TYM with which he signed his work.

Moran traveled frequently to the West, visiting Yosemite in 1872 and accompanying Major John Wesley Powell (1834–1902) to the Rocky Mountain region in 1873 (during which the survey team saw the mountains of Utah and the Grand Canyon). In subsequent years, he accompanied survey trips to Colorado, Donner Pass and Lake Tahoe in the Sierra Nevada, and the Teton Mountains of Wyoming. He also traveled abroad extensively, visiting England, Scotland, Italy, and Mexico.

After Moran's wife died in 1900, he went frequently to the Grand Canyon with his daughter Ruth, often staying for the winter in hotel accommodations paid for by the railroad company.

The images were lithographed by railroad companies for advertisement, as was this one; others advertised hotels, graced calendars, and were even printed on stationery. The Atchison, Topeka, and Santa Fe Railway System, which traveled from Chicago to San Francisco by way of New Mexico and Arizona, sponsored this lithograph, boasting that its railway was the only direct way to reach the Grand Canyon. Moran insisted that his pictures of the canyon had the realism of science. "In painting the Grand Canyon of the Colorado and its wonderful color scheme," he told reporters, "I have to be full of my subject … I must know the geology. I must know the rocks and the trees and the atmosphere and the mountain torrents and the birds that fly in the ether above me."[1]

Moran continued to travel to Europe in his old age but claimed to the last that the European Alps were nothing compared with the great beauty of the American Rockies, to which he had devoted so much of his life.

EJ

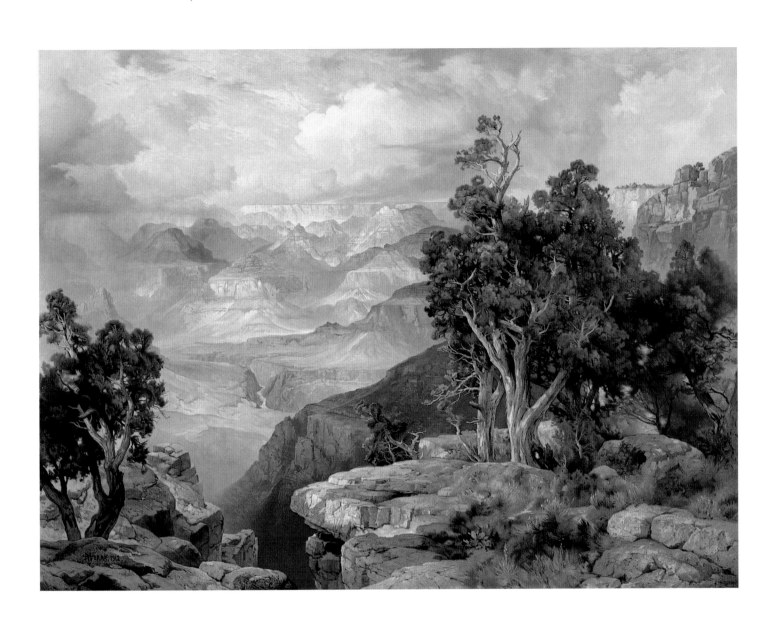

Anna Hyatt Huntington

American, 1876–1973

Diana of the Chase, 1922

Bronze, h. 8 ft.
Gift of the artist in honor
of the tenth anniversary
of the Washington County
Museum of Fine Arts, 1941,
A400

1. Hyde and Shepherd
Architectural Firm, New York,
*Architectural Rendering of the
Washington County Museum
of Fine Arts*, 1929, WCMFA
Archives. See also Myrna G.
Eden, *Energy and Individuality
in the Art of Anna Huntington,
Sculptor and Amy Beach,
Composer* (Metuchen, N.J.:
Scarecrow Press, 1987).

right
Unveiling of Anna Hyatt
Huntington's *Diana of the Chase*
in the Museum's rotunda, 1942

far right
Anna Hyatt Huntington's
Diana of the Chase on view in
the Museum's rotunda

Huntington was born in 1876 in Cambridge, Massachusetts, and became one of America's foremost sculptors, specializing in figures of animals and humans. She learned a great deal about the natural world from her father, Alpheus Hyatt II (1838–1902), a distinguished zoologist and paleontologist. He taught Huntington to make close observations from nature, and from a young age she was adept at identifying and sketching animals, particularly the hors-

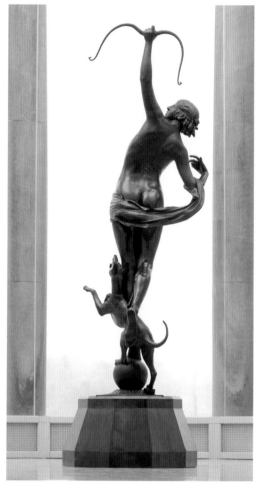

es she adored. With encouragement and instruction from her sister, herself a sculptor, Huntington began to experiment with sculpting as a young woman. She studied privately with Henry Hudson Kitson (1865–1947), with George Grey Barnard (1863–1938) and Hermon MacNeil (1866–1947) at the Art Students League in New York, and later with Gutzon Borglum (1867–1941). Beyond her training with these eminent sculptors, Huntington's best teacher remained direct observation from nature.

Huntington's proclivity for making observations from life and capturing figures in motion is evident in the finely rendered sculpture of the goddess

Diana and her hound. Diana's body is perfectly poised with her left arm raised in the air as she clutches a bow, her right arm pulled back, her wrist flexed as though an arrow has just been released, and her head turned to follow the path of the invisible arrow. The elegant curve of Diana's figure is offset by the drapery flowing from her right arm and billowing against her body. A lively hunting dog bounds at Diana's feet, illustrating Huntington's prowess in sculpting animals.

The cast of *Diana of the Chase* in the Washington County Museum of Fine Arts was a gift of the artist in honor of the Museum's tenth anniversary in 1941. The eight-foot-tall bronze sculpture is installed in the Museum's rotunda, gazing out over City Park Lake. A 1929 architect's rendering of the Museum building reveals that the rotunda was envisioned as the home of a large-scale sculpture even during these earliest planning stages.[1] It was not until the acquisition of this work that the Museum had an appropriate sculpture to fill the space. Because of her striking pose and prominent location, *Diana of the Chase* has since become an iconic image of the Washington County Museum of Fine Arts.

MD

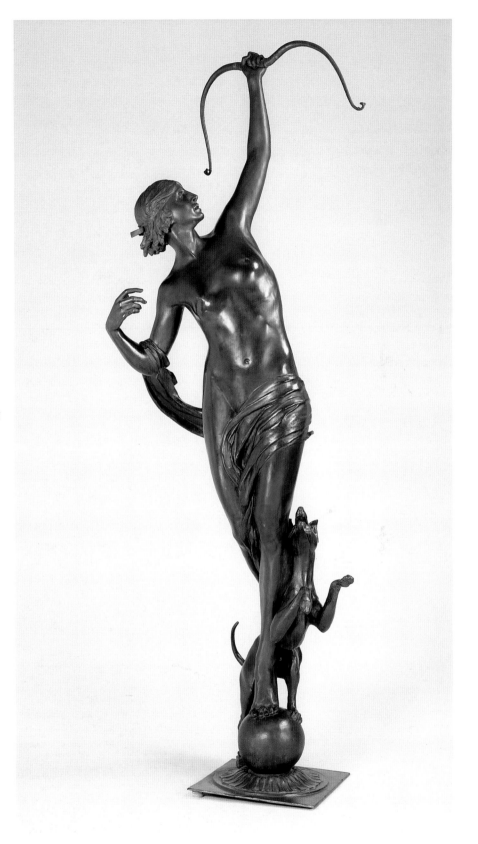

Malvina Hoffman
American, 1885-1966
Sicilian Fisherman, ca. 1935

Bronze, h. 21 in.
Museum Purchase,
1942, A399

1. Henry Field, *The Races of
Mankind: An Introduction
to Chauncey Keep Memorial
Hall* (Chicago: Field Museum
of Natural History, 1933)
introduces the plan of the
display. For an exhibition
catalogue of Hoffman's works,
see *A Comprehensive Exhibition
of Sculpture by Malvina Hoffman*
(Richmond: Virginia Museum
of Fine Arts, 1937).

Born in New York, Hoffman knew at an early age
that she wanted to be an artist. She shifted from
painting to sculpture and went to Paris to study
with Auguste Rodin (1840-1917). She learned dis-
section in order to be faithful to human anatomy in
her sculptures. Then, after studying the craft of
bronze casting so that she could supervise the cast-
ing of her own work, she established a studio in
Paris from which she carried out many commis-
sions.

Sicilian Fisherman is one of 110 figures that the
Field Museum of Natural History in Chicago
commissioned from Hoffman in 1930. The figures
were to be centerpieces in an anthropological
exhibition that would reveal the many racial types
in the world. The commission stemmed from the
now-discarded conviction of anthropologists that
the racial types of the world were arranged in a
hierarchy, the Asian and African groups being
lower on the scale than Europeans.[1]

Hoffman traveled extensively to carry out her
assignment to capture racial physiognomy and
customs accurately. Sculpted after careful modeling
from life, *Sicilian Fisherman* shows Hoffman's
devotion to accuracy in gesture, accessories, and
movement. The viewer can imagine the next stage
of the fisherman's arrested motion, a characteristic
that Rodin practiced in his own sculpture and
passed on to his students.

EJ

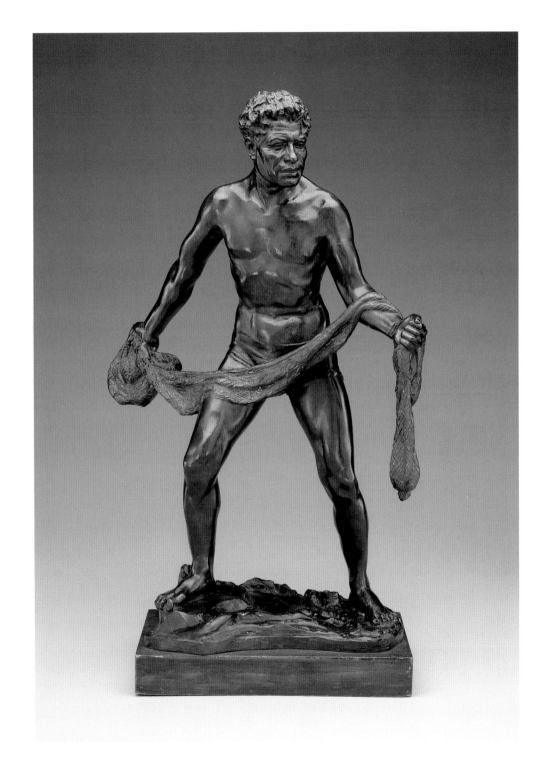

Charles H. Walther

American, 1879-1938

Ploughed Fields, Middletown, Maryland

Oil on canvas board,
9¼ × 11¼ in.
Signed lower right:
C. H. Walther
Gift of Mr. and Mrs.
Michael Merson,
Baltimore, Maryland,
1994, A2979

Walther, a Baltimore artist, graduated from the Maryland Institute of Art in 1901 and immediately joined its faculty. He traveled to France in 1906 for further study, where he was surrounded by developments in modernism by such artists as Paul Cézanne (1839-1906), Pablo Picasso (1881-1973), and Henri Matisse (1869-1954). In 1908 Walther returned to Baltimore to work and paint; he resumed his duties as a faculty member in 1910. Attentive over the years to developments in abstraction, he experimented in his landscapes, portraits, and still lifes with color and form, often departing from realism to examine space in a new way.

Such a work is *Ploughed Fields, Middletown, Maryland*, a scene in which Walther reveals his affection for the gently rolling hills by tipping up the land in the distance, enabling viewers to relish one field after another, finally reaching the high horizon. The artist owned a small house in Middletown Valley, where he painted and taught in the summer, and where, presumably, he worked on this painting. Walther helped form the Society of Baltimore Independent Artists in the 1920s and may have exhibited this painting at the society's first annual exhibition.

In the 1930s he became interested in the clean lines and colors of a style called Precisionism, with which artists painted industrial scenes in the confidence that industry, like the smooth, flat style, would prove to be an uncomplicated benefit to society. He also became involved in the mural movement, funded by the Depression-era Federal Works Project Administration; a mural he worked on for the Francis Scott Key Elementary School in Baltimore has long been lost.

The Baltimore Museum of Art held a memorial exhibition of Walther's work in 1939. In 1934 and again in 1999 the Washington County Museum of Fine Arts presented a retrospective of his work. EJ

Charles H. Walther
American, 1879-1938
"Untitled" Abstract (#121), 1915

Oil on burlap, 13 × 16 in.
Gift of Mr. and Mrs William
H. Everngam Jr., Bethesda,
Maryland, 1991, A2697

1. Percy North, "Bringing Cubism
to America," *American Art* 14
(Fall 2000): 58-77, discusses
the difficulties artists faced in
encouraging viewers to accept
abstraction.

The title of this work suggests that Walther kept track of the abstractions he created by giving them a number, which meant not only that his sequence was important to him but also that the paintings did not represent anything that could be named. Attuned to European modernist works on view in New York during the early years of the century, Walther could also have noted the practice of artists such as Wassily Kandinsky (1866-1944) and Pablo Picasso (1881-1973) and other Cubists in titling their works simply with a number.

In this small painting, brushed on coarse-weave burlap, Walther seems to have imagined a stage on which large creatures cavort, perhaps inspired by some of the movements of modern dance. We may be looking at a set with a sky and clouds as a backdrop and a skyscraper providing background, or perhaps Walther wants us to imagine a sidewalk theater. He used the pastel palette of the early Cubists, such as Max Weber (1881-1961) in America and Picasso in France—light browns, yellows, greens, and blues, with touches of bright pink and orange as accents. Our tendency to "read" the painting as representational reflects the difficulties faced by artists who moved into abstraction. Early in the history of abstraction, artists simplified motifs from an observed world rather than working completely nonobjectively, without references to the world we see.

Among Walther's other experiments with new possibilities were the landscapes he painted in the 1920s using color theory. He painted a number of rural scenes, some of which are in the Museum's collection, in which he moved away from optical color—what one sees in looking at a landscape—to arrange colors as they occur in a spectrum. In conveying landscapes of fields, houses, and barns, he placed complementary colors next to one another (complementary colors are across from each other on the color wheel: yellow's complement is purple; blue's complement is orange; and red's is green). The effect is to give the eye a jolt and thus bring energy to a painting. Walther developed much of his interest in color in his work with stained glass for the Walther-Gettier Studios in Baltimore, which provided stained glass for churches, hospitals, and homes in the city.

Working with other artists interested in avant-garde painting and sculpture coming from Europe, in 1926 Walther founded a short-lived modernist gallery in Baltimore. His reputation as a "pioneer modernist" led to his dismissal in 1929 from his teaching post at the conservative Maryland Institute of Art.[1]

EJ

Milton Avery
American, 1893-1965
Beach Scene, 1944

Watercolor and gouache
on paper over charcoal,
29½ × 37¼ in.
Signed and dated lower
left: Milton Avery 1944
Gift of Mr. Donald Gillett,
Hagerstown, Maryland,
1973, A1773

1. Barbara Haskell, *Milton Avery*
(New York: Whitney Museum
of American Art in association
with Harper & Row, 1982).

Created in flat, radiant planes of color with a wide brush, *Beach Scene* is typical of Avery's simplified compositions. The large figure in the foreground sitting on the beach is presumably the father of the family of four enjoying the shore. Represented in bright orange-red and brilliant yellow, he stretches out on the sand near a large beach bag and items of clothing, while family members clothed in light blue sit near the water on the right and left. The ocean, a deep green, rushes toward the beach, the breakers capped by swirling white foam. The high horizon draws viewers into the scene, where they indulge their curiosity about the family and stand in awe of the active sea. Avery's palette reminds one of the work of Henri Matisse (1869-1954), whom he admired: simple shapes appearing in unmodulated colors both warm and cool.

Avery was born in Altmar, New York, and grew up in Connecticut. He taught himself to paint, with limited studies at the Connecticut League of Art Students in Hartford, and supported himself with blue-collar jobs at night so that he could paint during the day. He moved to New York City in 1925 and married the illustrator Sally Michel (1902-2003) the next year; she made it possible for him to paint full-time. He began to be recognized by such painters as the Color Field artist Mark Rothko (1903-1970), who became a close friend. Critics and fellow artists hailed Avery as a link between the dazzling color of Matisse and the Abstract Expressionism of American artists in the 1950s.

Unlike his colleagues in New York, Avery refused to abandon representation. His paintings and prints move toward abstraction in their simplicity, but they always convey a scene and suggest a narrative.[1]

EJ

Reuben Kadish

American, 1913-1992

Untitled, ca. 1948

Oil paint and sand on canvas, 40 × 21 in. Museum purchase and gift of the Reuben Kadish Art Foundation, New York, New York, 2005, A4033

1. Jean Libman Block, "Reuben Kadish," *Arts Magazine* 51, no. 4 (December 1976): 17; and Reuben Kadish Art Foundation at http://www.reubenkadish. org.

This painting's strong suggestion of a figure, its intense color, and deliberate gestural strokes point to Kadish's early association in California with a group of Surrealists. These artists were exploring the impact of dreams, the results of automatic drawing, and the symbols of prehistoric art. In *Untitled* the mixture of sand and paint gives the work a rough texture as well as associating its meaning with the earth itself and its mysteries. Kadish was intrigued by Mesoamerican art (the art of Central America left by pre-Columbian civilizations), the strong images of which influenced his choices in his own art.

The artist spent much of his early life in Los Angeles, studying at the Otis Art Institute in the 1930s, where he met the artists Jackson Pollock (1912-1956) and Philip Guston (1913-1980). All were involved in painting for the federal agency established for artists in the Depression, the Works Project Administration, working on either murals or easel paintings. After his training, Kadish taught at the Pacific Institute of Music and Fine Art in Los Angeles. Like many of his colleagues, he was intrigued by the social and artistic implications of murals as art for the people. Sometime during the 1930s he became a close associate of the Mexican muralist David Alfaro Siquieros (1896-1974), whose work he admired for its energy and vitality.

After World War II, in which Kadish first worked for Bethlehem Steel and the shipping industry and then served as an art correspondent for *Life* magazine, he settled in New York, where he worked as a printer for the printmaker Stanley Hayter (1901-1988). Then, in the late 1940s, he sought the peace of rural life and moved to New Jersey as a dairy farmer. A devastating fire swept through his studio there, and he never painted again. However, in the late 1950s he returned to the art world, which he had regretted leaving, took up sculpture, and in 1960 embarked on a distinguished three-decade teaching career at the Cooper Union in New York.[1]

EJ

Dorothy Dehner
American, 1901-1994
Three Musicians, 1954

Ink and watercolor on paper, 15⅝ × 20½ in. Signed and dated lower right: Dorothy Dehner '54 Gift of The Dorothy Dehner foundation for the Visual Arts, Inc., New York, New York, in honor of the Museum's 75th anniversary, 2005, A4083

As a young woman, Dehner first set her sights on a career in drama. Born in Cleveland, Ohio, she moved to California in 1918 after the death of her parents and then settled in New York in 1922. There she developed her interest in the visual arts, studying painting at the Art Students League. She was strongly influenced by modernist movements in painting and sculpture, having seen such works shown in a succession of galleries owned by Alfred Stieglitz (1864-1946) and, beginning in the early 1930s, the Museum of Modern Art and the Whitney Museum of American Art.

Married to the sculptor David Smith (1906-1965) in 1927, during the years of her marriage (which ended in 1952) Dehner created only a few drawings and paintings. However, after she and Smith divorced, she became a productive printmaker and sculptor, eventually creating large sculptures in Corten steel.

Three Musicians reveals Dehner's fascination with the illusion of three dimensions on a two-dimensional surface. Having created her image in ink with a pen that left jagged points along many of the lines, Dehner used elongated triangles to suggest a lineup of three musicians. Some triangles are filled with watercolor–pink, orange, or yellow, in various saturations–others are empty. Horizontal lines link the musicians in the middle and top of the picture, but the overall effect is that air flows through the scene. Dehner departed from the brilliant color and flat shapes of Pablo Picasso's *Three Musicians* (1921; The Museum of Modern Art, New York), but her watercolor acknowledges her interest in his work.

EJ

Dorothy Dehner '54

189

Robert Indiana
American, b. 1928
Love, 1973

Silkscreen (4 prints),
each 31½ × 31½ in.
Signed and dated in pencil
at the lower right of the
letter *E*: R Indiana '72
Numbered in pencil at the
lower left of the letter
E: 38/150
Published by Denise René,
Paris and New York, 1973
Museum purchase, 1975,
A1829

1. In *Love and the American Dream: The Art of Robert Indiana* (Portland, Maine: Portland Museum of Art, 1999) the artist explains the convictions that underlie his most famous work.

Love has become one of the most well-known icons of recent American art, created by Indiana in both print and sculptural form. With its bold red, white, and blue color scheme, three letters upright and the *O* tipped on a diagonal, the slogan suggests all that was direct and at the same time skeptical in American popular culture of the 1960s. Did love prevail in societal relationships? Or was it a term that had been drained of sincerity? Or was it both?

Indiana, born Robert Clark in New Castle, Indiana, adopted the name of his state early in his career. After studying at the Herron School of Art in Indianapolis and the Munson-Williams-Proctor Institute in Utica, New York, he enrolled in the school of the Art Institute of Chicago, from which he graduated in 1953. The next year, he attended Edinburgh College of Art in Scotland on a travel fellowship.

In 1954 he settled in New York, where he assembled wood sculptures from found objects and stenciled words onto them with flat, bright colors. Influenced by the geometric shapes and bright, flat colors of painter Ellsworth Kelly (b. 1923) and the themes from popular culture in the paintings of Jack Youngerman (b. 1926), he began to create paintings of such words as *EAT, DIE*, and *LOVE*. His images of these common yet emotion-laden words seem at once political and ironic; he has claimed for them a spiritual content. A United States postage stamp in 1973 featured his multicolored *LOVE*.[1]

Since 1978 Indiana has lived off the coast of Maine on the island of Vinalhaven.

EJ

58/150 R. Indiana 72

Frank Stella

American, b. 1936
Les Indes Galantes, 1973

Lithograph (no. 4 of
a suite of 5), 15¾ × 22 in.
Signed, dated, and
numbered in graphite
lower right: 20/100
F. Stella '73
Gift of Kit Smyth Basquin,
New York, New York,
in honor of the 75th
anniversary of Washington
County Museum of Fine
Arts and of its Director,
Joseph Ruzicka, 2005,
A4022

1. Sidney Guberman,
*Frank Stella: An Illustrated
Biography* (New York: Rizzoli
International, 1995) provides an
illustrated biography.
2. *Frank Stella: Prints, 1967–1982*
(Ann Arbor: University of
Michigan, Museum of Art, 1982)
examines Stella's prints.

One of the most inventive of twentieth-century artists, Stella is generally categorized as a Minimalist. From Malden, Massachusetts, and educated at the Phillips Academy and Princeton, Stella began his career assuming the naturalness of abstraction rather than representation as the proper function of art and worked as an Abstract Expressionist painter. Soon, however, with a series of flat, black canvases, he rejected the personal quality of the brushstroke. The early target and flag paintings of Jasper Johns (b. 1930) influenced Stella to move even more strongly toward art that was geometric, patterned, and impersonal. In his Minimalist approach, objects were simply objects. He created painted surfaces that were clearly flat without any implications of symbol or metaphor, but later, moving away from Minimalism, used industrial materials to construct sculptures, often garishly colored, that hung from the wall like paintings. In terms of interpretation, Stella famously said, "What you see is what you see." From the late 1960s he also worked in a variety of print media, often elaborating ideas he had first developed in his paintings.[1]

Such a history belongs to *Les Indes Galantes*, one of five lithographs that follow the patterns Stella had developed in his Mitered Maze paintings in the Concentric Squares and Mitered Mazes series of 1962 and 1963. Stella was inspired to make the lithographs by the French composer Jean-Philippe Rameau's (1683–1764) *opéra-ballet* of the same name (1745); the five acts of the opera inspired the number of lithographs in the series.[2] This lithograph was printed from seven plates: gray aluminum for the lines and zinc plates for dark yellow, orange, red, green, blue, and purple. The mitered mazes, set together in the lower left portion of the mold-made paper, present two separate illusions. The square on the left, with tracks of blue, purple, and green at its center, suggests a maze descending into depth; the square on the right, with tracks of yellow, orange, and red at its center, suggests a maze rising to a high point.

EJ

Alfred Leslie
American, b. 1927
Richard Bellamy, 1974

Lithograph, 40 × 29½ in.
Published by Landfall
Press, 12/50
Museum purchase, 1978,
A1966

1. Joseph Ruzicka, ed., with
essays by Vernon Fisher,
Jack Lemon, Mark Pascale,
and Ruzicka, *Landfall Press:
Twenty-five Years of Printmaking*
(Milwaukee: Milwaukee Art
Museum, 1996).

The collector and dealer Richard Bellamy looks just beyond the viewer in this dramatic portrait. Created with a series of diagonal lines except for the flying locks of hair, Leslie's portrait gives his friend an air of mystery by leaving areas of the face empty, as though rays of light were falling across the sitter from a narrow opening, perhaps to the artist's right. Leslie reverses the effect of the dark lines by using white for the outlines around Bellamy's shirt and dots for his whiskers.

Bellamy was among the many friends in New York City whose company Leslie enjoyed in the heady 1950s as Abstract Expressionism gained critical approval. Among those who often gathered in the Cedar Bar in Greenwich Village were the painters Willem de Kooning (1904-1997), Joan Mitchell (1925-1992), and Helen Frankenthaler (b. 1928), the critic Clement Greenberg (1909-1994), and the dealers John Bernard Myers (1920-1987) and Richard Bellamy (1927-1998). Bellamy is generally credited for launching the careers of many post-Abstract Expressionist artists in his Green Gallery and as a private dealer.

Leslie, a New Yorker, has developed many talents over his career. After military service in the Coast Guard, he began a career in the mid-1940s as a filmmaker, supporting himself as a model (he had long been interested in bodybuilding), truck driver, carpenter, and housepainter. In the 1950s, after experience in musical composition, the design of stage sets, and editing and publishing a literary magazine, he turned to painting. At first, he worked as an Abstract Expressionist, but within a decade he had rejected abstraction in favor of representation.

Drawn to the unusual effects of strong light in paintings that narrated events in the lives of ordinary people, Leslie influenced a number of artists to abandon abstraction for representation.

Landfall Press, established in 1970 under the direction of Jack Lemon, has championed teamwork between artist and printer, respect for such traditional techniques as woodcut, intaglio, and lithograph, and experimental work in new media and combinations.[1]

EJ

Helen Frankenthaler
American, b. 1928
Barcelona, 1977

Color lithograph on
HMP handmade paper,
41 × 32 in.
Signed, dated, and
numbered in pencil
in left margin: 28/30
Frankenthaler '77
Printed at Ediciones
Poligrafa, SA, Barcelona,
Spain
Museum purchase, 1978,
A1965

1. Ruth Fine, *Helen
Frankenthaler: Prints*
(Washington, D.C.: National
Gallery of Art, 1993) is the
exhibition catalogue; John
Elderfield, *Frankenthaler* (New
York: Harry N. Abrams, 1989)
studies the artist's paintings as
well as prints.

A field of rich layered colors, some seeming to jostle each other for prominence, *Barcelona* translates onto handmade paper Frankenthaler's pathbreaking discovery in the 1950s of pouring paint onto raw canvas to achieve a stained effect. Earlier, Jackson Pollock (1912–1956) had revolutionized art making with Action Painting, a process in which he laid a large canvas on the floor, hurled or dripped paint onto it to create a record of his activity, and then selected what he would frame. Frankenthaler took the next step, encouraging paint to go where it would when she applied it to the horizontally placed, unprimed canvas. The resulting images suggested aspects of the natural world, posed against and within airy and seemingly fluid spaces. Often referred to as a Color Field artist, Frankenthaler moved art of the 1950s and 1960s away from the Abstract Expressionism of the 1940s and early 1950s, in which the shaping power of the artist was paramount. Following her lead into the exploration of sheer color and its unpredictable relationships were the artists Kenneth Noland (b. 1924), Sam Gilliam (b. 1933), Morris Louis (1912–1962), and others.

In the early 1960s Frankenthaler began making prints and soon discovered that she could create images that conveyed the spontaneity of her paintings. From aquatints, which involved etching copperplates with acid that worked somewhat unpredictably, she moved to lithography in the 1970s, realizing that she could achieve similar transparency and brilliancy of color with that process. *Barcelona*, one of several prints she created from nine colors at a workshop at the Ediciones Poligrafa, SA, in Barcelona, Spain, suggests the evening bustle of the city. Vertical strokes in primary colors stabilize the various earthy greens in the print.

Frankenthaler was among several contemporary painters who turned to printmaking in the 1960s, and print collectors followed their lead. *Barcelona* was included in an exhibition at the National Gallery of Art in 1993 that presented Frankenthaler as a printmaker.[1]

EJ

Christo (Christo Javachef)
American, b. Bulgaria, 1935
Wrapped Car, 1984

Mixed-media print,
22½ × 28½ in.
Signed, dated, and
numbered in pencil lower
right: VII/XX Christo 84
Gift and partial purchase
from Mr. Guy Kuhn,
Hagerstown, Maryland,
1990, A2654

1. Marina Vaizey, *Christo* (New
York: Rizzoli, 1990); and Adrian
Henri, *Total Art: Environments
and Happenings* (London:
Thames and Hudson, 1974).

Christo, a sculptor born in Bulgaria and a citizen of
the United States since 1973, has made his reputa-
tion as a practitioner of *empaquetage*, or packaging.
Before coming to the United States in 1964, the art-
ist studied at the Academy of Sofia, 1952–56, lived
briefly in Prague, Vienna, and Geneva, and settled
in Paris from 1958 to 1964. In Paris he first experi-
mented with wrapping as a form of art. In *empaqu-
etage*, suggested but not developed by artists of the
avant-garde in the 1920s, the artist hides the object
of interest under wrappings of paper, canvas, or
plastic. The process challenges traditional ideas of
art: that it is visible, beautiful, permanent, that it
can be displayed in a gallery or museum, and that it
can be purchased.

Christo, in collaboration with his wife, Jeanne-
Claude (née Guillebon) (b. 1935), began with small
objects in his studio but gradually increased the size
of objects to buildings. For large projects, such as his
wrapping of the Kunsthalle in Bern (1968), the Pont
Neuf in Paris (1985), and the Reichstag in Berlin
(1995), he spent most of the preparatory time in
negotiation for permission to carry out the work.
These and his landscape projects required the
participation of construction workers, rock climbers,
and volunteers. He finances his projects with
preparatory drawings, selling the drawings instead
of the completed work, which often lasted only a few
moments. Occasionally the drawings substituted for
the work, contradicting the expectation that
drawings were studies for finished works.

Among Christo's well-known landscape projects
were his packaging of one mile of coastline near
Sydney, Australia (1969), the twenty-four-mile

Running Fence, in Sonoma and Marin counties,
California, in 1976, and the project known as The
Gates for Central Park, New York City, 2005. He and
Jeanne-Claude claim that their intention is to
encourage viewers to see or participate in
landscapes in a different way.[1]

EJ

30cm

h 154cm

260cm

442 cm (400 + 30 + 12 cm)

25cm

130 cm

VII/XX Christo 84

WRAPPED Automobile (project for Volvo 122-S Sport Sedan) Total Length 442 cm x 154cm x 260 cm.

4

5

6

7

Decorative Art

Although William and Anna Brugh Singer, founders of the museum, collected the decorative arts with enthusiasm, they displayed these objects in their homes in the Netherlands and Norway rather than seeing them as fundamental to the collection at the WCMFA. After Mrs. Singer's death, many of these works made their way to the West-Norway Museum of Decorative Art in Bergen.

Thus the collection of decorative arts at WCMFA has grown slowly. It was stimulated over the years by travelling and loan exhibitions and, recently, a new awareness of the contributions of "practical" arts to local culture. Gifts and purchases contributing to the regional breadth of the collection have included embroidery, folk art, and Fraktur. Over the last decade, with the addition to the collection of premier examples of glassmaking, the Museum's holdings in the decorative arts have continued to grow, providing depth, strength, and beauty to the collection.

Most recently, gifts in honor of the seventy-fifth anniversary of the Museum, a special interest of Director Joseph Ruzicka (2004-2007), have filled in significant gaps all across the Museum's areas of emphasis: old masters, historic American paintings and prints, sculpture, and the decorative arts.[1]

EJ

1. This history, like that of the collection of American art, has been drawn from Museum bulletins and directors' reports in the Museum archives, recently catalogued by Curatorial Coordinator Margaret Dameron.

Mary Martin
American, b. ca. 1812
Sampler, 1826

Silk embroidery on
linen, 26 × 22 in.
Stitched inscription:
Mary Martin, 1826
Bequest of Mrs. Palmer
Tennant, Hagerstown,
Maryland, 1962, A1227

1. Susan Burrows Swan, *Plain and Fancy: American Women and Their Needlework, 1700–1850* (New York: Holt, Rinehart and Winston, 1977), 44–52.
2. Betty Ring, *Girlhood Embroidery: American Samplers & Pictorial Needlework, 1650–1850* (New York: Alfred A. Knopf, 1993), 506. As Ring notes, evidence of this fashion also survives on painted furniture of the time, such as objects made by John and Hugh Finlay of Baltimore.

In the nineteenth century, most American girls received only rudimentary academic educations. Instead, their schooling focused on developing skills that prepared them to become capable wives, mothers, and housekeepers. In the days when women were expected to sew all of their family's clothes and linens, learning expertise with a needle was one of the most important aspects of a young woman's education. Under the direction of a mother, grandmother, or a schoolteacher, girls produced basic samplers using plain stitches in order to practice fundamental needlework techniques.

Young women from more affluent backgrounds frequently embroidered a second type of pictorial sampler using decorative, or fancy, stitches. Decorative samplers required months of diligent labor to complete. When finished, they were framed and prominently displayed in the young woman's home as a symbol of her patience, education, and blossoming accomplishments.[1]

Imagery on samplers often reflected local experiences and fashions. Such is the case with this example, which belongs to a group of large "building" samplers created in and around Baltimore, Maryland, in the first half of the nineteenth century. Made under the instruction of teachers at a number of schools, the impressive brick edifices on building samplers mirror the area's unparalleled surge of prosperity and growth at the time.[2] While recognizable structures, such as the Baltimore Hospital, appear on a few building samplers, the elegant residence worked here likely depicts an imaginary scene.

Mary Martin embroidered this colorful sampler using a variety of fancy stitches on a linen ground. The composition of a neat brick building flanked by willow trees in a fenced yard surrounded by flowers and an undulating border resembles other examples created in Maryland in the 1820s and 1830s. When she completed the sampler in 1826, Miss Martin proudly stitched her name and the year on the lower right corner. The details of Miss Martin's life have not been identified. This sampler, however, remains as a testament to the great skill and refinement of its maker.

ASG

Matilda Lawrence
American, 1815–1894
Mourning Embroidery, ca. 1831

Paint, ink, and silk embroidery on silk ground, 19⅝ × 25½ in.
Inscribed on plinth: Sacred / to the / Memory / of / Upton Lawrence / who departed this life / March 30 / 1824.
Museum Purchase, 1992, A2758, 1933

1. Betty Ring, *Girlhood Embroidery: American Samplers and Pictorial Needlework, 1650–1850* (New York: Alfred A. Knopf, 1993), 20–21. This source provides an excellent introduction to the subject.
2. Ibid., 22.
3. Betty Ring, "Saint Joseph's Academy in Needlework Pictures," *Magazine Antiques* 113, no. 3 (March 1978): 592–99 [597].

Following the sudden death of George Washington in 1799, American artists created mourning prints as an expression of the nation's overwhelming grief. These prints commonly featured such elements as Neoclassical plinths and willow trees, the ancient symbol for death. Mourning prints provided excellent patterns for needlework teachers, who devised related embroidery designs used by students to memorialize deceased family members. Mourning embroidery later transcended its original purpose and became a fashionable form of needlework associated with refinement and culture, rather than an expression of grief.[1]

A student at St. Joseph's Academy in Emmitsburg, Maryland, produced this embroidery. Established in 1809 by Elizabeth Ann Seton, the first American-born saint, the Catholic school provided both academic and ornamental educations for young women. The procedure for creating pictorial silk-on-silk embroideries varied from school to school. Most often the teacher sketched the design on the silk ground and supervised the student's needlework before adding the ink inscription and painting the silk background herself. Alternatively, an artist might have been engaged to draw the pattern and add the final painting. Advertisements indicate that drawing masters and miniature painters regularly solicited such work.[2]

Matilda Lawrence, who created this mourning embroidery, attended St. Joseph's Academy for several years, beginning in 1831. A great-granddaughter of Jonathan Hager (1714–1775), founder of Hagerstown, Maryland, Miss Lawrence produced the piece as a tribute to her father, Upton S. Lawrence, a distinguished Hagerstown attorney who died in 1824. Worked in satin stitches and French knots, the composition incorporates several motifs that refer to death that were commonly used by the needlewomen at St. Joseph's: a Neoclassical urn, a blasted oak tree, a weeping willow, and a flowing stream.[3] Miss Lawrence later married Robert J. Brent, a member of the Hagerstown Bar and moved to Baltimore, where the couple raised a family of eight children.

ASG

Sarah Jane Bower
American, 1842–1920
Album Quilt, ca. 1860

Cotton, 93½ × 91 in.
Gift of Mr. and Mrs.
Robert S. Martin,
Hagerstown, Maryland,
2002, in Memory of H.
Jane Martin, A3777

1. Jennifer F. Goldsborough,
"Baltimore Album Quilts,"
Magazine Antiques 145, no. 3
(March 1994): 412–21 [413].
Appliqué is the technique
of laying one piece of fabric
over another and sewing
it down.
2. Dena S. Katzenberg,
Baltimore Album Quilts
(Baltimore: Museum of Art,
1981), 13–15.

Nineteenth-century American quilts are renowned for their inventiveness and beauty. Among the most sophisticated examples were those made by Maryland needlewomen in the middle decades of the century. At that time, Marylanders had access to a wide variety of imported textiles that arrived daily from Europe in the busy port of Baltimore, as well as domestic cloth. Women took advantage of these bright fabrics, cutting out patterns and sewing them onto plain white bedcovers to create quilts in a unique style that reflected Maryland's mix of British and Germanic heritage. These quilts merged the English fashion for appliquéd floral designs with the German red-and-green cut-paper style.[1]

Made by Sarah Jane Bower of Carroll County, this quilt is of a type known as an album quilt. Album quilts are made up of a collection of appliqué squares laid out in rows that resemble the pages of a scrapbook or album (fig.). Created by women individually or in groups, they were made to commemorate a special occasion, to honor a prominent community member, to celebrate a wedding, or to serve as a memento for a departing friend.[2] Album quilts were not intended for use as everyday bed covers; instead, they were made for special display and were cherished as keepsakes by their owners.

Family records indicate that Miss Bower made this quilt as part of her hope chest, before she married John Addison Martin, also of Carroll County. Appliquéd with vibrant floral wreaths adorned with birds, fruit, and flowers, the quilt also features a sinuous grapevine pattern that borders the squares and softens the rigidity of the grid composition. No two squares are exactly alike, the strawberries in opposite corners having different colored seeds, formed of tiny French knots. A skilled needlewoman, Miss Bower added embroidered details to the leaves and flowers and used fine quilting stitches throughout.
ASG

left
Sarah Jane Bower, Album
Quilt, detail, ca. 1860

Wilhelm Schimmel
American, 1817–1890
Eagle, 1860–90

Paint on pine, 11⅛ × 22¾ in. (without base)
Unmarked
Gift of Mr. Frank W. Mish Jr., Falling Waters, West Virginia, 1977, A1906

1. Milton E. Flower, *Three Cumberland County Wood Carvers: Schimmel, Mountz, Barrett* (Carlisle, Pa.: Cumberland County Historical Society, 1986), 6.
2. Milton E. Flower, "Schimmel the Woodcarver," *Magazine Antiques* 44, no. 4 (October 1943): 164–66 [165].
3. Ibid., [164].

Regarded today as one of America's most imaginative folk artists, Schimmel was an itinerant carver who roamed the Cumberland Valley region of Pennsylvania in the last decades of the nineteenth century crafting colorful wooden figures. Born in Germany, Schimmel immigrated to the United States shortly after the American Civil War.[1] Although little is known of his life before he arrived in Pennsylvania, the carver left an indelible impression on those with whom he came in contact.

Over a period of more than twenty years, "Old Schimmel," as he was known, moved from farm to farm, staying mostly with families of German descent who lived near the town of Carlisle. In exchange for room and board, Schimmel offered handcrafted objects that he fashioned out of odd bits of discarded wood, picked up on his ramblings through the area. Using a pocketknife, Schimmel created a variety of bird and animal figures, including eagles, parrots, roosters, dogs, lions, and squirrels. These objects show a debt to the folk carving tradition of Germany, which Shimmel doubtless had knowledge of before immigrating to America. Shaped from soft pine in expressive forms, his carvings feature crudely applied painted decoration that can be compared to wooden toys of the same period from Germany.[2]

The spread-wing eagle was one of Schimmel's favorite forms and the one for which he is best known. This example illustrates the vigorous posture, dovetailed wing construction, and sawtooth cross-hatching on the neck, chest, and wings that characterize the artist's eagle forms. Applied with a quick hand, the red, black, and yellow pigments convey the spontaneity of Schimmel's working method. Such eagles became especially popular objects in the decades following the Civil War and were displayed in storefronts and schools as a show of patriotism. According to town legend, Schimmel's eagles were once featured in almost every restaurant and tavern in Carlisle, exchanged by the carver for a meal or a pint of whiskey.[3]

ASG

George Jakob Hunzinger
American, 1835–1898
Chair, 1869

Walnut, 34 × 20 × 20 in.
Stamped on right rear
leg: Hunzinger NY / Pat.
March 5 1869
Gift of Mr. Richard F.
Driscoll, Washington, D.C.,
2002, A3790

1. Barry R. Harwood, *Furniture of George Hunzinger: Invention and Innovation in Nineteenth-Century America* (Brooklyn: Brooklyn Museum of Art, 1997), 38–40. Hunzinger's twenty-first patent was granted to the executors of his estate in 1899, the year after his death.
2. Richard W. Flint, "Prosperity through Patents: The Furniture of George Hunzinger & Son," in *Victorian Furniture: Essays from a Victorian Society Autumn Symposium*, ed. Kenneth L. Ames (Philadelphia: Victorian Society in America, 1983), 117–30 [124].
3. Harwood, *Furniture of George Hunzinger*, 52–53

Hunzinger designed and manufactured some of the most inventive chairs made in nineteenth-century America. Born into a family of cabinetmakers in Tuttlingen, Germany, Hunzinger immigrated to the United States in the 1850s, settling in the thriving German community in Brooklyn, New York. In 1860 he established a small furniture shop, where he worked as a diligent and astute businessman. In 1861 he received the first of twenty patents he would register during his lifetime, for a folding reclining chair that could double as a table.[1] Hunzinger's business soon prospered: between 1861 and 1873 he moved his shop four times, suggesting that he needed progressively more space as his business grew. The firm primarily produced seating furniture with distinctive lathe-turned parts and geometric decorative details that were described as "fancy chairs" and "ornamental furniture."[2]

This chair illustrates Hunzinger's characteristic system of diagonal braces, which he patented on March 30, 1869.[3] By connecting the seat back of the chair to the front feet with a single diagonal member, Hunzinger hoped to strengthen the frame against stress caused when the chair was rocked backward on its rear legs. The diagonal braces, which appear on a wide variety of Hunzinger chair designs, give the chair the appearance of a folding chair, although it is not. The implied ability to fold the seat, however, infuses the chair design with a quality of contained energy.

Devoid of traditional nineteenth-century decoration inspired by naturalism, exoticism, or revivalism, the chair illustrates the protomodern character of Hunzinger's works. Like his British contemporary Christopher Dresser (1834–1904), Hunzinger attempted to create designs free from historical references, which he felt would detract from, rather than enhance, form. While the chair vaguely recalls bamboo furniture, fashionable in the late nineteenth century, its principal source of design inspiration is the machine. Indeed, the pipelike framing and geometric elements of Hunzinger's furniture resemble parts of the machines that produced them.

ASG

Gillinder & Sons
American, 1867–1891
Covered Compote, ca. 1880

Pressed glass,
10 × 7½ in.
Unmarked
Gift of Mrs. George Roper,
Blue Ridge Summit,
Pennsylvania, 1959, A1041

1. Gay LeCleire Taylor, *Gillinder Glass: Story of a Company* (Millville, N.J.: Museum of American Glass at Wheaton Village, 1994) provides the most thorough account to date of the firm's history and products.
2. Emma Papert, *The Illustrated Guide to American Glass* (New York: Hawthorn Books, 1972), 193.
3. Ruth Webb Lee, *Early American Pressed Glass*, enl. and rev. ed. (Northboro, Mass.: the author, 1946), 284.
4. Nicolai Cikovsky Jr., "'The Ravages of the Axe': The Meaning of the Tree Stump in Nineteenth-Century American Art," *Art Bulletin* 61, no. 4 (December 1979): 611–26 [615].

America's most significant contribution to the history of glassmaking was the development, about 1825, of an economical mechanized method for pressing glass. This technology greatly reduced labor costs and made glassware affordable for most Americans. By the mid-nineteenth century, glassmakers were mass-producing inexpensive pressed-glass tableware in a variety of shapes and sizes, with glass objects available in matched sets. Although manufacturers created colored examples, most were made of colorless glass with designs in imitation of more expensive cut-glass objects.

This covered compote for fruit salad was made by the Philadelphia firm of Gillinder & Sons, one of the most prolific of the many glasshouses operating in the United States in the second half of the nineteenth century.[1] Founded in 1867 by the British emigrant glassmaker William T. Gillinder and his sons, James and Frederick, the firm produced several well-known patterns. In the 1870s the Gillinders began experimenting with frosting acids, which became a hallmark of the firm's tableware.[2] Used on this compote, the technique allowed for contrasts of opaque frosted glass with clear colorless glass.

Surmounted by a finial in the form of an Indian (fig.), the compote is pressed in Gillinder & Sons' Pioneer pattern, also called Westward Ho.[3] Introduced after 1878, the design features a continuous relief with a log cabin, leaping deer, and charging bison set within a mountainous landscape littered with tree stumps. Created in a period when an increasing number of settlers journeyed west in search of economic opportunity, the compote's

imagery conveys the rapidly changing nature of life on the frontier. Due to the relentless operation of American expansion, by the 1870s Native Americans were fast disappearing from their homeland. To the large number of Americans who believed in the ideology of Manifest Destiny, the Indian race was doomed to extinction in order to make way for American "progress." Thus, rather than an active participant in the dynamic landscape, here the Native American Indian mournfully kneels near a tree stump, a symbol commonly employed in the nineteenth century to represent the approach of American civilization.[4]
ASG

Christopher Dresser, designer

British, 1834–1904

Leuchars & Son, est. 1798; Hukin and Heath, est. 1855;

Worcester Royal Porcelain, est. 1751

Picnic Tea Service, ca. 1891

Gilt and silver-plated white metal, split bamboo, porcelain with gilt decoration, leather-covered wood with velvet linings, 7¾ × 11⅜ × 5⅞ in. (case)
Case marked: Leuchars & Son, 38 & 39 Piccadilly, London
Gift of Ms. Constance Caplan, Baltimore, Maryland, 2005, A4106

1. Harry Lyons, *Christopher Dresser: The People's Designer, 1834–1904* (Woodbridge, Suffolk, Eng.: Antique Collectors' Club, 2005), 202.
2. Michael Whiteway, ed., *Shock of the Old: Christopher Dresser's Design Revolution* (New York: Cooper-Hewitt, National Design Museum in association with V&A Publications, 2004), 142. The design of the teapot was registered with the Patent Office (Rd. No. 18367), which dates it to late 1884.

Housed within a leather-covered traveling case, these fifteen objects make up a picnic tea service. The set includes a pair of porcelain cups and saucers, two spoons, sugar tongs, a cylindrical flask for cream, a tea caddy, a sugar bowl, a creamer, a teapot, and a teakettle with a folding stand and paraffin burner (fig.). Composed of electroplated objects manufactured by Hukin and Heath and ceramic items produced by the Worcester Royal Porcelain Company, this popular set was packaged and retailed in London by Leuchars & Son.[1]

With its red case recalling a lacquer cabinet, the tea service reflects the pervasive influence of Asian culture on nineteenth-century British life. The beverage itself originated in the East and enjoyed widespread popularity in England after its introduction in the seventeenth century. Porcelain likewise originated in Asia and had been a luxury product imported from China and Japan before its development in Europe in the eighteenth century. The lobed cups and saucers here evoke porcelain examples produced in Asia.

The silver-plated objects, especially the kettle and teapot, also reflect Asian design. Positioned above the pot, rather than at the side, the kettle's handle folds down for ease of packing, a characteristic aspect of a traditional Japanese teapot. Furthermore, Japanese influence is noticeable in the woven bamboo handles of the teapot and kettle, which protect the hands when in use.

Christopher Dresser, one of the most talented British designers active in the second half of the nineteenth century, designed the set's teapot and kettle. Dresser became a passionate advocate of the arts of Japan after visiting the country in 1876–77, publishing an acclaimed book, *Japan: Its Architecture, Art and Art-Manufacturers* (1882), upon his return. The trip had a profound impact on Dresser's style, leading him to focus on the form of objects rather than on ornament. Dresser served as art advisor to Hukin and Heath from 1878 to 1881, with the firm producing objects based on his designs through the end of the century.[2]

ASG

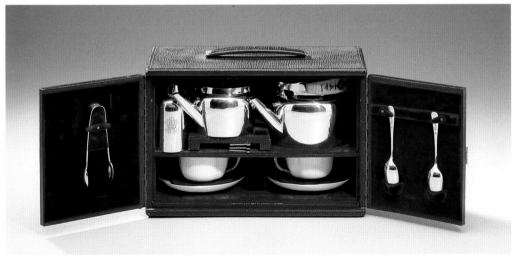

Tiffany & Company

American, est. 1853

Cream Jug, Sugar Bowl, and Sifter, ca. 1874

Silver-gilt with acid-etched surface, 5½ in. (cream jug); 5 in. (sugar bowl); 7⅛ in. (sifter)

Case stamped: Tiffany & Co., New York

Gift of Ms. Constance Caplan, Baltimore, Maryland, 2005, A4107

1. Charles H. Carpenter Jr., with Mary Grace Carpenter, *Tiffany Silver* (New York: Dodd, Mead & Company, 1978), 7.
2. For an illustration of a similar set in the original box, see Francis Gruber Safford and Ruth Wilford Caccavale, "Japanesque Silver by Tiffany and Company in the Metropolitan Museum of Art," *Magazine Antiques* 132, no. 4 (October 1987): 808–19 [812, fig. 5].
3. Carpenter and Carpenter, *Tiffany Silver*, 186.

Founded by Charles L. Tiffany (1812–1902) as a "fancy articles and curiosities" shop, by the 1870s Tiffany & Company was among the leading manufacturers of silver and jewelry in America.[1] Under the direction of Edward C. Moore (1827–1891), head designer from 1868 until his death, the firm created some of the most innovative metalwork of the nineteenth century, including Japanese-style silver. Japanese art became known in the West after Commodore Matthew C. Perry of the United States Navy opened trade with the country in 1854. From that time onward, Japanese prints, lacquerwares, textiles, porcelains, and metal objects flooded into the West and dramatically affected design.

An early enthusiast of Japanese art, Moore assembled a significant collection of objects as well as an extensive library of books on Asian art. These collections served as prime sources of inspiration for Moore's ideas, although his designs were reinterpretations rather than direct copies of Japanese artifacts. Greatly influenced by Japanese metalwork, Moore's Japanese-style silver for Tiffany and Company usually included asymmetrically arranged naturalistic motifs as well as textured surfaces.

This set likely held thick cream and powdered sugar to be served with fresh berries, a popular dessert of the period.[2] The sugar sifter, which features a bird nestled among branches and flowers, is in the Japanese pattern, which Moore designed in 1871 (fig.).[3] With their applied floral sprigs and acid-etched surfaces, the cream jug and sugar bowl also reflect Japanese aesthetics. Such surface texture imitated the rough surfaces of Japanese bronze or iron and stood in stark contrast to highly polished silver. The Japanese influence on the set, however, extends primarily to the decoration. True to the eclecticism of the period, the set freely assimilates elements from different cultures: the forms of the cream jug and sugar bowl are Neoclassical in style, and the sugar sifter's pierced bowl recalls Near Eastern art.

Tiffany & Company produced Japanese-style silver through the 1880s, when the fashion for Asian-inspired objects diminished. It was a small, specialty line made for connoisseurs who believed in the Aesthetic movement's mandate of "art for art's sake."

ASG

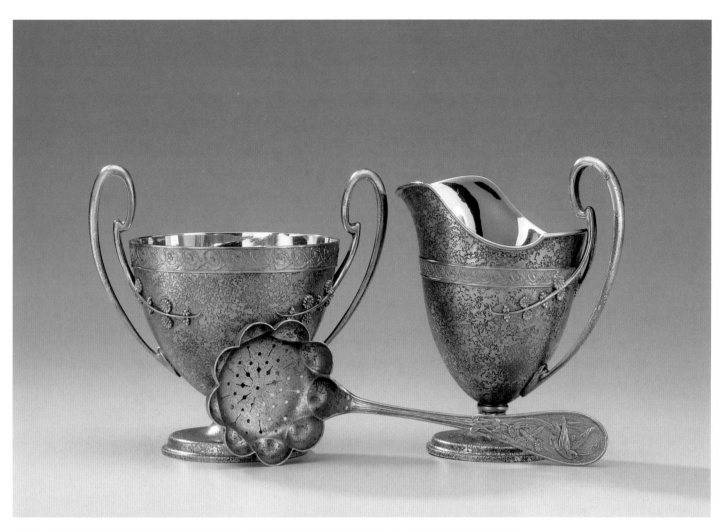

Louis Comfort Tiffany, designer

American, 1848–1933
Tiffany Glass and Decorating Company (1893–1902)
or Tiffany Furnaces (1902–28)
Vase, ca. 1894–1918

Blown glass, 11½ × 4 in.
Etched on bottom: 01128
Gift of Mr. and
Mrs. Michael Merson,
Baltimore, Maryland, 2002,
A3744

1. Alistair Duncan, *Louis
Comfort Tiffany* (New York:
Harry N. Abrams, 1992), 21.
2. Alice Cooney Frelinghuysen,
"Louis Comfort Tiffany at
the Metropolitan Museum,"
*Metropolitan Museum of Art
Bulletin* 56, no. 1 (Summer
1998): 1–100 [53].

With its fluid shape and brilliant coloring, this vase by Tiffany epitomizes the international Art Nouveau style. A conscious break with tradition and revivalism, Art Nouveau looked to organic forms and exotic sources for inspiration. Siegfried Bing, who promoted the Art Nouveau style through his Paris gallery, L'Art Nouveau, lavishly praised Tiffany's glass for its decoration, which the glassmaker integrated into the form rather than simply applied onto the surface.

The son of Charles Lewis Tiffany (1812–1902), founder of the prestigious New York jewelry and silver firm Tiffany and Company, Tiffany began his artistic career as a painter, receiving instruction from the American artist George Inness (1825–1894) before training in the Paris studio of Léon Bailly (b. 1826). As his artistic skills developed, Tiffany became fascinated by the cultures of the Orient, a term that at the time encompassed the Near East, the Middle East, and North Africa, from which he drew inspiration throughout his career.[1]

In the 1870s Tiffany began studying glassmaking techniques and chemistry, at first creating leaded-glass windows before experimenting with blown-glass vessels. Establishing a glasshouse in the New York borough of Queens, Tiffany developed a method whereby different colors were blended in the molten state, producing subtle effects of texture and shading. In an attempt to re-create the opalescent quality of ancient glass, a result of centuries of corrosion, the glassmaker perfected a technique using metallic oxides to produce iridescent surfaces. Tiffany called his line of glass Favrile, derived from the Old English *fabrile*, meaning "handwrought."[2] Favrile glass was strikingly new and earned Tiffany international recognition.

This vase displays the flowing lines and dazzling surface qualities that characterize the best examples of Favrile glass. Looking to the Islamic world for inspiration, Tiffany modeled the vessel's sinuous form after swan-neck perfume sprinklers produced in Persia. Rather than a utilitarian vessel, however, this vase serves as a work of art that encapsulates the sensuality and exoticism of the Art Nouveau style.

ASG

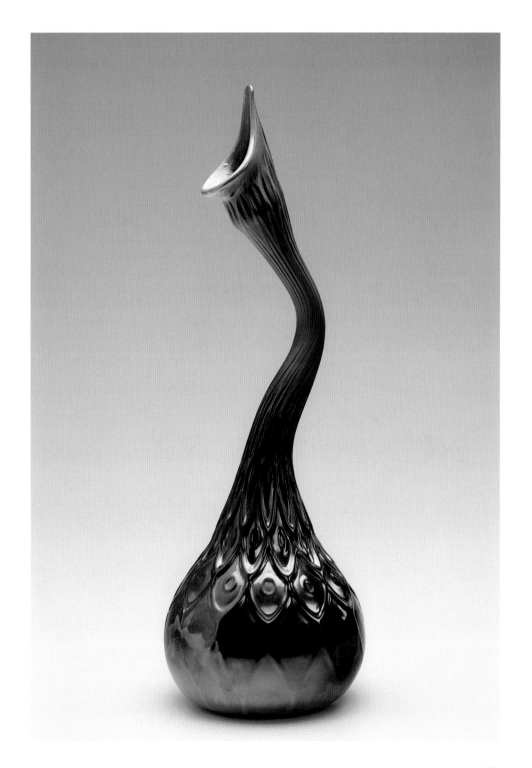

Johann Loetz Witwe Glassworks
Bohemian, 1836–1947
Vase, ca. 1900

Blown glass with brass frame, 22 × 11 in.
Unmarked
Gift of Mr. and Mrs. Michael Merson, Baltimore, Maryland, 1999, A3439

1. Waltraud Neuwirth, *Loetz Austria, 1900* (Vienna: W. Neuwirth, 1986), 20.
2. Jan Mergl and Duňa Panenková, "The History of the Firm, Its Production, and Sales," in *Loetz Bohemian Glass, 1880–1940*, ed. Mergl, Ernst Ploil, and Helmut Ricke (Ostfildern-Ruit, Germany: Hatje Cantz Verlag, 2003), 27–41 [31].

Bohemian glass has a long, rich tradition dating back to the medieval period. By the nineteenth century the region was known as a world center for glasswork, with more than two hundred glass manufacturers producing an array of functional and decorative glassware. In the town of Klostermühle (now Klášterský Mlýn), the Loetz factory gained prominence under the direction of Maximilian Ritter von Spaun (1856–1909), who assumed management of the glasshouse in 1879.[1] Under his direction, Loetz became one of the leading glass producers in Europe, selling its products through representatives in several cities, including Vienna, Berlin, and London.

The glassmakers at Loetz took full advantage of the malleability of glass, blowing the material in a great variety of vessel shapes, many influenced by East Asian pottery. After examples of Louis Comfort Tiffany's (1848–1933) iridescent glass were displayed in the nearby town of Reichenberg (now Liberec) in 1897, Loetz created its own works with pearl-like metallic surfaces in the style of Tiffany. The factory introduced its iridescent Phänomen glass in 1898 at an exhibition in Vienna, Loetz's closest and most receptive market.[2]

Set within a brass frame, this Phänomen vase exemplifies the Jugendstil, or "youth style," the branch of Art Nouveau that emerged in Munich in the late nineteenth century. Like their contemporaries in Paris and Brussels, Jugendstil designers drew inspiration from the natural world, seeking to capture a sense of dynamism and energetic organic growth in their work. In this example, the vase's shimmering surface and attenuated, curvilinear frame express the fluidity of the once-molten glass as well as the vitality of the natural world. The abstract ornament, rationalized form, and smooth bare surface of the brass frame also typify the Jugendstil.

Loetz's Jugendstil glass garnered wide praise for its inventive forms and dramatic surface effects. The firm's products received prizes at several international exhibitions, including gold medals at the 1900 Exposition Universelle in Paris and the 1904 Louisiana Purchase exhibition in St. Louis, Missouri.

ASG

Grueby Faience Company

American, 1894–1909

Inkwell, ca. 1900

Glazed earthenware and silver, h. 4½ in.
Impressed on bottom:
Grueby Boston MA
Purchased with funds provided by Paul and Karen Winicki, Baltimore, Maryland; Frederica Kolker Grossman Saxon, Baltimore, Maryland, in memory of Mr. Jack L. Grossman; and in honor of Dr. Joseph Ruzicka, Hagerstown, and Morton Katzenberg, Baltimore, Maryland, 2005, A4042

1. Paul Evans, *Art Pottery of the United States* (New York, 1974) provides a useful introduction to the Grueby Faience Company and contemporary American art potteries.
2. Susan J. Montgomery, *The Ceramics of William H. Grueby* (Lambertville, N.J.: Arts and Crafts Quarterly Press, 1993), 21–23.

The Boston-based Grueby Faience Company produced some of America's finest Arts and Crafts ceramics. Inspired by the matte finishes on French wares displayed at the 1893 World's Columbian Exposition, founder William H. Grueby (1867–1925) embarked on years of experimentation with glazes, eventually perfecting the dense green finish for which his pottery was best known. Although Grueby developed a rich repertoire of glazes, including cream, ocher, blue, mauve, and brown, the plantlike green glaze became the firm's most popular and was widely imitated by rival manufacturers.[1]

Grueby first displayed his products in 1897 at the inaugural exhibition of the Society of Arts and Crafts in Boston. Created at a time when other American art potteries promoted painted ornament, Grueby focused on the decorative effects of glazes and the harmonious integration of form, material, and decoration. Working with George Prentiss Kendrick (1850–1919), who designed the pottery's thick, organic forms, Grueby's ceramics were hand-thrown and decorated, primarily by female students hired from local art schools. The firm's products were an immediate success, especially with followers of the Arts and Crafts movement, which aimed to reassert the importance of handcraftsmanship in the face of growing mechanization and mass production.

With its vegetative green glaze, simple form, and delicately crafted sterling silver overlay, this one-of-a-kind ceramic inkwell exemplifies the pottery's early production under Kendrick's direction. Indeed, the designer likely devised the inkwell's silver frame, as he was an accomplished metalworker in both silver and copper when he joined Grueby in 1897.[2] The crossed, saberlike writing quills in the silver decoration identify the vessel's function and recall the Victorian novelist Edward Bulwer-Lytton's famous adage, "the pen is mightier than the sword."

Grueby's wares were exhibited in Paris in 1900 at the Exposition Universelle, where the firm garnered three medals, two gold and one silver. Grueby also won medals at the Louisiana Purchase exhibition in St. Louis in 1904. Despite its critical success, however, the company could not sustain itself financially and filed for bankruptcy in 1909.

ASG

George E. Ohr
American, 1857–1918
Vase, ca. 1895–1900

Glazed earthenware,
4½ × 3½ × 3½ in.
Signed on bottom: GE Ohr
Gift of an anonymous
donor, 2003, A3860

1. Robert A. Ellison Jr., *George Ohr, Art Potter* (London: Scala Publications, 2006), 17–19.
2. Garth Clark, "Clay Prophet: A Present Day Appraisal," in *The Mad Potter of Biloxi: The Art and Life of George E. Ohr*, by Clark, Robert A. Ellison Jr., and Eugene Hecht (New York: Abbeville Press, 1989), 121–44 [121].

Although receiving little recognition during his own lifetime, Ohr's ceramic works are today appreciated as some of the most inventive ever produced in the United States. Born to German immigrants in Biloxi, Mississippi, Ohr apprenticed as a blacksmith at his father's forge before learning the art of pottery from a childhood friend. Naturally gifted, Ohr labored tirelessly to develop the skills of a master potter, traveling throughout the country to visit potteries while reading widely on the subject of ceramics.[1] Calling himself the "Mad Potter of Biloxi," Ohr worked entirely alone at his studio, where he created innovative vessel forms out of local clays. Seeking to exploit the plastic quality of the ceramic material for its expressive potential, Ohr worked his vessels until as thin as porcelain before pinching and crushing them into irregular shapes. This thin-walled vessel began as a cylindrical form, but it has been altered through twisting of the upper portion. While known primarily for his daring and original forms, Ohr also formulated an impressive variety of unusual glazes. This vase features a blue glaze over which gold glaze has been sponged and green glaze has been dripped.

Ohr sold more conventional, utilitarian wares to provide for his family, but he had difficulty finding an audience for his avant-garde designs. Consequently, Ohr amassed thousands of such pieces, which he confidently asserted would one day be worth their weight in gold. In the years before his death in 1918, Ohr carefully stored this large collection in the attic of his studio before giving the building to his sons, who converted it into an automobile repair shop. Rediscovered by an antiques dealer from New Jersey in 1969, this trove inspired a reassessment of Ohr's work and established his reputation as one of America's finest art potters.[2]

ASG

Ruben Haley, designer

American, 1872–1933
Consolidated Glass Company, 1926–32
Ruba Rombic Sugar Bowl and Creamer,
ca. 1928

Molded glass, 2⅝ in. (sugar bowl); 3⅝ in. (creamer)
Unmarked
Gift of Michael and Anis Merson, Baltimore, Maryland, 2005,
A4075 & A4076

1. Jack D. Wilson, *Phoenix and Consolidated Art Glass, 1926–1980* (Marietta, Ohio: Antique Publications, 1989) provides a useful introduction to the history of the firm.
2. Alistair Duncan, *American Art Deco* (New York: Harry N. Abrams, 1986), 126. Ruba Rombic also subtly references its designer's first name, Ruben.
3. Wendy Kaplan, "'The Filter of American Taste': Design in the USA in the 1920s," in *Art Deco, 1910–1939,* ed. Charlotte Benton, Tim Benton, and Ghislaine Wood (Boston: Bulfinch Press, 2003), 335–43 [335–36].

Inspired by the display of modern works exhibited in Paris at the 1925 Exposition des Arts Décoratifs et Industriels Modernes, the American designer Haley created a line of glassware he named Ruba Rombic. Manufactured by the Consolidated Glass Company of Coraopolis, Pennsylvania, the Ruba Rombic line transferred the new fractured visual language of early-twentieth-century avant-garde art movements into three-dimensional tableware.[1] Haley's glass created a sensation when it made its debut at the 1928 Pittsburgh glass show, where Consolidated Glass exhibited it in its own room against a backdrop decorated with bright green parallelograms.

According to a 1928 advertisement, the name Ruba Rombic derives from *ruba'i,* a type of Persian poem, and *rhomboid,* a mathematical term for an irregular form with no right angles.[2] The designation implies the objects merge a poetic sensibility with modern technical knowledge, a fitting combination for art objects produced in an industrial glass factory. Consolidated Glass manufactured more than thirty different forms in the Ruba Rombic pattern, including plates, pitchers, candlesticks, and tumblers. The firm retailed the line in upscale department stores throughout the United States, which played a critical role in promoting the new modern design style based on the French Moderne, or Art Deco, mode.[3]

This colorful sugar bowl and creamer exemplify the American Art Deco style of the 1920s and 1930s. Composed of a rhythmic series of angular planes, contemporary viewers would have associated the tableware with the Cubist style of such painters as Pablo Picasso (1881–1971) and Georges Braque (1882–1963). Fashionable consumers welcomed the application of the latest fine arts style to domestic goods and believed such objects expressed an emerging American sensibility that celebrated the essential qualities of modern life—its dynamic character and nervous energy.

Although Ruba Rombic was a great critical success, Consolidated Glass declared bankruptcy in 1932 as a result of the Depression. Few objects in the pattern were produced and, thus, they are extremely rare today.

ASG

René Lalique, designer
French, 1860–1945
Lalique et Cie, est. 1909
Chamois Vase, ca. 1931–47

Molded glass with enamel
decoration, 4¾ × 3⅞ in.
Etched on bottom:
R. Lalique
Gift of Mr. and Mrs. Michael
Merson, Baltimore,
Maryland, 2004, A4021

1. Patricia Bayer and Mark
Waller, *The Art of René Lalique*
(London: Bloomsbury Publishing,
1988) provide a useful
introduction to Lalique's career.
2. The Chamois vase appears
as model no. 1075 in Lalique's
1932 illustrated catalogue, René
Lalique, *Lalique Glass: The
Complete Illustrated Catalogue
for 1932* (rpt., New York: Dover
Publications, 1981).

Ornamented with intersecting bands of gracefully striding chamois, this vase by the French glassmaker Lalique incorporates the simplification of form and affinity for repetition that were hallmarks of the French Moderne, or Art Deco, style of the 1920s and 1930s. Lithe animals such as gazelle, antelope, and chamois were particularly popular design motifs during this period, as designers believed their sleek bodies and great speed expressed the dynamism of the modern world.

Lalique began his career as a jewelry designer, creating models for such firms as Cartier and Boucheron before establishing a workshop of his own in 1885.[1] Rejecting the contemporary trend for diamonds in elaborate settings, Lalique produced unique designs using colorful gemstones and enamel, which established his international reputation.

From 1898 onward Lalique experimented with glassmaking, at first using the material in jewelry designs but later employing glass to fashion vessels, windows, and light fixtures. An early commission to produce a series of scent bottles for the French perfume maker François Coty led Lalique to explore glass-pressing technology. The technique of pressing glass in molds had been used from the early nineteenth century to produce inexpensive glassware. Lalique, however, adopted the technique to produce high-quality molded luxury glass in quantity.

Lalique's interest in glassmaking centered on the inherent qualities of the material–its translucence, plasticity, and solidity. For this purpose he used a glass body with a composition low enough in lead to be unaffected by high temperatures, which allowed Lalique to mold glassware with sharp edges and deep, bold forms. Made of molded amber glass, the Chamois vase was produced by Lalique's firm between 1931 and 1947.[2] On this example, the surface application of opaque green enamel highlights the angularity of the deep beveled design, in character with the preference for geometric forms in the Art Deco period.

ASG

Index

231